MW00444462

CONQUERING

THE

LIFE-BALANCE HOAX®

One Woman's Journey
from Despair to Millionaire

DONNA CORNELL

Conquering the Life-Balance Hoax: One Woman's Journey from Despair to Millionaire

Limit of Liability/Disclaimer of Warranties

ISBN: 978-1-7339338-1-0

Printed in the United States of America

Dedication

For my mother: Frances Konkol DeCrosta

*Thank you for being someone I could miss so terribly
that the pain propelled me to create a most remarkable
life. I hope you are proud.*

ACKNOWLEDGMENTS

In a life filled with ups and downs, successes and failures, where do I begin to tell you about the people who helped me along the way? My acknowledgments are for those who guided me through the author stage of my life, but also for those who supported me in so many ways throughout my life. The challenge in naming people is that our memories are less accurate than our life experiences and yet the kindnesses I have been shown throughout my journey are etched indelibly in my heart.

Thank you to my husband, Jeff Werner, who supported me while I reached for the stars over and over again. Jeff listened, and then listened some more. I acknowledge and thank our children, Erica, Ryan, Danny and Bret. Thank you to their spouses, Rob, Kristin, and Karen, who allow me to sometimes swoop into their lives with my advice and simply smile and give me hugs. I am so proud of you all and how you were so tolerant during this writing process. Thank you for enduring my ever-continuing ambitions and sometimes upheaval at home. A daughter is one of God's most precious gifts as she evolves from child to friend, to confidant. Thank you, Erica, for being you. And Bret, who at 12 joined us when I married his father and we blended families, and who with his spirit adds so much to my life. To my first-born Danny who was with me through the struggles. I love you all so much.

Thank you to my sister, Jaymee Scaduto, who showed remarkable strength as we buried our sister, Sally, and always listened, never judged, always loved.

Deserving a special shout-out is my son, Ryan Cornell, for his years of devotion creating our *Power of the Woman Within* product and working side-by-side at our corporate headquarters. Ryan's creativity and attention to detail every day are a marvel.

Thanks to my niece, Reana (Ohana), (and Darren) who always makes me laugh at my own shortcomings; and to Tony, Gina, Frank, and Jason and all their spouses; I hope you know how much your families are loved and what joy you bring to me, and for that I give thanks.

To the talented recruiters and support staff in my corporation who helped the company provide stellar service to our clients and bring prosperity to all of us, I extend a sincere and hearty thank you. Your contributions to my life are ever lasting.

Relating to the specific endeavor of creating this book, I offer thanks to Susanne Vondrak, Colleen Nugent and my talented editor, Doug Williams.

Thoughts about the three women on the back of the book

The endorsements of my book are so appreciated and especially by the three women on the back who loved the content and my story, because each of them has a remarkable story of conquering life's challenges.

They have each accomplished something extremely significant in overcoming challenges of life.

Leslie was the last person out of Tower II at the time of the horrific attack on America, when the planes killed thousands on 9/11. The trauma will be with her for life, yet she overcame that to become a leader in the topics of survival and the ongoing challenges facing our society regarding racism and prejudice.

Marla became world famous as the beautiful model whose face was slashed by a spurned landlord. An accomplished woman, she had to seek other careers. Worse, she had to overcome an unflattering TV movie depicting the horror of the incident. The trial of her landlord became national sport and can only be termed an ugly abuse of the victim. No longer a fashion model, today she is a role model for women on how to live well after surviving a tragedy.

Anne overcame an ugly divorce, loss of job, a terrific life plummeted to despair. A great talent with doors closed until she overcame it all and developed a program and a book to help others become aware of, and philosophically enlightened about, three of the most powerful influencers in a person's life — perceptions, beliefs and judgments. She turned her pain into helping others with grace and sincerity.

TESTIMONIALS

As a professional psychologist, many women come to me with issues of low self-esteem and having difficulty in relationships. Donna's suggestions are clear, concise and practical. Donna's program does for women what many of us professional psychologists cannot. She gives personal experiences and wise advice that is easily accepted by a person who feels as if they're her equal.

—Dr. Marc Linzer

Donna sees every problem as an opportunity to find a solution. She shares her energy and laser-beam focus with others, always with a smile, and always improving everyone's life. She finds a way to combine her own extraordinary career with compassion, understanding, and guidance for all who seek her advice. Her book will be read and shared for years to come.

—Dr. Susan Saxe-Clifford

Having this information is like having Donna in your living room; she is there to help and gives me the strength to face each day.

—Joellyn Auklandus

Donna makes it very, very realistic that whatever you choose to do as a woman, you have choices, and you can succeed, and you can do it. It's not facts. It's not research. It's not statistics saying that "yes, it can be done." It's a true-life story. It's real-life, easy, simplified ways to attain what you want. Today, I run a successful business. I work for myself. And, Donna's advice makes it all easier.

—Liz Howard

When you follow Donna's advice, you get a sense that there are steps you can take to realize what you've only dreamed of. She makes you feel like you have a friend right there with you. And not only that, but this friend has all the answers. Donna is an inspiration to me because she never gave up —no matter how hard it was. And yet she is not unreachable... there's so much that every woman can identify with.

—Rita Sturges

I've experienced great change with her guidance... it can help you too change your life — to make you feel more confident about yourself, to have better relationships, and to feel better and happier.

—Carolyn Bower

FOREWORD

THIS BOOK IS written with a focus for women although many men have followed my advice as well and noted exceptional changes in their lives also. Today's man has to face daily challenges not even on the table a decade ago. My advice can help either a man or a woman achieve success, find peace and live happier lives.

After a lifetime of messages screamed at girls from TV, Hollywood, books on success and books on fulfillment, the message conveyed is that we, as women, adopt a competitive perspective. Other women are so much better than me. I must catch up.

Other women are living a life of blissful balance. So, I, just like you, pushed myself to be all of that — a woman living a fully-balanced life, one who tried to be thin, successful and because I had children, *Supermom*, and of course the *Wife of the Year*... and I failed over and over again. My life was constantly out of balance. I certainly did not look like women on TV or the red carpet; I was far less than *Supermom* and, well, my relationships were often a mess. I am sure that you too experience a lot of demands. In fact, you may feel like you are running around in circles, even spinning out of control as you try to juggle career, family obligations, and finding a little time for yourself.

Something huge is happening today, finally, in the world of women. This evolutionary shift will forever alter the course of history and the progress is still so slow. Just recently, Saudi Arabia allowed women to drive. Our rights in the USA are getting stronger, while in other countries, progress of women is reversed. While reclaiming our femininity, we have just begun to awaken to our true and genuine power to reshape so very many things. Our society has undergone some positive changes with increasing numbers of women in professional schools and in the traditionally male professions. Women work at a wide variety of engineering, technical and blue-collar jobs previously closed to them. American colleges are turning out more female graduates than male. In fact, women outnumber men in today's workforce. Yet, despite the incredible success and status women have gained over the years, many studies show the overall sense of happiness and well-being of women continues to decline. And for the man reading this book, I understand that these outstanding changes in the role of women, have impacted you and your role in the home, your career, your relationships and your self-esteem.

A myriad of choices is presented to us each day, leaving us in conflict about what to do. Go after that promotion? What will it take? Can you achieve at that level? Do I change jobs? Industries? Stay at home? Home office? Buy a house? Do I qualify? Stay at home and be with my children? Move to the country and live simply?

Eventually, we realize there is a possibility of much more. We may have gained the freedom to be and do more, but we have not always been able to cultivate the power to thrive and flourish in our lives. Instead of living in the land of *"milk and honey,"* we find ourselves feeling discontent without being able to pin down what it is. Perhaps women have been developing

a masculine version of ourselves in order to level the playing field.

The price we pay can often be a diminished quality of life. We may have more money, freedom, opportunity, and education than any other generation of women in history, yet we may find it difficult to create the life we really want. One rich with things such as love, feeling alive, purpose, and contributing to a better future for our children and the world.

Often, we are simply adding to the burdens we already have. Conversely, we may feel we will never be able to achieve at levels we deserve. It is a lot to balance correctly and yet, if we don't balance it and create this perfect world, we get the message that we are a failure.

I want to help you create the life that is best for You, not following someone else's agenda; I want you to be able to truly identify what will create your life of peace and happiness. You will learn how I arrived at my goals and the steps I took and the sacrifices I made to achieve them. But far more than that, it is my intention that you learn how to identify the path that will bring *you* happiness and the steps that *you* will take to achieve them.

You probably bought this book because you want to know what changes took place to allow my life to go from one of deep despair to such financial success.

Yet, this is not simply a book about how to make more money or become a millionaire. Becoming a millionaire was certainly a goal for me, and I achieved it.

Chasing **"*The Hoax*,"** also called a *"Balanced Life,"* wasted my precious and valuable energy, and almost prevented me

from achieving the success I so desired. Wasted effort pursuing balance absorbed my time and energy and interfered with my ability to have loving relationships (who had the time?).

When I stopped believing in society's messages leading to perfection, I now understood *"The Hoax." From* this knowledge, I created my most remarkable life. I will tell you how to shed this mistaken belief as well, and how to carve out the life you truly want.

Simply discarding this dilemma called *"The Hoax,"* though, is not enough to achieve the life you desire. As I tell you my story, I will share with you some tools, philosophies, and strategies I created and used successfully to catapult my life from despair and loneliness to true happiness and wealth too.

This book will give you the tools to take charge of the direction of your life even when it is so far out of balance that you experience more than a tinge of panic. I most sincerely believe that you can achieve your goals, you can change your life, realize your dreams and transform your world.

This book will show you how I conquered the **Life-Balance Hoax** and I will take you on my *journey from despair to millionaire* — to living happily — even though my days and weeks were often *out* of balance.

Yes, I achieved my dream to change my life from living in total despair to living well, having attained millionaire status financially. But more than that, I was able to identify my treasures, those things worth a million dollars to me which made me a true millionaire in Life. My grandchildren are remarkable blessings. To me, the treasure of time spent on our sofa with Annie, at age 2 giggling loudly as I tickled her, or taking Annie,

Elise, and Amber to a children's play and having that cherished memory embedded in my mind and heart forever. And the hugs and sweet smile of Matt or Grace when they walk through our door. Or the moments with my older grandchildren that fill my heart with joy.

I cherish the million-dollar memory of the family vacation house on the beach or the cruise we all took together. Or the million-dollar joy of a surprise birthday party for my husband or creating a backyard that looked like Tuscany because my husband and I loved our visit there a few years before. And even the time our friends came over for a quick bite to eat and 5 courses later, much laughter and a dip in the pool created a very cherished memory.

Those are just a few of my joys and million-dollar moments. So, while I share with you my financial success, know that I found those million-dollar moments that make my life a true joy. Let me help you find yours too.

CONTENTS

INTRODUCTION

A Few Preliminaries...

Does any of the following sound familiar?

She...

- Wants to learn how to "*Juggle It All.*"

- Wants a career, but a family too.

- Is sad that she never has time for herself.

- Is in a rut and scared she will never get out of it.

- Is full of guilt for working when her children cry for her to stay home.

- Goes to work when she is sick because she used up all her "sick" days for her kids.

- Wants her family to stop living from paycheck to paycheck.

- Is overwhelmed by the unpredictability of her life.

- Sees her male co-worker get the promotion even though she deserved it.

- Holds in her anger and frustration while wishing for a better way.

- Never knows what each day will bring and is out of control.

- Strives for balance but continually fails to achieve it.

- Tries to stay feminine when her work demands that she be one of the boys.

- Wonders what happened to the romance in her life.

- Has no self-confidence.

- Doesn't stand up for herself.

- Pleases others in order to fit in or avoid conflict.

- Sometimes feels like she doesn't count.

- Worries all the time.

IS SHE YOU?

CHALLENGES FOR TODAY'S WOMAN

Gender discrimination laws have made much progress to make life somewhat easier for a woman today. The battles waged by decades of dedicated women to bring about equality have accomplished a great deal. We have witnessed positive changes in women's rights. But still more work remains to be done. Women need help finding the tools and resources to support their goal of greater fulfillment, to enhance their sense of purpose and to hone their ability to connect with the version of themselves, whatever that may be. Everyone has different skills. It is important to recognize this fact. We, as a society, need everyone and their differences. Find your personal empowerment to become your true self. Society needs you to become your true self and to use your gifts to become what you want to be. It has been my experience that many women share a common goal. They want to build healthy relationships and to finally achieve the success they desire while individually defining success on their terms.

Women still must fight the ongoing depictions that emphasize a woman's major strengths as sexuality and other stereotypical feminine characterizations. The latest rash of TV programs and movies depict women as sophisticated international spies working against terrorism, but they still have these great bodies, flowing hair, perfect makeup, and it is just so unrealistic. It is a well-known fact that women still face barriers when it comes to equal pay, promotions, and empowerment both at home and at work.

OUR SISTERHOOD

Once when I presented my concepts to a group, they seemed confused. They wanted to know if my advice was for married women, career women, stay-at-home mothers, rich or poor, young or old. They did not immediately grasp the fact that the common bond between each of us is that we are all women, regardless of which stage of life we are in. And as such, it doesn't matter what problems or challenges we face; often they are totally understood only woman-to-woman. Our Sisterhood links us, regardless of race, religion, ethnicity or country because as women there are unique challenges simply because we are *Women*.

Unique, yet similar. Many time zones and many cultural divides are crossed by our Sisterhood, but we face challenges and find solutions, and learn and grow as individuals. We are Sisters and that is why this book is written by a woman for women.

THIS BOOK IS A GUIDE

When a friend asked if this book was going to be a memoir, I replied, not really. It does tell my story, but it has self-help

value as well. This idea of living a balanced life, every day, is just so unrealistic. It would be awesome if it were possible, but it is not. I traveled that journey of dealing with an unbalanced life with so much grief and a sense of failure that continued day to day. I could not move forward until I stopped chasing **The Hoax.** So, I have advice and direction on ways you can take charge of your life, even when it is horribly out of balance, which truly is most of the time. This is real hands-on advice gained through direct experience. Yes, there are those rare —and I emphasize rare — times when life is balanced for a day or two, often happening spontaneously, not because of a super effort to create a balanced life, but more likely because the stars became aligned.

This book is a guide to help you live happily in an unbalanced life.

My advice in this book focuses on ways for you to be able to change your life, personally and professionally. There are some chapters that may be devoted to motivation and others that have a real self-improvement overtone, because changing your life from one of hectic imbalance to one where you are more in control and happier requires a profound understanding of who you are, where you are in your life, and where you want to go.

The analogy might be you want to take this trip to a new **You.** Is it wise to start out on your journey if the car hasn't been inspected in years? If the tires are flat? The engine is without the proper fuel? No, you need to be sure of the soundness of the vehicle taking you there. And now, think of that vehicle as **You.**

This book is the story of my journey, from the depths of despair to the happy existence I live today. I learned to take charge of

my life, to create the life I truly wanted. I will tell you about other women who have also met the challenge of conquering an unbalanced life head-on and some of the steps they took to bring about the changes they needed. I offer advice that will not only enable you to live peacefully with your life out of balance but, as it has helped others, show you how to take your life to the highest levels of happiness and success.

And what about the men reading this book or those who attend my conferences? When reading the beginning paragraphs here explaining the plight of today's woman, is his first emotion annoyance? Resentment? Empathy? Certainly, as the role of the woman has changed, so has that of the man. The traditional gender roles of a man have been stomped on by the heels of women during their parade of progress. The impact has been great. Some men have even switched roles becoming the stay at home Dad. If the man is in a relationship, often his role has changed from Provider/Protector to Partner. The expectations have increased dramatically. The man is supposed to now be more sensitive and aware. If in a long-term relationship, he can no longer focus only on his role outside the home. While continuing to strive for career success, he needs to be a participant in a multitude of new areas. And learn how to do it well, often without having had a role model to watch. I am not addressing societal differences where in many cultures, little or no progress toward equality and gender neutrality in daily living has happened; rather it has been entrenched for centuries. The American male often adds to his challenges trying to find enough time for it all, trying to find balance the same as the woman of today.

THE SEARCH FOR BALANCE

Let me begin to tell you how I got out of a continually down-wardly spiraling life and took control to create the life I wanted. The new awareness dispensing with **The Hoax** was the first step toward living this remarkably, rewarding life.

As a certified career consultant and strategist, I spent two decades tackling tough life-choice questions for thousands of clients. Although I always began by discussing their careers and professional aspirations, inevitably we would talk about their personal lives. Life challenges happen because we really can't separate what we do for 8-10 hours a day from the rest of our lives. I have guided men and women to better understand themselves and all that life has to offer them, motivating them to aspire to new heights.

Some landed rewarding careers with the financial rewards they deserve, sparked to successfully pursue their lifelong personal dreams and ambitions. Others recognized that financial rewards were not the highest on their lists, but rather peace and harmony at home. Most were looking for a combination of it all. By listening to these people both men and women, I recognized the tremendous need for solid, make-sense *how-to* information. I began to share this tough, earned wisdom through seminars. I shared the answers I found and also created a *Power of the Woman Within* series of motiva-tional audio products. I then committed myself to writing this book to help others understand my approach to living a fuller and happier life.

NEVER TOO LATE TO CHANGE

Embrace the concept of NOW. I put this section here because I want you to embrace this concept as you read the other

chapters, knowing that you can make whatever changes you want, regardless of where you are in your life today. Tomorrow *can* be different.

Recognize that once **You** control what is happening in your life and you focus on what is important to you, then you can implement the necessary changes. This applies to people who are in the fall or winter of their lives as well as the young couple who recently packed that bridal gown away and wrote their thank you notes and the couple that has who has one in the crib and one on the way. And the person who is unmarried or uncommitted and yet finds that striving for balance is exhausting. It is never too late to change.

We all have multiple responsibilities, multiple challenges — life goes awry regardless of where we fall on the age and professional spectrums.

Of course, I have advised the person who is employed and trying to juggle it all and wants more out of life in both her career and her personal life. And I have counseled those who were retired from the job market and confused about what's next. And the ambitious individuals who often sit in front of me in career counselling sessions, who are confused about what to tackle next to achieve success. And not even sure what success means to them.

I have worked with women who completed the most challenging job of all — raising their children — and after complete devotion to that role, wanted to explore what would make them happy now. I am speaking of women generally, but I take a moment here to acknowledge further challenges by some who must face an additional and oftentimes greater obstacle. Those

who must deal with another layer of challenge that I never faced.

I am reaching out a particularly encouraging hand to people of color, different ethnic background, religious beliefs, sexual preferences or whatever makes them so different that sometimes others choose to treat them inappropriately. I sincerely hope this book helps every woman who reads it.

Let me reassure you that it's never too late to change your life — all of it or parts of it. It's never too late to go after what you really want.

So, the *Big Question*: What do you *really* want out of life — not just what you think you *should* want?

Through this book, you will learn how to make choices that are yours alone. Perhaps you want to pursue a long-wished-for new skill. What is it? Increasing your financial acumen? Taking a course that will allow you to become more valuable at your job? There are many ways — audio, videos, an educational course, webcasts, a coach or a club. Do you want to advance your career? No matter how long you have been at the same job or company, it is not too late to move up or make a change. You choose what the priorities are and for how long. Did you invest four years of your life in college pursuing a career path and then, with great disappointment, realize it was not the career you wanted for the rest of your life? That happens more than you know. Other options generally exist. You have developed skills and have knowledge and now you need to identify where these "transferable" skills can take you. You can work with a certified career counselor or arrange to take some skills evaluation tests; there are many options available today through one-on-one or groups on the Internet.

I promise it is never too late.

Think about who *you* are; think about what your dreams, your goals, and your talents are *today,* not in yesteryear. Things change. Life changes.

I will guide you through an exercise to explore who you are today, and I recommend that you conduct a self-evaluation at least once a year—pick a date and do it for yourself. If you are unsettled, do it every six months or sooner if you choose. It is your life! I will help you with some of the thought-provoking questions. Perhaps some incident will spark it, as it often has with me, or perhaps you will just know instinctively that it is time to review where you are headed. At such times, I hope you will continue to open this book and reread any chapters you find useful to keep yourself on track toward the life you want.

THE ORIGIN
OF THE LIFE-BALANCE HOAX

Miriam Webster defines hoax as: something false passed off as real.

During my years of struggle, I eventually made this life-changing discovery about trying to create a balanced life: well, I just couldn't achieve it. I tasted failure almost daily. And then envy consumed me because all the magazines featured articles about these super-achievers who seemed to have the perfectly balanced life. I could not get even close to a balanced life. The fact is that trying to balance your life, every day, every week, and every month can be an exercise in futility and the failure to achieve it can be so depressing.

When did **The Hoax** take root for women? When did we start believing that women could have perfectly balanced lives? I do not believe this was an intentional deception played upon women. Unfortunately, I do believe we participated in its creation. During World War II, women were asked to work in factories while the men were away at war. We were expected to be both the man and the woman, handling it all. And we did it. The war ended, and we were quickly dispensed with, our new skills forgotten, our ability to master a job ignored, our unique talents put out with the garbage. But women got a taste of self-sufficiency and liked it. A lot. The decade that followed,

the 1950s, was drenched in a *Leave it to Beaver* message to women: Devote your energy to your house and family, waiting in your pearls with a smile on your face for *The Man of the House* to come home. Yet, we had already tasted liberty and the chance to be more. We embraced the arrival of the Freedom of the 60s, with its message of emancipation — from bras, from boundaries — to take charge of our lives. What came next?

The message "Welcome women to the new way of life but watch out! Make sure you have 'Life Balance'." The expectation, **The Hoax**, was that women could do it all, be it all, and do so without complaint. Times were different in the 40s when this all started. Women were able to juggle more because the demands were far less. They did go to work, often at factories, but they went in overalls, a scarf over their head and when the bells sounded end of shift, they headed home to the children and their cozy home. They didn't bring work home, weren't on call 24/7, phones and emails weren't demanding attention, and life was simpler in many respects, although I acknowledge that the war infected every household, bringing pain and loss. Yet, the war finally ended, and men came home; we left the factories. The big change is that, during the last decade and up to and including today, we are expected to compete against the men, earn top dollar, live in beautiful houses, sometimes beyond our means unfortunately, build a continuously progressive career, care for the children in an ever-increasing protective manner, perhaps an aging parent and the list goes on and on. So much burden on the woman of today. Balance messages scream at us, who has time for dreams?

And for the man, the Life Balance Hoax began to rear its ugly head as society changed dramatically and often too quickly to keep pace. New roles, new implications, more demands on their time. Much has changed because so many of jobs including

management such as a lawyer, doctor, politician, manufacturing, engineering, business executive, etc., are attainable by both sexes. And the construction field and other labor fields are now open to all, which means that past gender roles do not apply anymore, because both sexes are now equally capable of contributing to society. And this translated to major changes for the men in our lives. I am not writing a book on the gender differences, however. I have written a book that can guide us, both men and women to be able to find the tools to making life changes.

I learned so much to bring me to the wonderful place I am today.

I learned the balance message was wrong and my efforts were so misplaced. And finally, I learned how to stop wasting my efforts and apply them to this new reality of living.

I share my journey; what I faced as a businesswoman in a man's world, fighting for my place on the roster; wanting off the bench to play with the big boys, to go after financial success. A female, shoulder to shoulder with men, in the work life striving to achieve the golden ring of success. Therefore, what follows is a sensible perspective that will arm you with a new and empowering vision that allows you to stop trying so hard to constantly balance your life and to start living happily and successfully (according to your own definitions). Say goodbye to that behemoth of guilt most women carry around because they can't always be all things to all people, and heroically balance their lives.

In theory, a balanced life sure seems appealing, but the reality is that it is simply not possible to achieve.

WHAT IS POSSIBLE TO ACHIEVE IS — living happily and successfully in an unbalanced life and I am going to help you do just that.

MY GOAL FOR YOU: FREEDOM

This book will help you gain freedom from the **Hoax** and will give you two mechanisms, a template for a new reality that frees you from the constraints of the **Life-Balance Hoax,** and a set of **Power Tools** which aid in decisions and further actions to take toward the goals and happiness you want in your life.

After I stopped chasing **The Hoax**, I needed help so that I could take my life to the next level. I used the tools I am going to introduce to you. Tools can sometimes refer to a hammer, other times to a screwdriver, and still others to a wrench or a razor cutter. In order to make changes in your life, you too are going to need **The Tools of Choice, Communication** and **Control** which, when used properly, will strengthen your levels of confidence and connect you with your own powerful Character. Apply these "tools" as a "technique," "tactic," or eventually even a "method," and others when you use them to *"hammer home"* a new skill, such as learning how to say **no** effectively. I will share with you how these "Tools" aided me in changing my life and reaching the most remarkable goals. My goal is to teach you these "Tools" so, just as I did, you can determine when and where to use them in your life.

I believe that practical exercises and affirmation practices will support and enable you to recreate your own reality and successfully undertake that change. So, keep reading, have paper and pen handy, make notes in the margins, and take the journey with me.

A Life of Despair

WHEN YOU READ of my successes, please don't consider it boasting. Nor am I suggesting my goals should become yours, or that you should adopt my depictions of success and personal happiness. Let me just say that finding these answers and the inner strength to transform my life has allowed me more joy and fulfillment than I ever thought possible. *I want you to have that too.* I've achieved wealth, a touch of fame, acknowledgment of my work efforts, and I have been able to create a life of love, happiness, and laughter.

I am not in the category of an Oprah Winfrey, Barbara Corcoran, or an Arianna Huffington or Sheryl Sandberg making $50 million plus per year. But I did become a self-made multi-millionaire at age 33; with no inheritance, no sponsor, no mentor, no silver spoon. I am not of "household name" fame outside my region, but I have certainly been able to live a life remarkably fulfilled. I went from the depths of despair, suicidal thoughts, and horrible sadness to happiness, peace, and rich rewards.

My life strategies have allowed me to be surrounded by a loving family and great friends. I have been able to achieve a solid level of financial success that has given me peace of mind.

I finally found happiness in marriage because I took control of my life and refused to allow the unbalanced days to ruin my

treasured moments. Once that happened, I was able to create a most remarkable life. Also, I have enjoyed accolades for my accomplishments, been honored as Citizen of the Year several times by prestigious organizations and received recognition from my state Senate and the U.S. Congress. My image has been on the cover of magazines, and I've been featured in articles by well-known publications. I've even been on TV. All of this came to pass because I found the secrets to living a life to its fullest.

I mention all these triumphs with the highest levels of *gratitude and humility.* I acknowledge the generous, spirited support of many others, those who worked for and with me, those who gave me friendship and love. They helped me immensely, and I am eternally thankful to each one of them.

I was living a life of despair, as a single mother of three kids, fighting every day to put food on the table and then step-by-step journeyed to become CEO of a multi-million-dollar organization. I learned life lessons that helped me turn my circumstances around. There was a lengthy period in my life when I had days when I struggled to get out of bed... or even to want to live. I am not over-dramatizing. The pain was real and paralyzing. I thought I was destined to a life of endless mistakes. I was a single, self-supporting Mom for about 10 years and the challenges were tremendous; the struggles drove me to live in an atmosphere of hopelessness. Yet I was able to fix it. I found answers and I am going to share many with you.

Many people today are surprised to hear my story because, over the years, I covered up how I felt. I covered it up on the outside, but inside I seethed with emotional agony. I was convinced I was just a zero in life — incompetent, ugly, and, of course, unlovable. I couldn't find myself, let alone the right

man or career. I made mistake after mistake on a seemingly endless road to self-destruction. In this book, I will tell you how I dug myself out of that horrible pit, that seemingly endless and painful cycle.

This is a good place for me to share a disclaimer. This book is written in clear, concise, everyday language. It is not over-loaded with psychological self-introspection that is emotionally draining. I think most of us have enough on our plates without some rigorous course of study. Some of the chapters may have a hokey title or exercise for you to do. Often the simplest, maybe childlike terms help us revisit the habits and thoughts we have built our lives upon. And try to remember, this is a recount of one woman's journey... the way I achieved the happiness and fulfillment I have today. Your road to happiness may have a few more bumps, or perhaps less. Hopefully less! However, every word in this book is true... a true account of how I shed the ties that kept me from a happy life. Sprinkled throughout this book are examples of changes others were able to make by follow-ing my suggestions. I share stories of how they successfully changed parts of their lives too.

Hear how I was able to make discoveries that helped me change my life. But since it all had to start somewhere, let's go back to MY ugly beginning.

'SCARFACE' — THE FIRST TRAGEDY

I lived as a child on a large, old-fashioned farm with my grand-parents, mom, and my uncle, who was also still a child himself. My dad was away in the Army. For Christmas one year, my uncle received a home chemistry set. He was so excited. He had a curious, analytical mind and loved anything to do with science. The set brimmed with things a real scientist would

use in a laboratory: a Bunsen burner, test tubes, and a book of scientific formulas.

One formula was for making an acid solution. My uncle followed the directions and blended the ingredients carefully, making sulfuric acid. Then he looked around for an empty bottle in which to put his concoction. He chose an empty perfume bottle.

The story I have been told is, as a toddler of just eighteen months, I went into his room and spotted the beautiful perfume bottle. Apparently, I remembered that before we went out somewhere special, my mom would reach for that very bottle and put a little dab of perfume just in front of my ears. She would fuss over me lovingly. This made me feel so special, so I repeated that process that day, dabbing a little on my fingers and in front of my ears.

The acid immediately began eating away at my skin. I screamed and dropped the entire contents of the bottle all over my body. The acid ran onto my stomach and my legs, burning and eating away at my young skin. It destroyed layers and layers of skin. My grandmother was the first to hear my screams, rushed upstairs to gather me in her arms. Afterward, she also required hospitalization because the acid was so strong that it ate away at the skin on her arms and shoulders where she held me to comfort me.

Miraculously, my mother remembered something she had learned in her high school chemistry class. She quickly ran outside to the pump and filled the laundry basin with water. (The farm did not have indoor plumbing). My mom deposited me in that laundry basin, saving my life as the water neutralized the acid.

They tell me I was in critical care for a prolonged period. Fortunately, I was too young to remember. The physical trauma caused me to forget how to walk and talk, which I eventually relearned. As a result of that accident, however, parts of my body, including the sides of my face, my stomach, and my legs (particularly the left one), were, and still are, scarred. They were very visible, very ugly scars.

To this day, I can never follow the popular trend of stocking-less, toned and tanned legs. I must always wear a pair of nylons or slacks. That is how I can physically cover up those scars. Being able to cover up or accept the scars emotionally is a task that remains difficult. I shuddered with the fear of rejection the first time my husband and I became naked. At the beach, I often must cover my legs with towels to avoid sun poisoning because of the fragility of the layers of remaining skin. People will stop and ask me if I spilled something because you can still see the lines running down my legs from a horrible accident with lifelong traumatic impact.

It was so hard being different. Kids on the playground were so cruel, taunting me with the nickname "Scarface." It was painful. Pictures of me as a child always show me covered up with turtlenecks, cute little scarves tied around my neck, hair around my face and knee socks.

My pride made me want to hide how much the taunting hurt. Even at that early age, I learned to take control from deep within myself. I did not lash out or call the other kids names in return. I relied on the old saying, "Sticks and stones may break my bones, but names will never hurt me."

I learned that I felt better when I controlled my responses. Later, this helped me tremendously in many professional and

personal situations. Those kids weren't going to get me to lash back at them or cause me to run off crying. Stubbornly, I would say to myself, "I am not ugly. I am not a 'Scarface.' It is not my fault; it was an accident."

I became stronger by believing in and affirming myself and began to gain confidence. That was my first recovery from one of life's terrible setbacks, finding out that I could be in control of my responses and thus my life.

After a while, the kids changed. If they couldn't arouse me — hurt me — there wasn't much fun in taunting me. My days started to be a bit better so, instead of a day of insults, there were a few kindnesses and the creation of a few friendships.

Back then, the love of my mother often eased my pain. She would comfort me as only a mother can. She was there to make a tragic situation bearable. After a bad day for me at school or when I felt ugly, she would cuddle me, whispering words of love to bolster my self-esteem.

THE ATTACK

My life, however, took another difficult turn at the beginning of the summer when I was 14. My friends and I attended an outdoor concert together and we were so excited. The band leader even took notice of me and winked at me from the stage! Me... not the other girls... but me. After the session, he asked if I wanted to go for a walk and a soda. How could I say no? — I felt so special! Yet, on the walk, he pushed me behind the house for what I thought would be an exciting kiss and instead found myself on the ground and sexually violated. Afterward, the band leader simply walked away. I stayed on the ground for a very long time confused and devastated. I went home, washed

and washed again, and cried myself to sleep. I felt so alone and carried that "secret" with me for a long time.

Like so many others during this #MeToo movement, I have not shared this story until now. In solidarity with so many women now coming forward with similar stories, I do not pretend it was easy to get over the pain this brought into my life. This horrible event profoundly impacted me during my formative years in ways that took me a long time to fully understand. And that impact continued even as I gained wisdom and an understanding of so many other areas of life. I believe this attack triggered contradictory feelings and clouded emotions in my adult relationships with men for many years.

Confusion and insecurity birthed a negative energy deep within me. Like so many other women, I wondered what I had done to have this happen to me. I wrongly assumed fault and tried to find the courage to talk to my mom about what had happened to hopefully get comfort and clarity. However, little did I know that my life was about to be unfathomably challenged yet again.

HEARTBREAK

Tragedy delivered the biggest injury in October of the year when I was fourteen. My mother died suddenly. There was no time to say goodbye; no shared special moments, no words of wisdom or cherished bedside conversations to console my heart through the coming years. The pain of losing my mother haunted me for most of my life. For many years, it ruled my every thought with all my feelings drenched in sadness.

The day my mother died, my life underwent dramatic, permanent changes. I became a surrogate parent to my baby sisters.

One was three years old; the other only eleven months old. My carefree teenage years were over. I was burdened with responsibilities. The door to college slammed inexorably shut. I was needed at home. I felt so alone and couldn't get past the pain and anger. I was entrenched in negative emotions. So lonely trying to navigate the frightening challenges of adolescence by myself.

I think it is important for me to tell you that my dad was a great man. As a community leader and a volunteer fireman, and later as an elected official in our region, he earned great respect and accolades, all well-deserved. He was funny and dedicated to every undertaking he took on. However, at the time of my mom's death, he was almost immobile. He was 35 years old and left alone with three girls, two near infancy, and he simply did not know what to do. He was unavailable to me.

I know I am not the only person who has suffered loss, so perhaps you are thinking to yourself, "Gee, her mother died decades ago. Why didn't she just put it behind her a long time ago?" For years, I tried to lessen its impact on me, but couldn't. Recognize that the loss of a mother is a pain that keeps on giving, year in and year out. I feel full of invisible bruises, bruises that people can't see but that are nevertheless sensitive to the touch. For example, attending the play "Jersey Boys" pressed on my deep internal bruises because it celebrated in song the fun of the teenage years in my era. It made me sad because it reminded me of the stolen years of my youth when I was unexpectedly plunged into the role of a surrogate parent. The loss of a mother spawned many support groups of *Motherless Daughters* throughout the world because of the lifelong trauma caused by this loss. We are a unique group linked together through an eternity of pain.

I feel as though I was robbed of a lifetime. An unlived lifetime of experiences spent with my mom with our family complete, creating new stories, new memories. Our family was never a family again. We were a damaged dad, a teenager in pain and confusion, and two beautiful little girls who knew something was missing but did not understand what that was. Laughter stopped in our house. Truly. A pall permeated our everyday activities, and a fog or haze of pain fell over those typical times of celebration such as Thanksgiving and Christmas. My 3-year-old sister got confused and started calling me Mommy, and the baby got no attention. Her first birthday came a week after my mom's death. No cake, no candles. It is terrible to admit my lack of appreciation for what the little ones were going through, but at 14 and immersed in pain, I kept dropping the ball as the surrogate parent. My mother's death left me in a position where, with no experience or training, I had to run a household and care for babies. I hadn't done it before — not any of it. I would go into crying jags when I was alone. I never slept a full night.

Eventually I had to just step up and do it, and I did. I did it talking and crying to my mom every step of the way. I wanted her to know I would take care of her children.

Looking at a photo album of a friend's childhood, I realized with deep twinges of regret that there are no photos of me after age fourteen except for high school yearbook photos. Why? It is usually the mother in a family who takes photos. And while trying to put together a birthday album for my sister, there were no photos of her as a child to be added, nor will I ever get over the pain I experienced at what should have been a time of joy, when I was shopping for my wedding dress — alone.

Who we are and what we become is developed by our successes and our failures.

We grow and develop through the bomb shells life drops on us. My mother's death changed my life *for the rest of my life.* I had to learn to deal with a heartache that permeated my whole existence. I had to accept the loss of a love that most of us consider our birthright. The tragedies I experienced impacted every part of my life.

From the very beginning, my life felt truly unbalanced. I never knew what to expect each day and always needed to put out emotional fires. I didn't have the internal strength or wisdom to change anything. Tears in the morning and at night. My future was impacted. As a bright student, I had skipped grades and expected to be a stellar, accomplished college student. That doorway was now closed. My life became little more than issues with my sisters and the realization I would never again be a typical teen. I spent my days with adult responsibilities, feeling sorry for myself and at the mercy of outside influences. All the aspects of my life whirling around one another, all very disjointed.

My life continued like that year after year. Not much to look forward to. Twice I tried to build loving, lasting relationships in marriage. The results? I found myself a single parent of three children, struggling to pay the rent and to put food on the table. Even as an adult, my life continued to be one disaster after another. Mistake after mistake. This is who I was and how I got there. But how did I get out of this place?

You don't have to experience a tragedy to feel that your life is out of balance. The feeling that you are spinning out of control can come from what others might call a small issue

or, conversely, a major crisis. Whatever your issues and struggles, they are equally as important to you as mine were to me. Only when I stopped striving to achieve Life-Balance, aka **The Hoax**, was I finally able to apply my energies to making realistic changes; changes that were attainable, not a myth, and which resulted in a better life for me and my loved ones. Let me take you through the steps I took to achieve at the levels I did.

Discovering the 3 Circles of Life

Hᴏᴡ ᴅɪᴅ I achieve my goals? How did I go from the depths of despair to living a life of happiness, with love, wealth and peace?

The first step was Conquering the *Life Balance Hoax* and the second one was the **Discovery of the 3 Circles**!

Unable to achieve balance and happiness, I began to take my life apart and analyze why I was unable to achieve it and came up with this amazing discovery. I believe that our lives are comprised of **3 Circles** — three interlocking and overlapping circles — representing Work, Relationships, and Self, each constantly inflating and contracting, never in equal proportions, never on a schedule, almost always shifting in ways that defy logic. I identified **3 Circles**, these three major components of our lives, never in equal balance. Work with me and try to see the sudden ballooning of one circle as natural and temporary, not as a test of your ability to get it back down to size so you won't freak out at its dominance. I will guide you to manage your responses to the shift of the circles, and help you learn how to maintain focus on what matters to you and on what changes you want to create that happier life.

Through this discovery you will learn how to liberate your mind from the concept of "balancing" everything and awaken to the freedom of seeing life as a set of Circles that, far from existing in symmetry, constantly change in diameter and importance. This knowledge allowed me to make forward progress in my life and rise up from the bottomless pit I lived in. I didn't waste energy or time on useless efforts to balance; instead I applied all that I could to my personal goals. First, I defined my goals and then I achieved them. Let me explain this discovery and how it will help you accelerate your progress as well.

The **Self Circle** is who you are and how you feel about yourself. It holds your doubts as well as your aspirations, your emotional wellness; who you think you are and who you wish to become. It's your health, your appearance, your diet, your body, and the way you combat stress.

The **Relationship Circle** holds everyone you know and how you interact with them — friends and family, lovers, colleagues and co-workers, the guy behind the Starbucks counter who always gives you a nice greeting in the morning, the boss who pays your salary, people you know well and those you connect with only minimally or at specific times.

The **Work Circle** is where you are productive. It is *not* just the place where you claim a paycheck. If you are a stay-at-home mom or dad, if you care for an elderly parent, if you volunteer at the hospital, or serve on the town board, or give one day a week to the animal shelter, whenever and wherever, what happens when you're being productive is your **Work Circle.**

All **3 Circles** are constantly in motion — as alive as life itself. All in turn balloon in size, dimension, and importance; each then shrinks again, dropping back to normal proportions as

another circle grows in importance and impacts in your life, with every change in any circle affecting the other circles as well.

The difference comes in your perception of reality rather than the notion of achieving a balanced life. The circles make sense because life does keep moving, often at a rapid pace and in ways we cannot predict or control, with consequences that can stretch into every corner of our existence.

We may think we're struggling toward true life balance but, in fact, we have no levers we can pull or buttons we can push to shift the focus. We simply run between the poles of work and life and our own needs — frantically, for the most part. Seeing life as three shifting circles affords us ample wherewithal to adjust quickly to unanticipated events or changing circumstances and to take charge of our lives and stay in charge.

I will show you how you are going to have the choice of pushing back with actions that will help you manage what is going on in the dominant circle and ultimately stay in control when events in one circle begin to impinge on the others. You may simply choose to allow that one circle to dominate for a longer time because it is so critical to that day or week. It is your choice and navigating the changes with a calm approach will help you minimize stress, anxiety, or guilt.

What was stunning to me — and is stunning to the people I've coached — is that giving up the balance hoax and replacing it with the reality of **3 Circles** equips you not just for greater achievement, but for getting out there and taking hold of the life you've always wanted. Yes, there is some push back. You cannot simply allow one circle to dominate all other areas of your life unless it is the one that is most important to you at that time. As time progresses, you decide when you should

bring it back into a more reasonable size. You decide and, after reading and following the advice in this book, you will be able to make it happen.

Let's look at my circles as a teenager. The tragedy of losing my mother, and losing my youth changed my **Relationship Circle**. My relationships with others changed *forever*, starting with my closest relations, my sisters. No longer was I their sister or their peer. We never shared sisterly secrets, bonding against the adult world. I had to be the adult, the mother. Adult responsibilities were piled on top of teenage confusion and the search for answers on how to deal with, what seemed like, God's cruel hand. The magnitude of these losses stunted my emotional growth and my **Relationship Circle** was a void. I never learned the basics of developing a healthy relationship with a male or even the fun of friendship with girls.

This tragedy changed who I was in my **Self Circle**. The fun of after-school activities or shopping with friends didn't happen for me. My life was so different. I wasn't a carefree teeny-bopper. Above all, there was the constant emptiness. I didn't have my mom to help me with all those growing up questions about love, friends, sex, and marriage. I had no self-confidence because of that lack of support. My mom was gone, and my dad was in so much pain that he could not help me. Yet, some part of that young teenage girl, who accepted the responsibilities and challenges and learned to live with pain, inspired me to strive. An inner desire to have a better life, an inner voice, inner power propelled me to explore better ways to live.

All of my life changed that October day when my mom died. Before that, my school activities; my education, my friendships, my future plans had filled my **Work Circle**. No more. My **Work Circle** choices were no longer mine but thrust

upon me with the care of two little girls. The corner of my room, once filled with books on college selections, gave way to diapers and baby toys because the girls were sharing a bedroom and storage space was limited. I graduated at age 16 because I skipped grades in school, but instead of being a young college student, I had to grab the first job offered to an inexperienced 16-year-old because we needed the money. Money began taking on immense significance in my life when my Mom died, and we had to borrow money from Uncle Dan to pay for her funeral. Money shortages continued throughout my young years as it dominated life's choices. No money for the childcare we needed, no money for college, no money for extras. Dad worked hard at his job, but his salary simply could not cover what we needed so I went to work.

Five or six years down the road my Dad did remarry, and a stepmother came into the picture to help him raise my sisters. The transition was a very difficult one for all of us. For my sister Sally, the most difficult because, once again, she lost her Mother — that is how she saw me in that surrogate role. And for me, my most formative years, that of a young teen, well I was truly and for the remainder of my life damaged.

By now, you can see that I did not come out of a rose garden with all of life's good fortune handed to me. But I am happy now, and I have a life I am proud of, with more success, peace, and loving relationships than I ever would have thought possible. I am not claiming to be an expert on life or relationships; I don't have a Ph.D., but I have proven knowledge.

I recognize that your problems are different than mine, and the challenges you face may not resemble those I had to deal with. I don't know your personal definition of success or of happiness or if you even know what yours are. I do hope that, by sharing

my stories of an unbalanced life and the knowledge I gained as I lived each day, I can help you make the changes you want.

THE LEARNING EXPERIENCE

I want to talk to you for a moment about your learning experience. Years ago, when attending a business seminar, I realized that each one of us has a unique way of learning. The information we receive may not always be innovative or new. Sometimes, we are merely reminded to renew a process we knew we should be doing; or perhaps we just got lazy or we forgot about it completely. It may be the same way with this program. If, while reading this book, you think to yourself, "Well, sure, that's basic – I knew that," well, that's good. Keep reading because there are many gems buried in each chapter. In addition, if you are inclined to think to yourself, "Well, okay, I read it all, but I don't see where it will change my life all that much," please — give it a little time.

My experience has been that, with some people, the improvements might not be highly noticeable at first. You may not realize the impact right away, but you will down the road. You may find some of the material in this book written in a simple, humorous form. My intent was, if it sparked a reaction, perhaps a smile or upturned brow, you are more likely to recall it when needed.

Also, let's now address the topic of repetition in the learning process. Can you recall learning your ABCs? Via repetition? Or the school motto, or your prayers? You practiced over and over again... read the material over and over again. Repetition. So, if you come across a paragraph or statement and think, "you already wrote that," understand that the repetition is there for

emphasis. The repetition is there to help you remember and embrace the advice.

SEARCHING FOR ANSWERS

Perhaps, you purchased this book because something isn't exactly the way you want it to be. One of the most important steps is to determine what you feel is wrong with you and your life today, and I have included sections to help you identify what is not working because so many times we just don't know more than just — something isn't right. Once that task is done, you will need to apply yourself to making the necessary changes and your own motivation provides one big impetus that will allow you to achieve your goals.

That is why some sections of this book are truly motivational in tone. We know all about people who lack discipline and we have had our own moments when we wish we had more self-discipline. Does Hershey's or Godiva ring a bell? Dating the wrong type of man over and over again? Changing to the wrong jobs too often, just because? So yes, some sections may seem to push a motivational message of "yes you can do" ... or "if I could make these changes, so can you."

The insidious hoax that we should be able to live balanced lives every day, all year, has been prevalent for the last 40 years. We can attain lives of symmetry, right? So wrong! I am an ordinary woman who has achieved an extraordinary life and *trust me*— it has been anything but balanced.

I spent almost my entire early adulthood feeling like a "balance failure." Then, as a single mother, it made it easy to feel perpetual guilt about working too much and missing out on family life. Missing out on best-parenting efforts. Missing out

on career success. Where was the balance? Failure was the meal of the day, every day, because even after all those hours and effort, I was unable to have enough money, nor the needed time for the family nor did I have any time for myself. Every aspect of my life was lacking... lacking money, lacking time with my kids, lacking time to take care of my body, and lacking love in my life. I felt wholly inadequate, defeated at every turn, frustrated and a failure.

For so many years, I searched for answers, seeking ways to make my life better. I uncovered the same advice, repeatedly:

"You must live a "Balanced Life."

But "Balance" is not naturally achieved. And what does one do when her life is completely out of "Balance?"

Frankly, striving to attain this impossible ideal added more pressure and stress. I'd come home from a pretty tough day at work, feed the kids, do laundry, finally get the kids settled in, and get prepared for the next day. All I wanted to do then was crash from exhaustion. Living a balanced life, however, dictated that I should now also be doing something for personal fulfillment, for my personal development, perhaps take that course or read the latest best-seller or get on the treadmill. Or that I should reach out to a friend to keep my relationships fulfilling. Or that I should be exploring special events for the kids for the weekend. Simply denying myself the freedom to just be. Just relax.

I recall a time when the sitter for my kids got sick and couldn't care for them. I didn't have adequate backup (who really does?) so I had to take a week off *without pay*. That meant a loss of money we really needed. I then had to make up that money by

putting in a lot of overtime. It also meant finding a sitter for the overtime hours.

How was I supposed to balance life when it seemed so much of it was beyond my control? I could never separate work and home completely. I could never take care of myself as well as all my other responsibilities. **The Hoax** would beckon me to follow the mantra, but it was an illusion. When I lost my job and calamity stared me in the face, the idea of achieving balance seemed ludicrous.

This striving for the impossible went on for years. I really wanted a happy life. I wanted things to be good; I wanted to experience joy, bliss, and delight. I wanted to be comfortable and contented. I wanted to be a good parent, a good friend too. It may appear as though I am preaching a bit on this segment and I guess I am because the dispelling of that myth is critical in changing your life. In aiming for balance, I chased the wrong goal. Balance wasn't what I wanted. *I wanted a happy life and endlessly striving for balance wasn't doing it for me. And I was determined to find a way to get the life I wanted.*

YOU IN COMMAND

Wondering how do you begin to apply my recommendations? An important step is to learn how to Prioritize: take stock, evaluate where your energies are needed most for that day or that week. Here is what I realized: if you take care of the most pressing circle. then you can more readily handle other things that may simultaneously be going on in your life. Whether needed in your **Self Circle** or **Relationship Circle** or **Work Circle**, put the energies where they are needed most — this is You in Command.

No, I am sorry, I cannot promise that my techniques will bring your **3 Circles** into total balance because as I have said, it simply is not possible. But my techniques will help you create a realistic life that is enjoyable and filled with good happenings. And again, these are not just words, these are insights and lessons learned that helped me create the life I have today.

Just imagine this. You were looking forward to spending a cozy evening with your family, but a sore throat started to surface on the way home from work. Getting worse by the minute, you wound up in bed at 7:30 p.m. with severe chills, exhaustion, and a fever, while your kids used the leftovers in the refrigerator for dinner. Your *Self Circle* took over your *Relationship Circle*. Worst still, you had a presentation the next day at work, so a sense of panic added to the chills of illness. Relax, because I will introduce you to techniques that will help you communicate better, make good choices, and thus be able to deal with situations of imbalance with dignity.

Let's consider this example. You just finished a productive day at work but need to do some work from home after dinner when the kids are occupied doing their homework. Your fingers are on the keyboard when your teenage daughter comes in to tell you that she and her boyfriend have planned a trip away this coming weekend, just the two of them. Oh, my... Your *Work Circle* was just dwarfed in importance next to your *Relationship Circle*.

What about this scenario: You're home taking a day off after a month of overtime when someone calls from the office and informs you that a client just returned a major project, feeling there is an error that could jeopardize the entire entity, and that client wants initial feedback on it by the end of the day.

Your **Work Circle** subsumes your **Self Circle** (farewell to that day of rest) and you head to the office.

Life. It just keeps coming at you. Is there really any way to balance it? NO. Once you stop thinking life should be balanced, you will lose a truckload of guilt. You will come to terms with the fact that you are not *Wonder Woman* who can always do everything perfectly. You will accept it is not possible to keep things in harmonious balance, succeeding at everything, and looking great while doing it.

I admit there will be those stellar days when life appears to be perfect in all ways... perfectly balanced. But let's be completely honest — how often does that really happen? If it does, enjoy the moment, as they say. Conversely, how do you feel about yourself when day-after-day life is what reality is... *Unbalanced?*

"Unbalanced" ... a term used to describe someone who is crazy or out of control. "Unbalanced"? YOU? You don't want to be unbalanced, so you strive for this elusive "Balance" and instead taste the bitterness of failure. Once I abandoned the "Balance" idea and the burden to perform flawlessly at everything, the pressure lifted.

Visualize the three Circles of Life — the **Self Circle, Relationship Circle**, and **Work Circle** — any way you want to, but they should be three completely distinct areas of your life. Sometimes they may come together like a Venn diagram, connecting at the center; other times they may look more like a snowman, with one on top of the other.

3 Circles always *interlocking* and *interdependent*. They constantly change in circumference and significance, and each

has an *enormous impact* on the others because you cannot separate your **3 Circles of Life**, *ever*.

Accept that these three important circles are linked together and always changing in dimension and importance, such that you will have to give more attention to one or the other as life demands. Accept that there will be those instances when you need to create the necessary shift of attention on a temporary basis to allow you to deal with a more important demand.

Sometimes the change you need to implement may be an hourly one. Perhaps, you have a troubling personal situation that is causing you strife but there is a work assignment that is critical to be completed, well, and on time. You cannot ignore work; you need this job and cannot let the team down. You will learn how to manage both situations by intentionally putting the personal on hold while you take care of your work obligation. You will learn to do this by using new skills you will learn in chapters on Communication and Choice and by recognizing that most days you cannot have balance but will still be able to achieve your goals by embracing your new reality.

THE CIRCLES IN MOTION

Try to visualize these Circles as being intrinsically connected to one another. If something significant occurs in one Circle, that Circle will balloon, while the others may contract, diminishing temporarily in diameter. The Circle with the significant event becomes magnified, sometimes many times. The 3 Circles are impacted by one another and change in size and scope according to circumstances that are quite often beyond our control.

For instance, imagine you're on your way to work. You're already late and nervous especially because this is your third

time being late this month (it isn't easy getting out of the house all dressed and ready to go when you also have kids to get ready and dropped off at school). Your mind is on your **Work Circle**, then BOOM... you're in a car, bus, or train accident.

Your **Self Circle** is suddenly affected — you may be injured. In that instance, the ramifications of the accident may affect you adversely for months to come, and your **Self Circle** starts to blow up like a balloon. This affects your **Work Circle** — you're going to be late again, and the injury may jeopardize your job or that important project that now will not be finished on time.

Your **Relationship Circle** also takes a hit. Who will be able to provide transportation while your car is being repaired or replaced? Will the potential financial ramifications impact home life? All the Circles are affected by big events in any one of them, and you must worry about all of them on a day like that.

But which one is the biggest? That's what you must focus on at that *moment*. In the example I've cited here, at the time of the accident, your **Self Circle** supersedes your other Circles if you are hurt. Yet, you will see how quickly the focus can change as you deal with the situation. If you aren't injured, then the **Self Circle** shrinks and perhaps it is the **Work Circle** that becomes dominant when you call to explain what happened. Your relationships with your boss and co-workers may indeed be impacted. Your **Relationship Circle** then may explode as you frantically plan for someone to pick up the kids from school since your car is going to be in the shop. Don't approach a situation like this thinking you can balance things out at that moment. You can't.

Here's another scenario. Today's cupcake day at school. You misplaced the notice, so your child arrived at school sans cupcakes. When you get to work, the computer pops up a reminder, and you realize you probably missed the Parenting Award for that year. You ruminate all day, wearing the Scarlet Letter of shame for being a "working mother bringing up a latchkey child." Your self-esteem in your **Self Circle** now shrinks to the size of a pinhead. All your thoughts scurry to your **Relationship Circle,** where you are making promise after promise never to have this happen again, vowing you will make cupcakes on time, every time, and you will now give energy to planning a fun-filled weekend to make it up to your child. These examples I give you are not something dreamed up; no, my friend, more often than not, they are life challenges I faced.

Or this. What if your company has a major reduction in force? People laid off. Whether you are now out of work or not, the changes at work probably mean it will consume much of your energies, emotions, and time. I doubt you will be able to take a long lunch with a friend or leave early on Thursday for drinks and a movie or that basketball game. Even though you may say to yourself, "I am not going to let this consume me," the reality is that such an event in your **Work Circle** siphons off a great deal of energy from your other Circles.

Some scenarios slice through two Circles at once. You are at work and realize your co-worker has dropped the ball. None of the data you need for the report tomorrow is ready. She left the office, leaving you a note that says, "Sorry, but Jim called, and we have tickets to the Game!" Let's peek inside your **Relationship Circle**. That Circle expands with anger and adrenaline as if it were being blown up with a pump. You are very upset with her, and your working relationship will

need attention going forward. Your **Work Circle** now almost consumes you, because you must do the research and report yourself, tonight, to meet the deadline.

One action sliced through two Circles at once. What about the fate of the remaining Circle? Your **Self Circle** is almost non-existent at this point. Exercise plans? Getting your hair colored? Shopping for the new shoes you need? No. No. NO. None of that will happen. There is no balance, and you can't ease up until the project is done to your boss's satisfaction and you complete the final action of relaying your disappointment during a discussion with your co-worker.

As you complete the report and earn kudos from the boss, the **Work Circle** returns to a reasonable size. Now you can put some reward time into your **Self Circle**; take your day at the spa, have your lunch with the friend, get your hair done — do whatever "you" need. Maybe the shoes too. I am not suggesting you become a workaholic for weeks on end or that you focus on a relationship so much that other areas suffer, but rather I urge you to attend to the most urgent things first. Focusing on the most urgent thing allows you to give it all your focus and to make the best choices that will generate the best results. It relieves the stress of trying to do it all, and generally not as effectively as you wish. And that will eventually result in relief and peace of mind.

NAVIGATING YOUR NEW REALITY

Living happily in an unbalanced life. Is it possible? What does this mean? Simply means that you are living in a new reality... that you accept that life is unbalanced and accept that pursuing **The Hoax** is a waste of energy. Instead you must learn now how to navigate your life with a different approach. When you

attend to the most important priorities, you will be managing the most important circle, the top priority in your life at that time.

Winning the Lotto creates a new reality, a new path, a new way to live your life. Troublesome happenings such as divorce, death, or loss of job create a new reality. Those events may force you to navigate a journey different from what you had ever envisioned. Accepting that achieving everyday Life-Balance can be a **Hoax** that requires a new reality for you to navigate. A reality that can take you closer to living a fulfilling life, a happy life.

You never know what's coming at you. Some unexpected ripples are minuscule while some are gargantuan, and there are ripples of all sizes in between. This doesn't mean you can't plan. I *love* to plan, but it can mean that you should also plan on life taking some unexpected turns too. Who once said, "Expect the unexpected, and you'll rarely be surprised?"

Your Happy Place:

One answer to living happily in an unbalanced life is to determine what your circles look like when you are happiest and most at peace. If you are a highly ambitious career-driven person, then perhaps your **Work Circle** is always larger than the other two and that is how you want it. If you feel happiest when your **Relationship Circle** is the dominant one, then you may want that circle to be the largest as much as possible. Think... what do your circles look like when you are the happiest?

Define your *Happy Place*. That answer must come from you. If you are pleased with where your life is now because you

are helping care for a loved one, then for as long as you desire to continue this, your **Relationship Circle** will be looming large. To live happily while living an unbalanced life, you will apply all that you learn in this book to design the optimum harmony of your own **3 Circles**. Your own *Happy Place*.

And I have worked with some people who felt that their *Happy Place* was dominant in the **Self Circle** where they focused on self-improvement, a major hobby, art and educational enrichment, travel and a personally focused list. Each of us has our own *Happy Place* and sometimes it changes year to year or even month to month. There are sections in this book with some thought provoking questions that might help you clarify your answers here.

My brother in law worked in the large corporate sector for decades. Sadly, he got caught in the restructuring and the company relocation to an offshore location. I cannot even begin to explain the emotional impact initially. Horrid. He explored many options and finally found work in our region as a referee in college sports. He obtained his certification and now spends his work circle in his happy place. I know there is a pay disparity, but I assure you it is his happy place now.

Unexpected Explosion in your Circles:

Let me help you cement this new concept of the **3 Circles** and possible explosions in your mind by way of a vivid example from my own life.

I had worked hard and had finally achieved one of my goals, which was owning my own business. An entrepreneur! And tasting success. All was going quite well, so well, in fact, that we were expanding and moving to a new location. It was a

beautiful new office building, which I had purchased with pride. My own business and my own real estate; I was so proud and Oh, it was all very exciting. The selection of office furniture, decorating the new offices, and the renovations were dynamically stimulating. Every little detail seemed of major significance and my **Work Circle** was an all-absorbing and exciting place to be. My Relationship and Self circles were humming along at an easy pace without major problems.

Then one Sunday evening, the phone call came. My son, Ryan, at the time fourteen years of age, was the passenger in a very bad car accident. I arrived at the scene to see blood all over. My son was hooked up to intravenous tubes and lots of frightening medical equipment to keep him alive. He was badly injured, eventually requiring over fifty stitches in his face alone. His ribs were broken, and his lung was punctured, so he was having trouble breathing. Most worrisome of all, his liver had sustained severe damage.

Ryan spent weeks in intensive care. He underwent surgery. It was touch-and-go, no one could guarantee he would not die! Day by day, watching his body shrink before my eyes, it was all I could do to breathe. Adding to the fears our family was already dealing with, he had received several blood transfusions. This was right at the time when the first news reports were coming out about people getting the HIV/AIDS virus from blood banks. We had a priest visit the hospital and give Ryan last rites according to our religion. Can you imagine our panic?

It's a good thing I had already discarded the balance theory and was working with life's realities. My **Relationship Circle** now filled my life. Picture the dynamic of my **Work Circle** dwindling from normal size to the size of a dime. Who

cared about office color schemes, new office furniture, whether we got the new client, unpaid invoices, or any aspect of work? Not me.

My **Self Circle** diminished to the size of a pea. I slept in the hospital for days on end, wearing the same navy-blue workout suit I'd been wearing when I got the phone call. My **Relationship Circle** was now as big as the earth itself. All **3 Circles** changed in proportion due to an event I could neither control nor predict.

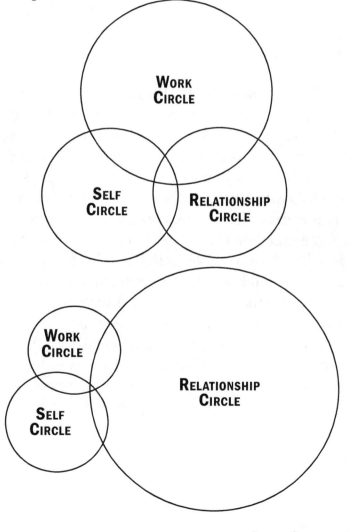

Since I understood the existence of these **3 Circles** and their interdependence, I eschewed guilt because I couldn't take care of myself nor could I give my business the proper attention. Therefore, I handled only the most critical issues within the other two circles and focused on my son and his full recovery. I committed my energy to my **Relationship Circle**. I could fully focus on my injured child who needed me most.

I was not burdened by feelings of guilt that I was neglecting my business. The fact that I wore the same clothes day after day did not impact how I felt about myself; rather, I knew that the **Relationship Circle**, my son, was going to be mammoth until he was out of danger.

Once we are truly armed with this knowledge of the complexity of 3 ever changing circles, we become so much stronger to deal with the blows of life. When my sister Sally died at 49, it was easier for me to focus on the tragedy taking place and eventually how to get relief in both my relationship and self circles. My **Work Circle** was again the size of a dime. Yet as I am sure you can understand, my other two circles were spinning out of control generated by a wide variety of emotions and pain. The loss of Sally was a horrible feeling similar to what I imagine losing my own child would create; remember, I was involved in her upbringing since she was 3. I had the role of parent more than sister. To get through this terrible time, I knew I needed help. I hired a psychologist to guide me through this horror of losing my sister. Appreciatively, the doctor was able to help me immensely and I was able to go back to work eventually. But it took a few years to find even a morsel of true peace. That is grief.

THE SELF CIRCLE

I had some difficulty with thinking about Self and what "Donna the person" wanted out of life. The concept of "self" in our society usually has a negative ring to it, often with terms like self-centered, self-focused, selfish, or phrases such as "you were only thinking of yourself."

Yet the word "self" has many positive associations too, such as:

- Self-esteem
- Self-worth
- Self-made
- Self-assured
- Self-confident

I certainly understand that the concept of focusing on your "self" can be a strange one to many women because we expect ourselves to be giving, nurturing to others, self-sacrificing, and *selfless*.

So often, we don't put our own needs first — if we consider them at all. But honestly, taking care of yourself is not narcissistic. It's being kind to a wonderful human being — you! When we are focused on achieving this elusive balance, we miss the opportunity to focus on our Self, our own needs. Instead, we waste energy, becoming exhausted and demoralized.

Think of taking care of yourself as similar to the times when you are on an airplane when, during safety instructions, they tell you to secure your own air mask first before helping your children on with theirs. In other words, take care of yourself because that puts you in the best condition to take care of others. If your mind is all wrapped up in negativity or

self-deprecation, then you constantly sacrifice what *you* need. Not a good thing.

You may not want to admit this, but we all know that, if we are depleted, miserable, on edge, in a bad mood, or have had a bad day, we won't be as kind to our family members as we would like to be. Nor will we be as productive or successful at work or in completing any of the responsibilities we have for that day.

The lesson that I learned which is so critical for you to remember: Take Care of You. It's okay to put time, energy, and attention into YOU. Frankly, many times you should put yourself first, because if you let yourself get run down, you aren't going to be of any use to anyone!

Yet, because of poor self-esteem, we sometimes don't love ourselves enough to take care of ourselves. I'm giving you permission — I'm saying that it's all right and it's okay to put some time into self-enhancement into betterment of yourself. It's okay to work on increasing your levels of confidence, because when you are confident about yourself, you can reach for that life of your dreams, and you *will* make it happen! Then life will be better for everyone connected to you. You owe it to yourself and all the people in your life to be the best you, the happiest you, the person who is at peace and glad to be on this earth.

Know what else can drain our self-confidence? Often, other people's opinions! We suffer from an approval syndrome. We hunger for others' approval. Our self-esteem is dependent on what others think of us, instead of what *we* think of us. The funny thing is, we don't really know what others think of us! Maybe they are busy comparing themselves to us!

Is this you? When you go into a beautifully appointed, impeccably decorated home, do you feel inferior? Do you vow to get in touch with your inner "Martha Stewart" from now on? When you drive past the houses of the neighbors with beautiful yards, do you say to yourself, "How do they keep the property like that? How do they find the time? Why can't I do it?" Then there's that couple living next door. There they are, heading happily out to the gym or to take painting lessons. They throw cool parties, and they never seem hassled like you, right? Plus, they're obviously so happily married. It seems like everyone you know can do things better than you can. No one ever seems to have that wide-eyed, crazed, unsure look in her eyes like you do.

Feelings of inferiority might be a daily occurrence, so much so that you just want to go home and pull the covers over your head sometimes. I've been there, and it's a terrible feeling. I wanted to be one of the "perfect women." I was always dieting, always longing to look thin, like the model on the cover of that month's fashion magazine. I simply did not have a model's body. Also, I wanted to be a perfect Mom, reading stories at bedtime and attending every school event. And mostly I wanted to have patience galore, which I did not. I did not like myself very much. I was not in touch then with the parts of me that make me special in my own right. It was a long painful road to realize that I was wasting energy. Sadly, I was trying to be something I could not ever be and didn't need to be.

I needed to start working in my *Self Circle* on my self-image and to stop trying to reach someone else's standards of beauty or capabilities or intelligence. Intellectually, I always felt that others were smarter than I was. I needed to address both of those issues in order to have a life where I could exist comfortably. Being true to myself, I needed to buy the type of clothing

that looked good on me, not necessarily the ones that were in the fashion magazines. I needed to have good posture, to take care of my grooming, to be the best me. Self-improvement is good, but don't live the myth of perfection. There is nothing wrong with wanting to look your best, but make the effort to be the best you. Strive to improve you — who you are. Trying to be something you are not will cause you significant inner turmoil, discontent, and sadness. And those feelings are not the ones that will empower you to build a life of success.

A secret to not feeling as though you are somehow deficient in comparison to others is *not to compare*. The only person you should be comparing yourself to is yourself.

It doesn't matter that *Mrs. Perfect* down the street jogs every day for an hour. It does not matter the guy at work gets to the gym at 5 a.m. each day and maintains a showcase body. You're you, and you must go at your own pace, with your own goals. And if you are doing an exercise program, it should be because it is good for you, not because you are going to get miraculous TV results. Those are just commercials to sell a product, not reality.

Stop comparing yourself to the gal in the adjacent office who has fast-tracked her success and appears to be zooming by you. Stop comparing yourself to the size 2 you see at the store when you are shopping. Stop comparing.

WHAT ARE YOU WEARING?

I admit that in today's world we live in a visual society and appearance does seem to matter in many instances. Therefore, many women enjoy wearing clothes with designer labels. The high-fashion shopping delights them. That's fine and they

should enjoy the trendiest levels of fashion if that is what they want. Or if your style is classic, or athletic that is fine as well. And while there is certainly a relaxation of rules regarding men wearing a crisp suit and tie to work; there are certain expectations.

But what about the perple who wear old, outdated labels put on them by others? Not clothing, but labels about who they are and what they can and cannot do.

Think back to when you were in school. Did someone paste a label on you? I remember when I was in third grade and turned in a math test I had not done well on. My teacher said, *"Oh, Donna, you're really not good at math and you're never going to be good at math."* I carried that label with me into my adult life and into the business world until I realized that it wasn't me at all. Here I was, managing a multi-million-dollar business full of complex financial statements, reviewing them with accountants, buying office buildings, doing mergers of other businesses into my own and understanding exactly what they were talking about... but I still lugged around this label in my mind!

Are you doing the same thing — wearing an old, outdated label that doesn't suit you and probably never did? Is there a strict teacher or an angry parent's voice in your head telling you that you are no good in some way? Do you believe you are not any good at drawing because you failed an art test, or a poor cook because somebody didn't like your first or even most recent attempt at dinner? Let me ask you this: are you a victim of your own outdated labels? Have you ever said, "oh I could never do that!" Have you said, "I am shy so I can't go to an event by myself?" Or "I could never ask for a raise?" Or said, "I am lousy at relationships?" Those are labels you put on yourself

and wear for years and years. And I would almost guarantee that most of them are wrong!

And what about professionally the label of "I'm not good with customers" or "I could never do sales" or "I have only worked in the health care industry and wouldn't know how to work in any other field." Or the ones that prevent you from applying for the job you see listed online?

I have had a great deal of experience helping others shed those labels. When my recruitment company accepted an outplacement contract, which means helping someone who lost their job identify new opportunities, we also aimed to help the now jobless person evaluate and connect with their transferrable skills. We helped them identify their own skills and abilities and experiences that might be able to be used in another industry, in the next job. We helped them shed the labels that may have been preventing them from new journeys. For example, customer service is customer service, not industry specific. We helped them realize that successful work in the health care industry was welcomed in manufacturing or banking. Often that was one of the focus areas of our contract to help them shed whatever restrictive work-related labels they had placed on themselves so they could create new beginnings.

Whenever you notice a little voice in your head putting you down, answer it back: "I am not a loser," "I am not stupid," "I am not mean," "I am not incompetent." Often, we are our own worst enemies and our biggest critics!

IDENTITY THEFT

Sometimes when we are introspective, we discover more than just outdated labels. Think about this. Almost every

day we absorb commercials, print ads, pop-ups, all scream-ing alarms at us to avoid having someone steal your identity. That refers to your numerical identity — your address, bank account numbers, Social Security. But I want to talk to you about the other part of your identity. Who are you? Have you allowed someone in your life to steal your identity? By beating you down emotionally? By stopping you from pursuing your own desires. Do you feel burdened by the wishes or demands of others to the point where you ignore what you want? You are experiencing identity theft of something more important than your credit card number. Whether done intentionally or not, you are allowing others to steal your identity. One prime example is the one I cited earlier about the labels/the identity you allow your coworkers or your boss to place on you. They steal your identity. And you give them the power to do so.

Our identity is truly the way we define ourselves. This includes our values, our beliefs, and our personality. Our identity also encompasses the roles we play in our society and family, our memories and our hopes for the future and the impact we have on others, whether at work or at home. Most of these things can, of course, change. We can switch jobs, move to a different community, or experience life-changing circumstances that challenge our beliefs. Your life can become one of imbalance quickly, changing the circumstances for one day or longer, so that your own identity, who you really are, can get lost or even squashed into nothingness.

An *Identity Crisis* is generally described as: a period of uncer-tainty and confusion in which a person's sense of identity becomes insecure, which can happen due to a change in their expected aims or role in society or role in a relationship. It has been said that our identity basis forms during our adolescence as we endure those stormy times. But You are not a teenager

any longer and the person you were then has undergone many life experiences that have re-molded You over, and over again, creating a multidimensional woman.

Far too often we accept the labels our coworkers or boss slaps on us similar to the "Hi my name is" sticky label that we wear at networking events. Do you feel vulnerable when you participate in a meeting and offer your opinion? Timid because you're afraid of being labeled an aggressive bit...? It's a tight-rope that women are asked to walk. We are expected to be in touch with our feminine side to be nurturing and sensitive, but the question arises "is she ready for a leadership role? Is she strong enough?" "Does she have the brainpower of her male counterpart?" You are the one who must stop accepting those restrictive labels. Show those people in your work environment your desire to advance and your lack of fear in tackling just about any assignment. Be willing to compete openly, confidently and with a smile, creating the label you believe fits you i.e. Successful, Talented, Creative, Capable, Born Leader. Great advice, you respond, but how do you do it; are you saying that to yourself now? Please keep reading._

You do not need the approval of friends or neighbors for each decision you make; the decisions and choices should be yours, coming from the heart, after thoughtful consideration. That is done via a technique I learned and will share with you.

Yes, there are times the choices we make stem from our love for another. We make sacrifices, some small, some much larger, to cement a relationship or bring joy to someone else. But those should be conscious choices made after consideration, and with your full awareness of the potential results. This is *your* life and it is time — *now* — for you to read this book, cover to cover, and to carve out the life that will bring **You** happiness.

An important step toward change is to now take some time to consider *"Who am I really?"* We will start by answering a few questions. No one but you will see the answers, and there is no right, wrong, or final answer. Understanding yourself requires a continual discovery process. Your answers today may be different from your answers three months from now, or a year down the road. Write down all the thoughts that pop into your mind when you read the questions. Don't think about how they sound or what they mean, or how crazy they may seem! Just write them down. I needed to do this exercise before I could implement any significant changes in my life. How could I plan anything if I did not clearly know the actual resource I had... ME.

AN EXERCISE

This is an easy exercise, just some thought-provoking questions. If you really want to measure how you change on this journey, buy a notebook or journal, and put a date on the top of the page every time you make an entry or complete one of these exercises. I promise you that, if you read this book completely and embrace the material in it, you will look back six months or a year from now and see good, positive change! Are you wondering how does this help you with fixing a life really out of balance? If you don't know who you are and what your strengths are and what you want out of life, you will not be able to bring about the changes that will bring you the life you want. Then you may not be able to effectively grab hold of your **3 Circles** and your **Power Tools** and make changes in your life.

I've added this exercise because it has been my experience that so many women just float along without taking stock of who they are and what they truly want out of life. They simply

respond to whatever current crisis they face or conversely just glide along, taking what comes their way, ceding control to external events, people, and promptings.

As I mentioned earlier, people carry around old, outdated visions of themselves. Are you doing the same thing? Are you carrying around the vision of yourself as 'shy' because in some circumstances you are more reserved than others? Are you embarrassed to ask for help with your smartphone because someone said you were not tech-savvy? If you are not tech-savvy, so what. Get someone to help you. That action does not make you any less of a person. Each of us has specific talents and skills. Acceptance of Self means accepting all facets of ourselves. Not just the good, but also the weaknesses, the limitations, the not-so-nice parts of our responses and/or actions.

Whether we refer to our patterns of behavior as "habit" or "life on autopilot," now is the time to take stock and challenge our ingrained beliefs. First, to take control away from that "autopilot" in our heads, the one our past life/influences has assembled; we must understand it, recognize it, challenge it, and consciously remove the fallacies we discover. Then we must gain an appreciation of how all that "external" input and promptings "triggers" our "autopilot" by taking well-traveled paths in our brain to prompt habitual responses, rash conclusions, or a flood of hormones and feelings. Taking control involves mindful regulation of not only externals, but also of internals locked in place long ago. Taking control by evaluating those labels that you so willingly wear, that no longer apply, need to be truly reconsidered for accuracy, and more than likely shed. And those labels that stop you from taking that next step, the voices of "I can't," or "I never will," which are based on old assumptions, need to be put to sleep. And you are

the one who has to do it. No one else can instill confidence in you; that is why it is called Self-Confidence. The changes must come from you.

This is an exercise. You are the most important person in your **Self Circle**; if you aren't right, no one else and nothing else in your life will be right. If you don't know who you are, what you stand for, your own values, and what you want out of life, then your life will not evolve into your dream life. So, instead of waiting for a possible new job to conduct a self-analysis, let's do one now. Again, there are no wrong answers.

Exercise: Who Am I REALLY?

- What do you spend most of your time doing?

- What do you wish you could spend more time doing?

- What makes you smile? What gives you joy?

- When was the last time you had a really good laugh?

- What decisions do you feel you could have handled better? What regrets do you have? Why?

- Can you let go of the past? Truly close the door?

- Does it matter to you how you are viewed by others? Why?

- How do you think people perceive you? Is that how you want to be perceived?

- What are some of your biggest fears?

- Do you like yourself? Why not? What's wrong?

- Can you give love freely? Can you receive it?

- Do you think your future looks better or worse than the present? Why?

- If you could change two things about your work life, what would they be? Why?

- If you could change two things about your personal life, what would they be? Why?

- If you could change two things about yourself, what would they be? Why?

Certainly, the list of questions could be longer; I simply want to help you begin thinking about this most critical topic. Gaining insight into who lives inside of your soul can help you make sure the changes you embark upon will indeed bring about the enhancements to your life that you so desire. There is power in the mind: the power to make changes. I am living proof of that! I know this advice works because I made so many changes in my own life that allowed me to achieve positive results. I had to do it the hard way with little guidance and learning the stove was hot by the burn on my hands. I hope that my hard-won understanding can be yours through reading this book. I hope to guide you to avoid some of the emotional bruises I encountered, the painful feelings of failure and so much more. My goal is that the help for you is in this book.

THE PHYSICAL YOU

Sadly, I've had multiple operations in my life. Some have been rather significant, and each was traumatic and scary. The worst one, I think, followed a diagnosis of lung cancer with advice that I had six precious months left to live on this earth. I followed all the medical guidelines and got a second and third opinion from respected, prestigious hospitals, and all concurred. Reaching for my inner power, I did not respond

to the hysterical voices of panic in my head, and instead purchased a wig and warm-up suits for follow up treatments in anticipation of a successful surgery. The statistics were grim. The five-year survival rate for lung cancer is 55 percent for cases detected when the disease is still localized (within the lungs). However, only 16 percent of lung cancer cases are diagnosed at an early stage. For distant tumors (spread to other organs) the five-year survival rate is only 4 percent.[1]

As it turned out, I had a different illness, fortunately not lung cancer. I still required major lung surgery, with months and months of recovery and significant scars. From this very scary experience and others, I know that we only have one body and we need to care for it.

Wherever you are on the "health" scale today, know that you must take care of your body. This means getting regular checkups. This means going to a doctor when you need to instead of putting it off for days or weeks at a time. You are no longer a child who can hide her head under a blanket to avoid possible bad news. If there is a health issue, I advise you to find out what it is, and take care of it as soon as possible, before it gets worse. Talk to anyone who has had a serious health challenge, and she will tell you that most of the problems in her life practically faded into oblivion until that health issue was identified, resolved, or accepted.

Taking care of your **Self Circle** means taking care of your body too.

Some people spend more time and money on their cars than they do on the vehicle that will be with them always: their

1 American Lung Association

bodies. Your body is the only one you are going to get! Take good care of it.

Think about those days when you wake up feeling great. One of the goals in this book is to help you live more of those days. If your health is not taken care of properly and the **Self Circle** looms big because of this neglect, no amount of strategies can fix your health, and thus your life.

New clothes and a new haircut are always nice, but the biggest lift you can give to yourself is to take the time to take care of your body. If you don't and then become ill, you will never be able create the life of your dreams because your **Self Circle,** *in crisis,* will overwhelm everything else in your life.

THE MENTAL SIDE

I used the quote "we are what we think we are" often. Not sure where or when I first heard it, but indeed it has proven true in my life. So, whatever your beliefs, whatever you call that inner strength, inner spirit, that part of you that needs nurturing as a living part of you is your essence. The word *essence* was first listed in a dictionary in 1650 and its synonyms include infrastructure, principal element, and fundamental part. As you embark upon this journey to change, your inner spirit, your soul, your essence needs care and respect for how vital a part of you it truly is. Somewhat like the mechanism in your watch: the essence of your being.

Your human journey is about you. The journey entails understanding who you really are and mastering skills, such as the ones in this book, so that you can have days as wonderful as you always dreamed they'd be.

To thine own self be true. Shakespeare had it right centuries ago. Unless you know who you are and what you want for your mind, body, soul, and spirit, you are at risk of putting forth an amazing effort to bring about changes. Possibly though, not the changes that will truly bring you happiness. You could invest hour upon hour, finding the inner strength to implement a change that does not bring you the needed result because you have not invested the time initially to determine what will really make a difference in your life.

The task is an easy one in principle. Take the time to think, to consider who you really are, the direction in which to guide your life, and allow yourself to connect with your inner self. You will be creating the foundation for developing a stronger you — a you that you are proud of. Your spirit, your inner self. Again, what do you *really* want out of life — not just what you think you *should* want?

No Excuses Allowed. If you really want to change, a big first step is that you need to be honest with yourself and stop making excuses for why you can't do what you want. Excuses are rationalizations we make to ourselves about people, events, and circumstances which are really invented reasons we create to defend our behavior, to postpone taking action, or simply as a means of neglecting responsibility.

Living a life of excuses can sadly have lasting consequences and looming large among them would be to prevent you from reaching your full potential.

If you don't challenge yourself to reach new heights, you will never really know what you're truly capable of.

I recognize that today's woman is often so stressed out that self-improvement feels like an added burden erupting as an internal battle of choosing to stay in a habit rather than connecting with the energy to change. I promise you, however, that implementing the changes suggested in this book will bring you amazing life-enhancing rewards.

THE RELATIONSHIP CIRCLE

I learned that relationships are an important part of life and, I instinctively knew I needed people in my life. While we have work relationships and they can bring us joy or conversely aggravation, they generally don't get "inside" our hearts and minds the way that our closer relationships do. As you learn more about relationships and how they fit in your life, you will realize:

Fate may decide who you meet in life, your heart decides who you want in life, and your behavior decides who stays in your life.

WHY DO WE NEED RELATIONSHIPS ANYWAY?

The May 21, 2013 issue of *Psychology* magazine has a great article on "15 Reasons We Need Friends." Each of us is so unique that, while you may need only 2-3 friends, someone else needs a cluster. Some need to maintain childhood friendships to provide a foundation for their todays. Others may easily go in and out of relationships and leave minimal negative impact. But according to many of the top behavioral psychologists, people do need people. "Human beings are an ultra-social species — and our nervous systems expect to have others around us," states Emiliana Simon-Thomas, PhD, science director of the Greater Good Science Center at The University of California, Berkeley. In short, according to

biology, neuroscience, psychology, and more, our bodies actually tend to work better when we're not alone.

Knowing this, what else can you do to have great relationships? The answer is simply: Choose to spend your time and energies with those you enjoy the most.

Call that friend who always makes you laugh. Reach out to the longtime friend and recall fond memories – walk down memory lane. Arrange to take a course with a person who challenges you to grow intellectually. One phone call with the right friend is worth three evenings out with the wrong ones. This positive step can bring your life into peace and serenity by means of laughter and love, like a bucket of water dousing a campfire.

These are the types of actions we should take, but we often forget. We may get drawn into spending time with the first person who calls us instead of thinking, "Is this really who I want to spend a valuable Saturday afternoon with?" Maybe we accept a date because at least it gets us out of the house; but if it is with the wrong person, it leaves us unfulfilled. We'd be better off watching an old movie with someone who makes us feel good inside, who adds to our happiness within. Or simply to be alone. Or going to the local animal shelter and getting that cat or dog.

Let's explore this question: what do you do if you are already in a relationship that's wrong? Is it with someone who is just not right for you? Maybe it is a mate with fundamental character flaws, or perhaps it is a friend who always drags you down and places you in uncomfortable situations, or takes advantage of you, repeatedly. Maybe it is a *habit relationship* — one that started long ago when you both were very different and now

simply does not work for you, and more than likely not the other person, either.

There are things you can do, changes you can make, and an important task is to consider what degree of change may be necessary. If the person has fundamental character flaws, if you have irreconcilable differences or it causes you grief, it might be time to simply end that relationship — at least the way it exists now. Are you involved in a bad relationship with a lover, a friend, or a co-worker?

Now, I'm not just talking about someone with a few faults, someone who's "not perfect," or someone who's not all that you would like him or her to be. Those relationships often still have the potential to bring you great moments of happiness, especially when you learn about "Managing Your Relationships," later in this book.

I'm talking about a relationship with someone who makes your life miserable or sucks energy from you, draining you to the point where you cannot do much else that day. Or the person who constantly reminds you of bad experiences and leaves you in a negative state of self-reflection. Then it's clearly time to move on, leaving that person behind. You do not need to suffer in misery any longer.

Even if a relationship does not cause pain, sometimes we must accept the fact that there are those times when we just outgrow each other, when what we had before is no longer there. Sometimes a relationship just fizzles out. All it needs is a little push from you to reach its final ending. Not all relationships in our lives are destined to be forever. Situations change, people change, and it may be time to just let go of a relationship, making it a memory.

FRIENDSHIPS

The mystery of friendships. It is not always easy to figure out why we hit it off with some people, and not others. What causes a relationship, whether romantic or friendship, to start out with vibrancy and then dissolve and eventually end? There is not always a clear answer because each situation is unique. I told you earlier however that I knew I needed people, good people, in my life.

Once you realize which people matter to you, those you wish to spend your time with, those you love — the focus of your **Relationship Circle** is to keep those relationships as wonderful today as they were yesterday. Your good relationships will nourish your soul. I recall reading that the average American has three close friends, down from four a decade ago. We have many acquaintances but not many deep, mutually fulfilling friendships. You need to give of yourself to those truly important relationships, exercise care, concern, and the highest levels of tolerance and forgiveness. The journey to success, whatever your definition, can be an arduous one and our friendships can be a source of strength.

If you want long-term, loving relationships, then you must make it happen. It's not just the luck of the draw, nor is it magic. If you want your relationships to flourish, to work, then it is up to you to make it happen. Think about two of the words I just said: "relationships" and "work." They go together. You must work at relationships if you want them to be good. Sure, it might not always be easy to maintain relationships at the highest levels of joy, but the rewards of a truly great friendship can be most remarkable.

It's the things you do — your actions — that determine the quality of your relationships and the rewards they bring. Your

actions "set the stage" for the way others act, which in turn determines the quality of your relationships.

Think for a moment. Are you patient, caring, and considerate, or —you can be honest here — are you boring and selfish? Do you find yourself trying to impress people, pretending to be someone you're not? How considerate are you? Really? Do you go out of your way to say and do nice things for others? The stronger your relationships are, the better the possibility that they'll survive the hard times. And when you face the hard times, these treasured friendships can be so powerful in helping you cope.

Usually, it's an unexpected misunderstanding which, if left unresolved, not only throws that circle into a wild spin, but also can ruin a relationship. Instead of resolving an argument or misunderstanding with a person, we become stubborn. We won't "give in." We think, "I'm not going to apologize; it's not my fault." Too often, we avoid the person, or at least the subject, and we stay sore, holding a grudge.

That's the way of a weak person. At those times, your **Relationship Circle** expands, needing your attention and yet you refuse to acknowledge it. Trust me, it still will impact the rest of your life. We cannot hide from ourselves. That's not the way of a strong woman with power to influence her relationship. If a relationship you cherish hits a snag, don't run, don't procrastinate; take the initiative to face it and fix it.

So, what if you're right and end up winning the argument? Usually the other person feels poorly — like they've lost something — and your relationship has lost something too. For heaven's sake, don't let pride or ego get in the way. Learn to say two simple, little words: "I'm sorry."

Remember: What matters most is the relationship itself, not the argument.

Relationships and personal interactions can be most difficult when you are dealing with a work relationship. Sometimes these work relationships develop into friendships adding layer upon layer of complexity. And those work relationships are so challenging to maintain on an even keel and a bigger challenge to fix when they get broken. I have made great friends through my work and retained many and also lost a few. I lost ones I treasured and could not fix. I learned from those mistakes. The major point here is for you to recognize that you may have to take the extra step to keep that work friendship solid. You can use the tools you are learning about in this book to help you. If the potential loss of the friendship, or the possible negative impact on your work life looms large, then don't sit idly by hoping for it to change. Put ego aside, sensitivities aside, take the initiative to figure out what must be done to repair it.

Friendship is a gift, one that you must give in order to receive. Because of my friendships, I have gained so much support and wise counsel — wonderfully happy times, fantastic memories. I have also gained a unique perspective and eye-opening views, which have helped me to grow and be more tolerant. And I want to help you create incredible friendships. And why were my friendships so important to my journey? They were a source of support, encouragement, a shoulder to lean (and cry) on. My friendships lifted me up during some of the worst times and added great joy to the celebratory gatherings as I achieved yet another plateau.

A common business term is ROI — a return on investment. Reduced to the most simplistic format: is it worth it? Applied here in relationships, it means you invest your time and

yourself in a relationship and you are the only one who can evaluate each relationship as to how much it means to you.

Your **Relationship Circle** is a unique Circle in that you don't absolutely need relationships to go through life, but having good, strong, positive relationships nurtures the **Self Circle** and enriches the **Work Circle**. And if the **Relationship Circle** explodes from bad choices or sometimes simply from life itself, it can bring you unanticipated losses of a valued relationship, some emotional agony, and also compromise both the **Self Circle** and **Work Circle**, throwing your life way out of balance into major upheaval.

Men are from one planet, women from another? No, I think not. That type of approach sends a message that women and men cannot connect effectively. Sure, relationships are a challenge. All genders. Do a bit of research and look at the best-sellers over the past few years. So many are dedicated to the secrets to great relationships or fixing love relationships. We read these books with voracious desire to have healthy and loving relationships because our relationships are so critical to how we feel about ourselves and how we live our days. Apply what you are learning in this book and choose your relationships with care and with love. Remember, you determine what you get out of your relationships and the depth of reward it will bring you and what you bring to it as well. And that applies to all relationships, your friendships, love life and co-workers.

COMPLEXITY OF CHANGE

Relationships are indeed complex, whether they be family, friend, or foe. And that complexity can increase when there is a change to even one relationship in your circle. My son Ryan's terrible accident provides a good example. I shared earlier how

that changed my **Self Circle** dramatically and reduced my **Work Circle** down to microscopic levels. Now I would like to explain its impact even further. The relationship between my husband and I changed immensely during that time. No in-depth husband and wife conversations, only conversations about Ryan and his medical condition, discussions about specialists, who should be consulted. No meals taken together. I ate in the hospital cafeteria, but my husband was now in charge of running our home with two other teenagers there who also needed attention. Months on end... family trauma. Not just one relationship impacted, but all of them.

My work relationships were almost non-existent. I did not conduct a staff meeting or do a client presentation; I didn't even go to the office. My longtime focus on nurturing relationships really helped me during this terrible time. A friend and employee, Flo jumped in to manage the office, my other employees stepped up sharing all the burdens. Those relationships were so helpful and allowed me to focus on my relationship with Ryan during his time of injury. My relationships with my other children and my husband, my employees, my clients were temporarily on hold until the doctors' announcement that Ryan would survive. Then and only then could I consider my other relationships, my other circles.

I was able to survive a very difficult time because I truly focused on the most important thing in my life at that time. And of course, the burden was made a tad easier because I had the support of the loving and caring relationships I had developed.

THE WORK CIRCLE

Are you willing to pay the price?

Anything is possible, but everything has a price.

During my journey, I spent a lot of time in the **Work Circle** and indeed it's an interesting, ever-changing place. Whether you work from home, are on the road, or volunteer for an organization, the **Work Circle** can consume most of your time and has the potential to be very draining. You may come away from working on a committee or a project feeling great or, conversely, you can come away feeling poorly about yourself. Can I possibly count the number of times I wanted to resign from this committee or that? What about you?

Have you ever been frustrated with yourself because you're trying to learn a new skill — maybe a new computer program, or are taking a course that should help your career or worse that is mandated by your employer — but just can't seem to get it under your belt?

What can happen? You begin to feel inept, and because you're not feeling very good about yourself, your confidence in everything you do starts to get shaky. I found that when things were horrible at work, I struggled to enjoy my relationships or to be a good friend, wife, or mother. My **Work Circle** threw a blanket of insecurity into both my **Self Circle** and **Relationship Circle**. Another affirmation as to why Life-Balance is not a reality.

Listen to some oh-so-familiar statements: "He was in such a bad mood, he came home, walked right past me and didn't even acknowledge my presence." Or "She walked in the door

and started screaming at the kids before she even said hello to them."

Sad picture — right? A bad day at work spills over into the other circles of life. In the above examples, the bad situation at work was going to create bad situations in their relationships, and their feelings about themselves in their *Self Circles*. And life quickly becomes very unpleasant. I know because when I felt hopeless to change situations at work, I carried the ugly mood home.

Let me clarify again, that the *Work Circle* refers to any work activity... whether you are staying at home, raising children, or whether you're volunteering your time to a worthy cause, or the typical going to work for a paycheck. It may even be a combination of any or all of these activities. People around the world have overloaded their days and that is why I am trying to help you identify what is truly important to you, in each of YOUR 3 circles.

The *Work Circle* can quickly undergo dramatic change furiously impacting both of the other circles. Sometimes the changes occur because of choices you make. Maybe you decided to take a new job, start a new career, or resign from a committee. Maybe it's that great promotion you've wanted for so long, but it's going to create a significant change in other areas of your life. Sometimes, others cause the changes. Maybe the company you work for has a major reduction in force and you're told unexpectedly – ugh – that you are out of a job.

As a single mom of three small children, I needed to identify my priorities. Top # 1 for me, I needed to make enough money to support myself and my children. I did not have a college degree, nor did I have a real marketable technical skill. I knew

that money formed one of the biggest challenges a single mom can face, and it definitely felt like I was trying to win a 10k race with a broken foot.

I began my career in data entry in a collection agency at age 16. As I told you, I had skipped a grade in school and was admitted to an accelerated program so I could graduate early and enter college. But that of course could not happen after my mom's death; I was needed at home. But I progressed in that first job to typist and then collection support, making phone calls to collect overdue payments. Then I juggled two jobs, doing stenography transcription at night at community and municipal meetings and then on weekends working for a Realtor. But still I had not gained any highly marketable skill other than a willingness to work very hard. Those efforts were gaining recognition, but it was going slowly. Because of the life challenges I already had experienced related to a lack of money, such as having to borrow money for a family funeral or having my life's dreams squashed, or the continuing worry about past due bills; those instances kept money on the top of my agenda.

The Big Question was: What price was I willing to pay to achieve financial success? The price of dedication and very long days? That was okay. No money during the beginning years? That was okay as long as I could earn enough to pay our basic bills. And perhaps I had to consider other sacrifices such as working weekends or two jobs to make enough to cover our family overhead. As a single mom at that time, I had to concede that time for dating would be pushed aside. Financial survival was more important.

I sincerely considered the above and a whole host of issues, and determined that yes, I was willing to pay the price! I was willing to make a lot of sacrifices that I anticipated as well as

the unexpected ones that were sure to pop up. One aspect that was important to me though is that I did not want to dislike what I did every day. I wanted to enjoy my work and feel some sense of satisfaction, some worth. I knew myself enough by then to know that, if I was unhappy every day at work, it would impact me for 24 hours a day. And in all **3 Circles**!

My goal for my work life became: To be a success, earn big money, and not hate what I do for a living. I dispelled the balance *Hoax* idea and set my own goal for financial success, not balance.

Of course, the path I chose, to go after financial success, over-flowed with challenges and concerns.

If I did aim for financial success, would that mean I would have to compete, really compete, with men? More than 25 years ago, that was a journey not taken in a small community by a woman without credentials. Another big question... did I have the talent and ability to take my life to that next level? How would I be perceived? Would I be labeled an "overly aggressive woman" or that hateful term, a "pushy broad?" Those terms sounded so ugly, and it seemed to me at that time that people automatically labeled a really ambitious woman with some horrid terms — cold, insensitive, brash, harsh, bitch.

And I must admit those obstacles and concerns are still alive today.

Success topped my agenda, but could I do it? I kept thinking of all the ramifications. Did I have the confidence to "buck" the system? Could I deal with people saying negative things about me? Could I deal with envy? Was I capable of succeed-ing? Was I too stupid to realize the numbers were against me

and I should actually fail? It was a slow, step-by-step process, but I did it.

Since financial and career success were at the top of my agenda, I began to do some solid research to learn: What makes some employees more valuable than others? What makes a person worth more money than the person sitting next to him or her?

Here's the result of some of my research as well as the knowledge gained from years of recruiting experiences. Companies pay the most to people they can depend on, employees who have the company's best interests in mind, who take their job seriously and make a daily commitment to do not just a good job but to become a stellar performer and are loyal. Those are the ones an employer will pay the most. Those are the ones who get the promotions and the increased salaries. In a nutshell, increase your value and you will increase your compensation.

Conversely, I learned about those who were never noted for promotion or, at worst, fired. Often, it was based on their interpersonal skills, lack of effective communication or lack of dedication to the company, and on the fact that the employer could not count on that person.

Here is something else important that I learned: Never say someone else prevented you from getting that promotion, from pursuing the career of your dreams. Look at your own actions. Own up to your choices. It is all up to you.

Many women focus so intently on "breaking the glass ceiling" that they lose focus on doing their job well and succeeding at their current level. I counsel women to stop thinking about the glass ceiling. Ignore it. Choose to put your energies into doing the best job you can and into personal growth. Trust me, when

you do hit the glass ceiling, you will feel it, and at that time, you can evaluate the situation and make good choices about how to meet the challenge. We are fortunate that today there are many organizations dedicated to helping women reach many levels of success, perhaps not attainable in prior years. If that is the path you choose and eventually reach, they will be there to help you.

I've told you about some of my choices and particularly my goal of achieving financial success. Did that choice have an impact on all areas of my life? Yes, perhaps initially from a time management point of view, but not from an emotional fulfillment or inner satisfaction point of view. And remember, life is truly never balanced. Let me explain further. If you are sacrificing a dream or desire you have and choose not to pursue it because it will take some extra effort, or you simply don't believe you will be able to achieve it, then that is definitely the wrong choice. Your disappointment with the situation will permeate your *Self Circle*, you will carry over that dissatisfaction to your *Relationship Circle*, and certainly your performance in your *Work Circle* will then be diminished. Your life will not be a happy one because the energies you are putting forth are not in pursuit of what you truly would choose to do.

You must make decisions about your life's journey, not by acquiescing to the demands of others, nor by default, meaning doing nothing. You must make your life based upon what you want your *Work Circle* to look like. Choose your direction based upon what rewards you expect via your *Work Circle*. If you are not sure what you really want, we are going to help you address that in a later chapter.

We spend most of our life at work. From day one on our first job to the moment we qualify for Social Security — that is, for the bulk of our adult lives — we're spending probably a third of every day employed at some productive task or purpose. Five days out of seven, 50 weeks out of 52, we're on the job. Whether a job with a paycheck or the job of caring for others, we work. All of us. And everybody does it. We all work, men and women, sitting and standing, with muscle and with brains. Women who work outside the home — and there are some 72 million of us — constitute a significant portion of our nation's labor force. Women who stay at home to be full-time mothers are "employed" full-time from their first pregnancy till their youngest child departs the nest, realizing incalculable economic value for the nation. So, in terms of the numbers of us who work, the time we spend doing it, the effort, and the consequences, the *Work Circle* of our lives is so critical to our existence.

It's also huge in importance: you need that paycheck, or the validation that work brings, or the sense of identity, or the excitement, or the feeling that you're needed, or all of the above.

That's true whether your work takes you to an office or a factory floor or a laboratory or a shop — or keeps you at home. It's true whether you work for pay or for love, maybe volunteering for a cause, or to fill a social or family need. It's true whether you're the cowering secretary, afraid of her boss's wrath because she could lose her job, or if you sit in the plush CEO seat in the big, shiny corner office with a staff of assistants and all the perks. I've been in both positions. And I know that, despite the difference in monetary reward between the two types of jobs, the challenges of the *Work Circle* of life are pretty much the same for both — and for everyone in between.

EXPLORING CHALLENGES IN THE WORK CIRCLE

We all know some of them. After all, the **Work Circle** is the place where we're required to meet obligations and commitments, whether we feel like it or not, and where collaborating with others is a necessity, whether we like those others or not. That means that just about everything having to do with ourselves and our relationships can affect our work — and vice versa. And as everyone knows, there's nothing like a bad day at work to poison everything — to sour a friendship, break up an intimate relationship, burden family life, undermine self-worth, and sow self-doubt as it sends ripples cascading through our **Relationship Circle** and our **Self Circle**.

Say the sales and revenue figures came in under forecast and everyone is jittery. Suppose you can't seem to get the hang of the accounting software upgrade no matter how hard you try. And then suppose you find out that your assistant, whom you have trained for months to be your reliable right hand, has had a very attractive offer from another company.

All sorts of things, some of which you can control and some of which you can't, can shake up your **Work Circle** and send waves of disquiet into the other circles of your life. Sometimes, the cosmos itself puts challenges and obstacles in your way, and sometimes you put them there yourself — by accident or by design. Management suddenly announces a pay freeze; there goes the raise you counted on. Or there's a crisis a million miles away and your suppliers suddenly have no supplies. Or there's a crisis in your boss's personal life that throws him into emotional turmoil, which renders him virtually useless and puts great burden on you.

Challenges that come from within can be just as powerful. Maybe you're hankering to move laterally within the

corporation, or to look for a new job in another corporation, or to start a new career altogether. Maybe you earned a great promotion, but it's going to mean relocating or taking on a whole new scale of responsibility. Or, you've decided to add to your family; everyone is excited but it's going to rattle all the circles of your life.

When your BFF calls and wants to chat, you whine that you haven't got time for her. The kids ask what's for dinner and you simply can't face cooking, so you order out for pizza again — the second time this week and that is something you had vowed not to do, ever. When the twins get rambunctious after dinner and your husband deals with it by settling down in front of the TV, you scream your head off at them and give him the silent treatment. You feel let down by others and disappointed by life, all because a bad day at work has sent everything south: relationships, family life, self, fun, health, even the taste of the pizza you wish you hadn't foisted on your family yet again. A bad day at work can take the joy out of being a friend, a wife, a mother. It saps your confidence, and that diminishes all the circles of your life.

The opposite is also true: When work is good, it can boost your confidence, ignite your energy, and bring you fulfillment. One way or the other, what happens in your **Work Circle** will have immense impact on all aspects of your life.

I found that my own increasing success in my **Work Circle** also had a profound impact on my relationships with my co-workers. Some colleagues resented my dedication to the job. I stayed late; I showed initiative; I pushed myself to build my value as an employee. I was sorry to experience their responses and frankly found it uncomfortable and disconcerting. But I made sure I never let their agenda dictate mine. I kept my eye

on my own goal. When I achieved the goal and owned my own company, I then had to adjust to the fact that, instead of being a friendly co-worker to others in the office, I was now The Boss. Me? The Boss? That required a real shift in my *Self Circle* as well as definitely changing my *Relationship Circle*!

People obstacles can rear their head in subtle or obvious ways. Do people — men and women — resent the fact that you make more money than they do? Yes, many do. Is it possible that a co-worker who was a friend will grow jealous of your success? Or that a supportive boss will feel threatened by you as you ascend? Yes, yes, and yes. And don't forget: if you're the one watching a friend or associate rise, you could be the one feeling threatened and gripped by jealousy.

Any advantage may incite others' envy. If you are able to arrange flextime or position yourself to work from home, will some others be envious? Quite possibly. If you are the one who gets the bonus because of that great cost-saving suggestion, or you win the trip to the Bahamas, are you likely to get the cold shoulder from co-workers? You bet. Will your sibling be annoyed if you are the one who has the time to care for Dad and she sees it cementing your relationship with him? Yes. Will your other sibling be resentful if you are the one with the money to pay for Dad's care but can't spare any time to care for him? Yes, those are all possible responses. But this is indeed your life, your only life.

Years ago, people thought differently about work. You took a job right out of school and stayed there until they gave you a gold watch and retirement party four decades later. Those days are long gone. Now the challenge is often finding that first job and then it is expected that we will have multiple careers in our lifetimes. Seven different careers aren't out of the question,

but even three or four means a number of transitions in your **Work Circle** over the course of your life. That means we're all going to have to learn to roll with the punches — to adapt to changes in our **Work Circle** and to manage the impact of **Work Circle** changes on our **Relationship Circle** and **Self Circle**. I would be lying if I said that my own road to success in my **Work Circle** wasn't littered with very substantial challenges to my **Relationship Circle** and **Self Circle**.

I was able to deal with all of that because I had brought two key perspective-shaping components into my **Work Circle**: One, I knew what I wanted in terms of success and had set goals that expressed my definition of success. Two, I was willing to pay the price to realize those goals and achieve the success I wanted.

RUNGS OF THE LADDER

Many women have a goal of "Shattering the Glass Ceiling." And perhaps at this moment you are saying yes you are willing to work hard and certainly are willing to pay the price to achieve whatever level of success you have in your vision. Likewise, many men reference the "corner office" as a goal and strive to achieve it, regardless of the price.

But what about your current place on the ladder? If you are in a non-decision-making position, providing support but having only minimal authority, any advice on "Shattering a Glass Ceiling" is meaningless. I understand that. And more than that, it is achieved by so few, yet success itself does not have to be elusive.

I had diverse experiences at each stage of my upward movement and sometimes I stumbled and did not make progress, even

losing ground. I learned that if you are standing on the rung of the ladder that is generally classified as middle management, you could have some very difficult days. On that rung, you have some authority, yet you are often not empowered to choose which directives to follow. Your days can often feel as though you are living in a vise, squeezed between upper management and those you supervise. And that rung can be pressure-filled for days on end. Often the only choice you have is whether to implement a directive or challenge it. The challenge may not lend itself well to career advancement in your **Work Circle**. When I encountered those situations, I would indeed speak up and challenge the standards. In my case it served me well as I earned a reputation for being honorable and honest regardless of the personal risk.

And I also learned through my experiences, that if you are closer to the top rungs of the ladder, then perhaps you do have the power, yet also the heavy responsibility of making decisions. And they must be good, sound, solid, wise decisions! In each instance, your own **Self Circle** can inflate due to frustration at not being able to get the job recognition you feel you deserve, or if, as the middle manager, then possibly the resentment of having to implement a directive you feel is without merit. At the higher rungs of the ladder, the **Self Circle** can become all-consuming from the angst that is involved in making decisions that will impact, possibly negatively, those you manage and/or the success of the business. Your **Work Circle** can loom like a dark cloud hovering over all the rest of your life and create so much stress that you wonder if it all is worth it. I admit I've had those days but sitting here writing this book I admit also that I would do it all over again.

Regardless of where you are on the Rungs of the Ladder, you will have to face issues, often daily, that could impact your life

for either a few hours or a day or, we can agree, even longer. Thankfully, at every level you can choose to make changes to improve your situation. Recognize that the choices you will make may jolt all of your circles. But remember, they are your circles and with the advice in this book, you will learn how to reshape them to best fit you and your life at that particular time. The circles rotate, life changes and balance is gone but that does not mean you won't be able to take charge and reshape or massage the circles to create a very livable and happy life.

It is not cumbersome, it is not magic, but it does work. Now, with these enhanced skills you are going to develop, you should be able to move up the ladder if you so desire or drop down a rung without losing the respect of others. The decisions will be yours and yours alone. You are a smart woman, just take the time to think it all through and apply the various techniques you are learning in this book.

BIG CHALLENGES: JUST BECAUSE YOU ARE A WOMAN

Your **Work Circle** has all of the issues I've listed earlier, but because you are a woman, there are some challenges that will be unique to you, not faced by your male counterparts. This isn't a book about the all-too-familiar-issues such as inequality in the workplace or getting passed over for that promotion because you are not part of the boy's club. Yet we do need to touch on these real, documented issues all women still face in today's workplace. Female CEOs in the *Fortune* 500 aren't quite the norm yet, but they have been making inroads, even if these are tiny steps forward. More has to be accomplished. As of May 2018, there were 24 female CEOs on the list — just under 5 percent of the total list. For many of us, however, our goal is not making it to the top of a *Fortune* 500 company, but

rather getting paid fairly for what we do, getting recognition for a job well done, not being harassed, and being able to go to work with a smile on our face and come home with the same smile.

As recently as 2018, a study based on 50 years of data by the Institute for Women's Policy Research titled "Still a Man's Labor Market,[2]" found that, while there is considerable progress, there remains a significant gender pay gap. Between 1968 and 1982, a woman who took off just one year made, on average, 12% less than a woman who worked all 15 years straight through — and considerably less than men. So, women who have children and take any time off are significantly penalized in their ability to earn fair compensation. The challenges are there just because you are a woman.

Even though women are making strides in politics for example, a report by Washington, D.C. — Representation 2020, Common Cause and the Center for Responsive Politics[3] revealed *"the systemic disparity in funding for female candidates by PACs, individual donors and major parties. Women are under-funded to run for open seats despite that they are more likely to win open-seat races than those in which they challenge an incumbent."* Every article I read reports that female political candidates do not raise as much money in donations and support as males, regardless of how superior their qualifications may be. The barriers continue to exist simply because we are women.

I recall reading[4] "that men, for example, tend to be seen as more authoritative and women as more communal in

2 https://iwpr.org/publications/still-mans-labor-market/
3 https://www.commoncause.org/resource/individual-and-pac-giv ing-to-women-candidates/
4 https://scholars.org/brief/how-gender-inequality-persists-modern-world

orientation. In workplaces, this can readily lead people to expect and defer to men in charge – and to look to women to carry on routine group maintenance efforts. Studies show that in job interviews where men and women have the same qualifications, one gender gets more offers according to traditional assumptions about gender proclivities. Without anyone consciously intending it, even very highly qualified women can be left to the side – and they are unlikely to make up ground as long as the original "boys' club" atmosphere and assumptions about the kinds of people most likely to be innovative and high-achieving persist in the organization's outlook and ways of attracting and promoting people.

I share this "just because you are a woman" information in this section on the **Work Circle** because I want to emphasize something important I learned which helped me achieve at remarkable levels. Before you proceed any further in the book, please accept that the challenges in your **Work Circle** are and will continue to be tremendous just because you are a woman. No, it is not fair, but it is a fact still. Much has changed, but not enough. If you desire to build a strong career, you have no room to be lazy or inattentive to your job. Accept that you don't have the same margin of error as your fellow male employees. What does this mean therefore in your **Work Circle**? Remember: Anything is possible, regardless of the depth of the challenge, if you are willing to pay the price.

Here is what I learned during my journey to success: A most important piece of advice to those who wish to excel: The challenges in the **Work Circle** are large but not impossible to conquer. Your success will not be achieved unless you first define the goal and then map out a plan. This will not be achieved by casual effort; rather, you will need to develop a plan, stay focused and make sacrifices; you will have to

determine your goals and then the price you are willing to pay. You must not allow yourself to get distracted by petty issues at work, office romances, or your coworkers' personal problems.

You will have to outperform in order to get recognition; you will have to work harder and be smarter and more aware than others in order to secure that raise or promotion. And always you will have to outwork your competition. That is the price. More often than not, your **Work Circle** will be expanding second by second, not always because of anything you initiated, but merely because of the unique challenges facing you, a Woman.

I certainly know that equal representation of women at all corporate levels, whether for profit or non-profit industries, has not yet taken hold nationwide. So many women work in environments without the benefit of high-level female role models. Decades ago, there was a County Court Clerk in our region who was the highest-profile woman I knew. She had earned the respect of all. I went to work for her part-time at a lower rate to observe, and learned what she did to attain such respect. During the beginning of my career, no one I knew served on a corporate board of directors. And I could not find a savvy woman business leader to guide me. When I was starting out, there were few organizations dedicated to helping women achieve their true potential. But there are now. So, yes, do your job and be a stellar performer, but think about your work life and network and plan your work future. I will help you learn how to make choices that will bring you closer to your goals both personally and professionally.

I am an advocate for working hard as you will read in this book, but ask you to recognize that working hard, without a master plan, can also stymie your career advancement.

Superior performance can bring about salary increases and job security, but it may not increase your ability to leverage/advance your career. Keep doing a great job but remember the plan you need to develop and implement: your long-range career and life plan. From the earliest stages of your career, you need to work strategically to make wise choices regarding where you work, what you do, who you work with, and who is going to help you. Follow that plan and you will take your professional life to amazing heights.

YOUR NEW AWARENESS: LESSONS LEARNED – QUICK REVIEW

Remember the 3 Circles (Recap)

Self Circle: This is who you are, how you feel about yourself, including your doubts, dreams and aspirations. It is the circle of your emotional wellness, and your spirituality, the circle of who you are, who you wish you were, and who you shall become.

Relationship Circle: This includes all of the relationships in your life. It includes friends, lovers, sisters, brothers, parents, and all your family members. It also includes your neighbors, store clerks, doctors, nurses, and the strangers that come into your life. It even includes your co-workers and anyone else who is part of your life.

Work Circle: This includes where you are productive and not just the place you go to get a paycheck. If you are a stay-at-home mother, you work, don't you? For millions of us, it is both. We are changing the face of America. We... the working mothers. If you care for a parent or don't work outside the home, yet are

involved in multiple community organizations, all of these are activities that take place in your **Work Circle**.

> *Visualize three circles. Each of them is linked together and totally connected, one to another. The **3 Circles** are like the ones used for the Olympics. Each one is connected, and you cannot separate them – ever.*

If something significant occurs in one circle, that circle is likely to expand, like a big balloon, while the others will contract, getting smaller in size and importance. The circle with the event or major happening, the one needing attention becomes bigger than the others, sometimes much, much larger. In other words, the three circle sizes change depending on the circumstances and where your attention is needed the most.

Often you cannot control all the circumstances that affect the size of each circle. BUT you can push back with some measures to massage the overblown circle, addressing the important issue that is causing the expansion and ultimately getting relief. It won't be balanced, won't be perfect, but with new knowledge and skills learned in this book, you will find relief during those times and most of all experience less stress, less guilt, minimizing the taste of failure.

The Hoax is offering you a life in perfect balance; the reality is that it is not possible. But the larger point is that, with my advice, you can manage the imbalance issues to live a bit easier.

- **Say Goodbye** to the Life-Balance Hoax.

- **Accept** Life's new reality.

- **Prioritize...** Focus on what is truly important right now.

Is there something going on in your life that, if you don't take care of it, could possibly have a major negative impact on many areas of your life and possibly for a very long time? Put the spotlight on that issue, explore solutions to that problem. Focus. Let's consider something major is causing your **Work Circle** to expand and then expand again. This focus could last a few days or longer because your job may be critical to many other areas of your life.

How would you strive for balance when you've just lost your job? Does helping the Little League with a fundraiser have the same degree of importance now? Or how about getting those tickets for your friends to that concert? No. There's no symmetry. In this example, clearly the **Work Circle** is gigantic now. And will remain so for a while. Don't feel guilty about not going to the concert or helping Little League next week.

Others may advise you to continue to do those things so you can have a modicum of steadiness in your life. The reality is that you may not enjoy the concert right now. Rather, you may be thinking about the cost of the tickets, now that you have no income. While you like the Little League organization, you may be fraught with worry about finding a new job and grumpy and not the best person to be working with little ones. You must *decide for yourself* what you can realistically handle while the **Work Circle** is so enormous.

The focal point for your energies would most likely be securing a new job. In this example, the **Work Circle** is most important, and your **Relationship Circle** will have to take a back seat. Understand that, in the example I am citing, the **Relationship Circle** may take a real hit because you may lose some sensitivity to the needs of others as you struggle with how you feel about yourself, now unemployed. Unemployed

and more than a tad tense, you may find yourself giving rather terse responses to a family member or friend. You'll have a high degree of worry about getting a new job, the right job quickly enough — so your *Self Circle* is also affected. I can guarantee your life will not be balanced. It will be overrun with classifieds, Internet searches, resumes, and interviews. Life changes, impacting all three circles, all at the same time. But remember, my recommendation means taking care of the most important circle, the largest one first. In the example above, for most people it will be the *Work Circle*.

Now, I accept the fact that any plan I have for a day or week can change quickly. I do not seek symmetry every day because I understand that any one of the **3 Circles** can expand and another contract with little, if any, warning. If that happens, I understand it is a natural occurrence and I don't get all stressed out or feel like a failure because things are out of balance. *That is one of the biggest benefits to embracing this new life reality — seeing yourself as human and minimizing your stress.*

If I take the time to assess a situation gone awry as I should, sometimes I find that the root cause is with me...my responses, my behavior. Maybe I am over-reacting to the situation, maybe I am allowing a simple snarky remark by a co-worker to ruin my day or week. Introspection... root cause analysis... whatever term you want to apply to it, means you must take responsibility for your own part; that your own behavior could be allowing the circles to bounce around like a juggler dropping those bouncing balls. Life all over the place? If some of it is a result of your actions in one circle, remember:

You can't separate your life into individual pieces; it is all connected.

- The **3 Circles** are connected constantly. Embrace this concept and stop striving for daily balance that is not real. Remember it is a **Hoax**. Accept that life can change suddenly.

- You can find a new way of living where your feelings of failure, depression, and low self-esteem can vanish.

- When you feel good about yourself, you will have more energy; instead of being tired or feeling fatigued, you will create great days.

- Whatever your definition of success you will be more likely to achieve it.

- It is never too late to make changes and it is all within your reach.

- This is your life and you have the right to make it be whatever you want it to be.

- Take the time; learn a new way of living.

Don't misunderstand me...

It's great to plan. The point here is to accept that life can and will take unexpected turns. While you thought you were going to spend your time doing x, it might just as likely be spent doing y. And when that happens, it is not your failure. It is just life.

As you become stronger, you will be able to stop the past from ruling your "todays" and *manage* the changes when they occur and make the changes you want.

Once I discovered the **3 Circles,** almost overnight my life changed. It changed because my view of life changed, and my view of myself along with it.

The significant change was within me. I no longer felt incompetent, compared to others who seemed to have the perfect life. As I paused to take a good look at their lives, I realized that often they too were striving for balance, and obviously not always achieving it. With this knowledge of the **3 Circles**, I changed because I gave myself permission to be less than perfect. If the family was having leftovers tonight because I ran late and did not get home in time to make that food-magazine-perfect dinner plate... it was okay. My children were healthy and actually liked pasta two nights in a row. And the laughter at the dinner table was the most delicious thing served.

And when I forgot to get the baby shower gift I had in mind and had to get a gift card (at the grocery store no less) on my way to the shower, I was delighted with the choice. Why? Because my gift would have been a duplicate of one already opened... so guess what? My gift card was quite appreciated.

I started to forgive myself for the little glitches along the way. With knowledge of the **3 Circles**, I was able to put things in better perspective. I accepted the fact that today one of the circles might dominate my entire day, and there would be no balance, but it was okay because I did not get rattled or feel like a failure. I just accepted the fact that this one circle was the Big one for now. As I conquered ***The Hoax***, I got stronger day by day. I was living my new reality and I was the one guiding the decisions, not some outdated theory.

One of the other changes I noticed took place in my ***Relationship Circle***. Since I was less rattled, less hassled, less frantically trying to do it all, I was easier to live with and truly more pleasant in my exchanges with my loved ones. And if someone needed more of my attention at a particular time, I was not annoyed or worried that I was taking time

from me or my work; I acknowledged that, at the moment, my *Relationship Circle* needed me the most.

Every time I used my energy to effectively handle life's unexpected twists and turns, without panic, I grew stronger. With newfound self-esteem, I began to trust in myself. I acknowledged my abilities and didn't feel inept or afraid. I was encouraged to reach for new horizons. I wasn't afraid to do things differently or at least try to do something new.

I went and bought a car... by myself... with my own money and made my own deal. Twenty years ago, that was not the norm. Did I get the best deal? I am not sure, but the sense of satisfaction in making enough money to buy my own car and selecting the one I wanted was awesome.

As I gained some extra money, I put a certain amount into a safe savings account. But I realized somewhere along the way that I wanted more than just financial security. So, I expanded my entrepreneurial ventures by investing in real estate; purchased several investment houses and did a few "flips." I also purchased an office building as I mentioned earlier. I conducted the necessary research, very thoroughly, before I took those steps which I never would have attempted had I not gained immense confidence along my journey.

I worked so hard that I was able to initiate a change I desired. I did my job so well that I had enough confidence, based on performance, to go in and ask for that raise I really had earned. And that felt good. I incorporated the **3 Circles** concept into my entire daily thinking, decisions I made, how I handled work, my relationships, and myself. And as I realized that it was true, that I was the one in control, that I was strong, that

there was no reason to be afraid of what life could toss my way, I became more confident and more at peace with myself.

People want to know about my journey and specifically more about my success: how I became successful at work, how I went from being destitute, driving a car tied together with rope, avoiding bill collectors, electricity turned off periodically to having real financial security. How did I go from being a single mom crying myself to sleep at night because I was worried that I could not put food on the table to having a life filled with savings accounts? Was there magic or luck? Was there a secret I could share?

I am sharing what I learned, not secrets but solid knowledge, practical actions that changed my life. One step was the discovery of the **3 Circles** and the clarity to understand that all aspects of my life were really in my hands. To understand that I truly had the ability to make changes in my life. The awareness of the **3 Circles** gave me the strength and power to believe in myself. One realization was that I finally appreciated that I was worthy of that promotion or increased compensation. Once I believed I was capable at work, I applied myself to every task with increased intensity. I worked very hard and delivered my best performance every single day. I ignored distractions at work and focused on performing my duties to the very best of my ability. I believed in me and put forth the effort to always perform in a stellar manner, did the extras, went over the top in my work effort and believed that I would achieve certain levels of recognition, and I did. I never complained about too much work, not liking the work, and never spoke a negative comment.

In order to accomplish my ultimate goals, I had to develop an increased ability to focus, not simply at the time when I was feeling more than a bit distracted, but to focus on each

task at hand. I reached inside for discipline and monitored my behaviors even more than I previously had. First it was an increased discipline at work because financial success was critical to my family's survival. With increased discipline, I was able to apply myself better, to focus better on my other circles as well. Conscious discipline helped me earn success in my **Work Circle** and live happier in the other two circles. I grew, I embraced change, I had an ongoing eagerness to always learn more and improve myself.

I often say I am not smarter than others, definitely not. But I wanted it more and was willing to work for it.

I carried that same approach of excellent performance forward when opening my own business. I took work home without a gripe. I did my job and more. Once I owned a business — recognize I started with one employee and sold it when we had 8 offices in 4 states with hundreds of employees — I applied the same philosophy. I was willing to work hard, not see negatives, focus only on my positive future. Retrospectively, I believe it took courage, but not necessarily wisdom, to go into business with that one employee and an office in the *basement* of an office building.

It was an enormous gamble and represented challenges that, upon reflection, make me marvel at how bold I had to be. Did I think it through completely? Not sure, but I did not let fear of failure stop me. I set goals to make enough money to support the children on my own, pay rent, get groceries and put gas in the car. I found the inner discipline to work and work hard. Each day, I would strive to do an excellent job, stay positive, never complain, did not get distracted, stayed confident, and worked harder yet. I didn't let the disbelieving voices of others stop me. I am not superhuman, and I made mistakes.

But I wanted the financial relief more than addressing a petty annoyance with a coworker or to allow myself to get distracted by a nonsensical issue.

The business started to grow at a very rapid pace. Clients asked us to do more. We found new clients, often referred to us. We adopted a philosophy of being user-friendly as I called it... to be a pleasure to deal with, and a resource the client could count on. Admittedly, I made lots of mistakes, but kept trying. I only had a high school degree, with no formal business management training. I did not let that stop me. I devoured just about every business management book available and subscribed to all the business magazines, and, frankly, they helped me a great deal. I attended workshops both far and near. I did not have a mentor but was not afraid or embarrassed to ask for advice from others who were successful. I reached out and opened new offices. I started businesses in Arizona, New Jersey, Connecticut... even on Wall Street! I became involved in international recruiting, even being featured in one of the industry's magazines.

Certainly, at that time, my **Work Circle** dominated my life often, but I was focused on achieving what I needed in that circle and did not feel guilty if my house was a mess. I did not feel guilty that I said, "No" to those house parties where they sold household goods, clothing or jewelry with wine and laughter. Sure, achieving success in my **Work Circle** meant there were times it was disproportionately large, but with the strategies I learned and share here, I was able to enjoy the journey, create some great relationships, and feel good about myself and my accomplishments and thus achieve at remarkable levels. Because I was happy with my **Work Circle**, while the demands were great, the emotional strain was not there. During my journey, I believe I became a better parent too.

I could give of myself in my **Relationship Circle** and to the most important people in it: my family and friends. I was living the reality of life, not some **Hoax** about balanced perfection.

When I was able to make a dent in my sometimes-overwhelming concern about financial security, I took the time to look to the future and consider what else I now wanted out of life. What vision did I have for me, my family, my career?

Here comes a key point I ask you not to forget. Take time for self-reflection, introspection... root cause analysis... whatever term works for you. Look at your own behavior, your own responses so you can improve your live, while becoming a stronger, better person.

Now, I am strong enough to put my head on my pillow at night with peace in my heart.

I became strong enough to welcome each day as a new adventure, accepting the joy in this roller coaster ride called Life.

YOUR POWER TOOLS

I AM NOT ASKING that you make these major changes in your life without arming you with the tools to do so. I have always been curious about how things are made. Buildings, equipment, works of art... how is it constructed? What special tools were needed to create that masterpiece? How long did it take? I even started a construction company in addition to my recruiting business. I did not get to wear the hard hat often, but I had the fun of visiting the job site and watching new construction or, even more interesting, the renovation of older homes with marvelous features. Often using the right tools made all the difference for a successful outcome.

Remember when I told you I was going to repeat some things? Let me emphasize, that whether you need to rebuild your life in many areas or simply repair a certain piece of it in order to make these changes, you are going to need tools.

Here are the "tools" that I have developed over the years to help me build my successful, happy life:

- Power Tool of **Control**

- Power Tool of **Choice**

- Power Tool of **Communication**

These tools may seem simple on the surface, but don't be mistaken; they are very powerful, very practical tools, to be

used every day. As you now know, I wasn't born "lucky." I had to pay my dues to become the woman I am today. Modest compared to many, but a big improvement from the shaky start. These are the tools that I used to turn defeat into victory. I will give you very real, practical "how-to" advice for using these tools to make the changes you wish. Consider this section the instruction manual on how to make the changes needed to build the life you want and deserve.

You cannot change yesterday, and your tomorrows will all be the same — unless you use your "power" to change today.

The Power Tool of Control

"Boy! Is she out of control!" "Get control of yourself."

"He's always out of control. He never talks, he screams!" "I'm afraid I'll lose control if I try to talk to her."

"Every little thing seems to set me off these days." "I can't seem to control my reactions."

Feeling a bit overwhelmed by all the demands on you? Ever find yourself screaming at the slow-moving car in front of you? When someone yells at you, do you join right in and yell back even louder? Do you snap at the people you live with because you have had a bad day at work? Are you always exhausted? Is time for yourself impossible to find?

That was me until I found this tool and learned how to use it masterfully.

What would it feel like to be in control? How would it be to react calmly to whatever happens? It is possible, and the way to make all of this happen is to use the **Power Tool of Control**. Use it to build an incredible life, to create wonderful relationships, to open doors in your career, and to give you a peaceful, happier self. The **Power Tool of Control** can change every circle of your life. It did mine.

It's been my observation that women suffer a great deal because so often they simply do not know what they can control and what they cannot. So, let's start there with some basics.

My first rule for you is: know what you can and cannot control.

Let's review some examples of what you *can* control:

- Eating too much or too little
- Drinking too much
- Being a good listener or a poor listener
- Being kind or being mean
- Blaming others
- How you appear to others
- How hard you work
- Gossiping
- Being lazy
- Being a good friend, sister, wife, or mother
- Your professional behavior at work

The list of examples of things you can control goes on. Next, these are examples of what you *cannot control:*

- Someone else's anger
- Your neighbor's messy yard
- You sister-in-law's envy
- Interest rates
- The governor's decision to cut unemployment benefits
- Your child's teacher
- Your boss' mood

- The job market fluctuations

- The price of gas or coffee

You get the idea. This list also is virtually endless.

> *No matter what is said to you, no matter what is done to you, no matter what goes on around you, you CAN control your response and behavior. Nothing — no one — can take that away from you.*

Do you ever find yourself thinking! "I just did it without thinking," or "I was out of control," or "I was so angry I couldn't help myself." *Wrong.* You can help yourself. I know because I did it. I changed. There I was, spinning out of control. For a long time in my life, I felt like I was never the one in control. Everybody else was. I hated how I reacted. I found myself screaming and losing control of my emotions, crying on the spot, always annoyed.

When I would get my emotions back in check, I would regret what I had said, but there I was, out of control sometimes being hot-headed with poor results. And it was such a waste of important energy that I could have used to accomplish my goals. I wanted to avoid those times when my actions made me feel more depressed than I already was that day.

REALIZING IT'S ALL UP TO ME

Recognizing that I could not make significant changes in my life without help, I learned how to wield this **Power Tool of Control** to amazing results.

Let me ask you this: do you tend to react too fast to problems with your friends, children, or your mate? Do you speak too fast, letting the emotion of the *moment* determine what you say? Then, do you wish you had paused for a *moment* and thought it through more? How about at work — do you ever find yourself showing your annoyance at someone's mistake before you know all the facts? Or are you simply annoyed at them, their style? Are you often ready to jump into battle?

Maybe you're in a situation where the reflex response is a negative emotion such as anger, or to become defensive and nasty. Yet, if you had an opportunity to think about it, you probably would not want to handle the situation in an impulsive manner. I began to realize that my response was truly up to me and me alone. My success, reaching my financial goals, *my dreams were up to ME.*

Only those situations that are truly life-threatening require an absolute immediate response. In almost every other situation, you can take the time to consider your response. Seems difficult? Try to hold back your response when the person at the desk next to you is interfering with your ability to finish that important project; try it the next time a counter person is rude to you or makes a mistake in adding up your order, or the person cuts in front of you while you are waiting at the grocery checkout, and your first reaction is to get angry. Stop. Use the **Power Tool of Control**. Control the inner warrior who wants to roar a response and instead say something pleasant. Smile. You'll have a lot less stress that day if you do that, and you'll make the counter person's day a lot less stressful too. That's worth a little self-control. It's much better — and much more fun — than wallowing in anger and annoyance that can convert into despair, and depression.

What makes the difference between the person who is disabled and just gives up and the person who is disabled and goes on to live life fully? Their response to the situation. The one who goes on to live life fully decides to be in control, to control the response to the hand that life dealt. That's the one who decided to control anger, self-pity, and a list of other sad emotions, and instead, put energy into making the best out of a difficult challenge.

Let's look at a simple situation as an example, something that could happen any day of the week. You head off to work in the morning, knowing you have a critical meeting first thing that day. The meeting has been planned for a month. Then, halfway there, your car dies right in the road. You are totally upset. You just had it serviced. And here you are — late on this important day.

More than likely, your impulsive response is not a pretty one. Do you want to get out of the car, slam the door, and kick the tires? Want to call the service station and yell at them at the top of your lungs? Throw your papers up in the air? Scream something nasty for the entire neighborhood to hear? Maybe you would want to do all of these things.

But what good would any of it do? Stress and anxiety would take over and completely ruin your entire day.

Use the first approach I taught you in this chapter. *Recognize what you can and can't control.* You cannot control the car's performance. You just had it serviced. You did your best. What could you have controlled in this instance? The only thing you can control in this situation is how it affects the rest of your day — how rapidly and well you respond.

Power Tool of Control— You can control how it affects your *Relationship Circle* and your *Self Circle* by controlling your reactions. No need to stress out and poison your whole day with unpleasant interactions with everyone who crosses your path. Change your habitual action of over-reaction to one of clear, concise thinking. With a clear head and controlled response, you'll consider solutions: Is there another way to get to work? Could I catch a ride from a friend or neighbor? Is there a way I can participate in the meeting by phone if they have the technology? Can someone else cover for me?

You know you cannot control the car's engine. But you can control how you respond to the situation. The car breaking down is not a life-threatening problem. It doesn't deserve hysterics, anger, and displaced energy.

The meeting of the PTA, the job interview, on the job... in all these circumstances you want maximum use of the **Power Tool of Control**. You will not give in to the co-worker who is trying to bait you. You will not show your annoyance that he always comes back from lunch ten minutes late. Instead, you will develop a plan to speak with him and then, if that fails, to your supervisor, with all your emotions under control.

Are you wondering how does this knowledge about the **Power Tool of Control** help you attain your wish for a "better" life? I've shared with you that I have indeed achieved professional success, the accolades, the money, and all the fringes that go with it. Without using this **Power Tool of Control**, often on an hourly basis, many of those accomplishments would not have happened. You can wish or dream of a fabulous life for yourself, but it won't happen if you don't have control of your actions.

Power Tool of Control — recognizing that I was the one who had to be in control of my mouth, my responses, my body language and my attitude placed me at meeting tables with a smile on my face and a can-do attitude that often got the me the reward I was after.

Control is important, but just how do you do it? Every one of us has a different point at which we blow our fuse, so you may have to try different control mechanisms to see what works for you. Here is one method that helped me a great deal.

INTRODUCING *TAKE 5!*

I admit it... I am an impulsive person and often would impulsively shoot from the hip with a response, sadly not getting the results I had hoped. I was making more enemies than friends and that was not helpful to my career. And it certainly wasn't good for my friendships or in my family. I needed to change my actions, but how? Eventually I implemented a new technique.

Take 5! No, I am not suggesting you buy a Lotto ticket to turn your life around. Although certainly a big winning one would change the way your circles work and talk about an unbalanced life! Wow.

If you have ever had any exposure to competitive sports, whether yourself, a relative, or simply watching on TV, then you have seen where the coach calls for the team to take a break. They huddle up, strategize and PLAN their responses both on offense and defense. Same thing happens in the making of a movie. Filming is stopped with a *"Take 5!"* called out because the director notices something that is not exactly right, or he/she wants to consider an alternative. Perhaps he sees his talent

is stressed. For whatever reason, he wants to take control of the situation and change something.

I have attended some very important business meetings where the decisions made at the table could result in impacts in the millions of dollars. And I have seen heat coming from the participants, with extreme hostility building moment by the moment. And then one of the players, with wisdom much appreciated, suggests "let's *Take 5!*" and revisit some of these topics in a few minutes. Admittedly, the break often lasts longer than 5 minutes, but the point is there is a halt in the exchanges. He took Control. And that is what you can do, take control. He used a simple **Power Tool of Control**.

I was involved in a $90 million business transaction, an acquisition with so many moving parts that it would be easy to make a major mistake and it was scary. Emotions ran high and the parties involved almost became lifelong enemies. Sitting in that conference room, centered amidst all the parties, I used this "*Take 5!*" technique more than once. It worked well. I was able to calm down the buyer and seller, the lawyer for this side, the lawyer for that side. The transaction closed and they shook hands, perhaps never friends, but not enemies either. Because the situation and players were controlled.

In this section, I've mentioned some of what you can and cannot control and I am sure you can add to the list. But in so many more instances, the *Take 5!* method can pause a situation about to get out of whack and put you back in control. Try it and don't be worried; you don't have to yell out *Take 5!*

Example: you and another are in a discussion that is starting to turn more than a bit borderline combative and you ask for a break so you can use the facilities or return a scheduled phone

call. But truly, you are implementing the *Take 5!* of the **Power Tool of Control**. When you return, I can guarantee the tone will be less intense and you will make more progress as you reopen the discussion.

Building a successful career, I had to use this *Take 5!* method oh so often. One time at the beginning of my career, I attended a staff meeting and I made a solid suggestion regarding how we should handle a challenge that came up with a valued account. As usual, they smiled and ignored me. Within 15 minutes, the guy sitting next to me pipes in with the same suggestion; yes, different phraseology, but same idea. It met with great acceptance. I was so upset, ready to jump up and let my emotional response represent me very poorly. Instead I took a deep breath, *Take 5!* Method internally. When the guys were done sharing the kudos, I responded in a normal tone, with a professional voice. "Thanks, Joe, for validating my suggestion and, with your spin on it, I am confident it will work."

I asserted myself, professionally, did not back down, but did not push his face into sour pie. After the meeting, I noted a few positively raised eyebrows and a tad of increased respect. So often, women are perceived as overly emotional that, at work, we must, individually, be extra-sensitive as to how we are considered. Yes, it is an outdated assumption, but I assure you it still exists and, if you want to build a strong career, it is up to you to exercise the highest levels of control, at all times.

Workplace respect can move your career forward at amazing speed. This method of taking control in a situation such as stated above, and earning respect, can work just as well whether you are involved in a family discussion or committee meeting.

LESSONS LEARNED: FAILURE TO USE *TAKE 5!*

Now I will share a story about failed leadership. Mine. I now embrace the *Take 5!* but did not learn about **Power Tools** soon enough and made a big mistake in business. In the heat of the moment, I terminated a very good employee. I was stressed, he did something very unwise, costly to the business. He had been with me a fair amount of time and was generally wiser than he was this particular day. My upset motivated me to respond poorly and rashly and he was gone. The cause and effect? Not knowing then about the *Take 5!* had a long-term negative impact on me and my business. I had not yet learned how to fix those situations, so I did not know how to fix that mistake yet. As an experienced and successful businesswoman, I rely to this day on my *Take 5!* I use it often.

Lily

Let me tell you about my colleague, Lily. Lily was a business development professional who made a visit to a very lucrative prospect. She was told, on the spot, that they had chosen someone else to handle the account. Recognize that Lily had put weeks of work into developing this account and creating a detailed presentation. She had no warning of anyone else in consideration and did not even get the opportunity to make the presentation on behalf of her company. She drove 45 minutes, left a desk piled with work she had to tend to upon her return, and ran into a door basically being slammed in her face. Without any consideration, she was simply advised they had selected someone else already and shown to the door.

Lily, *without* the **Power Tool of Control,** would have been less than pleasant. She may have told them how inconvenienced she was, how annoyed, and, I suspect, not in a gentle voice either.

Lily had already learned about her **Power Tools** though, and as she stood at the exit door, turned and controlled her response and thanked them for the opportunity while reminding them she was available any time to come back and make a full presentation. She continued smiling, controlling all that negative energy, and she left graciously.

Thanks to the **Power Tool of Control** and her behavior, three weeks later the prospect invited Lily back to make the presentation after something went wrong with choice # 1. She got the account. This never would have happened if Lily had not controlled her response. Through this action, this **Power Tool of Control**, she was earning accolades from her boss and positioned herself for upward mobility and got a nice bonus as well.

Let's imagine you are being asked the impossible at work, perhaps a deadline that is not realistic and with no help. In complete frustration, you want to throw the papers across the room. But you won't because you are in control. You reach for the **Power Tool of Control** and you will go into your supervisor's office and say, "I am concerned about this deadline being achieved and wonder if you could help me with a plan to make sure we have the resources to accomplish it." And then gently push for advice, resolution, acknowledgment that something else needs to happen. Professional demeanor, concern about the project and its successful completion, not whining about yourself or being overworked; this recommended type of behavior raises the level of respect you will gain.

No, With a Comma

Another method that helped me achieve at above average levels was learning how to manage my life better when faced with

using the word NO. I was often hesitant to say no to a request. I wanted to be liked and not disappoint others. The desire for popularity birthed in school, often follows us into the workplace. So instead of tossing out the no, I disappointed myself by being over extended or stressed from a chore or burden I really did not need to take on.

My own goals were being circumvented because I was afraid, sadly insecure and unable to say no. Are you reluctant to say the word no? See it as a rejection or a veto, rebuff, refusal, nixing someone's idea or request? Afraid they won't like you anymore or actually dislike you and stand in the way of your own goals? But doesn't the word "no" help you control the impact people or situations have on your life? Yet, with all those synonyms, we all understand why we may be reluctant to simply say no sometimes. I was this way until I learned how to say no graciously, retaining good will and respect.

What happens when you are on a tight time frame for a project and someone asks you to help them with a project of theirs? I was rather efficient in my duties, so that happened way too often. Or a co-worker asks for a ride to pick up her car from the garage, yet you are supposed to leave a bit early and take your son to soccer practice? Or you need to drop off clothes at the cleaners which closes in an hour (really need them back in a quick turnaround for your important job interview) and PTO (Parent Teacher Organization) is asking you to drop off three extra cakes because a few people bailed and the time crunch may interfere with your ability to get to the job interview on time.

Increasing challenges simply because you could not, were afraid to, were reluctant to, simply say NO and remain focused on your circle of greatest priority at that moment.

You will not be able to achieve your goals unless you learn how to say no, kindly, gently, yet effectively without risk of ruining a relationship or being viewed as not helpful or not a team player.

Allow me to show you examples of how you can take control of situations by learning how to say *No, with a Comma*.

No (here comes the comma).

> No (Insert the Comma) I cannot take you to get your car. I am so sorry, but I must pick up my son for soccer.

> No (Insert the Comma) I cannot help on your project; unfortunately, I have a very tight deadline and am behind. I am so sorry.

> No (Insert the Comma) I am sorry other people let you down, but I have an important meeting and must be on time.

> No (Insert the Comma) I can't cover for you on Thursday, I have something important to do.

In each instance, you have taken control with little impact, if any, on your relationships whether personal or at work because you were simply not the voice of rejection or your actions were not seen as a rebuff. Rather, you took a few minutes and used the Comma to explain why.

It is up to you to take control and set boundaries; to use a gentle *NO, with a comma*. By doing this, you will avoid so many days when your life could spiral out of control, taking you away from your efforts to achieve or realize a particular goal, because you were afraid to face the disappointment of others.

Muster courage take control and start saying no, (with a comma) and free yourself from demands or requests that you really don't want to accept. Be gentle, use that comma and maintain control of your life.

Remember: It's all up to YOU.

YOU control your thoughts, behavior, and responses.

Jess and Lack of Control

I have served as chairperson of a board of directors for a large health-care system employing thousands. I had the opportunity to observe some very talented employees and there is a case I wish to share with you, a sad example of someone who has not yet learned how to be in control. Jess (not her real name) was a good nurse; caring and sensitive with the patients.

But when a new procedure was introduced, Jess became a warrior, out of control, resisting the change. Her negativity would drip all over and she would make everyone's life miserable. These new procedures were often new mandatory regulations adopted by the state or federal governments. Sometimes these procedures streamlined methods to provide even better care, which could enhance her level of care. Yet she resisted and complained constantly about the changes and was out of control. She never achieved recognition for her excellent nursing care because it was overshadowed by her poor performance in the area of professional control. Out of control meant out of consideration for a promotion or positive recognition. Our organization recognized her problem and assigned her a "coach" and developed focused training for her. I hope it works. Lack of an ability to control her reactions, all were negatively impacted by her lack of control.

Unless you are the top player at work, you probably must report to someone – a supervisor or boss. When you have respect for that person, their directives are more than likely accepted. However, when you report to someone who you do not respect or whose philosophies are quite different from yours, you may want to resist. Those are the times when you must exercise high levels of control, so that you clearly think it over. Is this the time to resist, are your objections truly valid on behalf of the organization or are they personal or spurred by some other motive? In order to advance my professional progress, I had to accept directives or fulfill an assignment that I did not agree with or did not want to do. However, with my eye always on my personal goals, I did what I was told to do as long as it was not something I thought detrimental to the company or organization. That decision to control my actions was not based on fear but rather clear vision of where I needed to go and how I could best help the company I was affiliated with. I was not going to let that one person stop my progress by reporting me as uncooperative or a problem employee.

I promise you, if you begin to control the small things, like the car problem, or the juice spilled on the rug, you will be calmer and then more in control of all aspects of your life. You will be able to take charge when your circles are whirling around, one the size of a bowling ball and the other two small tennis balls, and you will rein them in to more realistic proportions.

EMOTION AND ENERGY

Emotions can govern how you act, your choices regarding your friends, mate, and how far you go with your life. Emotions will have an enormous impact on how successful you will be. Think about this, when someone is described as emotional, it is not

usually a compliment, is it? We want to keep our emotions in check, under control, yet be in touch with them ourselves.

Whenever we have a situation where we have allowed our emotions, usually the negative ones, to rule because we lack control and we behaved in a way that fails to live up to our own personal standards, the result is a feeling of shame or at the very least, embarrassment. You can learn the management of unwelcomed emotion and how to cope with emotional upheaval. You don't have to be a victim of your emotions. Once you truly understand the impact of your emotions I am convinced you will want to be more in control of them.

POSITIVE EMOTIONS ENERGIZE YOU AND NEGATIVE EMOTIONS DRAIN YOU

Donna Cornell is highly emotional. Doesn't sound too flattering does it? But it could be. Let me talk to you a bit more about this topic of emotion. Ah, the joy and exhilaration of good news converted into positive emotion. The pregnancy stick says yes or conversely says no. Good news: your promotion came through, and all of a sudden you are filled with positive emotion, positive energy and quickly get your old desk cleared for the newbie who is taking over your old job for you.

That's how you should live every day... energized by positive emotion... lots of energy. But often we allow the negative emotion to rule. How often have you felt tapped out after a bad argument or exhausted because fear and worry sapped your energy? How about these examples:

- **Guilt:** You didn't finish the laundry because you had to take your aunt to the doctor, or the other situation where you forgot you were supposed to take her to the doctor.

- **Stress** (caused by negative emotion): You had to work late so you couldn't keep your date and you're filled with annoyance at your boss, and add more stress when you think about your date — is he annoyed?

- **Anger:** It's 5 p.m., how dare he still be upset with you because of what happened this morning?

- **Panic:** You have that important meeting tomorrow and you are unsure of what to do, what to say or how to act.

- **Jealousy: You just could not help it.** Need I say more?

Your mind and body are agitated to the point of immobility because you are so angry, furious or plotting revenge; filled with negative emotions, wasting your precious energy. Let me say it again: What I learned during my journey is that: Negative emotions drain you, while positive emotions energize you.

With the wisdom I have now, I realize that my identity, my self-image was damaged during the most formative adolescent years of my life. The disfigurement of the acid accident, being called names, thinking I was the ugliest child on the planet really hurt me. Then the day my mother died, my life underwent dramatic change — forever. This is where the pain really was accentuated. I carried the "negatives" of my childhood experiences into every new year of my life.

I have observed that many of us do that: we carry the negative emotions resulting from our bad experiences throughout all of our lives. We lug them with us sometimes right into our grave, wasting the energy needed to reach our goals, be a success, create loving relationships, and build our dream life. What about you? Are you lugging around old emotion from a hurt inflicted upon you when you were 10? 16? 2 years ago? In order to get where I am today, I had to put down the baggage filled

with old experiences, old negative emotion and accept the past. As it was *The Past.*

We can learn from our past, but we cannot change it. But by changing our own behaviors, we can change and create our future to be one we want.

There are these examples of Positive emotions: **Joy, gratitude, hope, pride, love, awe, inspiration and so many more.** Think for a moment about when you last felt one of these emotions. The memory should bring about a smile and a positive feeling that engulfs you.

- **Joy:** The birth of a baby, the new house.
- **Inspired:** Watching graduation day for your sister, or your friend.
- **Gratitude:** For the kindness you were shown at a time of need.
- **Inspiration:** Watching your co-worker complete the marathon.
- **Love:** love is one of the most energizing emotions.... to receive and to give.
- **Pride:** Career recognition, job well done.

If negative energy is baggage you carry with you, then positive energy can be a multiplier that brings you rewards and joys for years to come. Here is a bit of what I experienced that brought me this knowledge.

During my career as a recruiter, I helped companies find good talent and, in reverse, helped individuals find rewarding careers. Each "placement" as we called it in our industry,

brought me much joy, positive emotion, and of course financial benefits. And the good feelings continued.

As the years passed, I learned about the multiple effect of positive emotion and it was fabulous. I watched individuals I had helped secure that new job move forward and achieve progressive levels of advancement, move to the highest levels in their company. I watched companies prosper because they had the talent to do so and the pride I felt was so strong because I had a hand in joining the two together. Years of positive emotion from one business transaction provided a multiplier effect of positive emotions of pride and joy going forward.

Have you ever known someone who, for some reason, brings out the worst in you? We tend to call it bad chemistry. For some reason, your emotional response is a negative one and your responses may even have a hostile overtone to them.

Conversely, have you ever known someone who brings out the best in you? Your emotional response is generally positive, bringing a smile to your face when you see them. In those situations, as with so many, the responses are automatic. It is my belief that you simply must accept the bad chemistry issue and embrace the positive energy relationships with glee.

What I want is for you to embrace these tools to monitor your potentially automatic responses and create the response that is targeted to, or compatible with, your ultimate goals.

VAMPIRES

"The oldest and strongest emotion of mankind is fear, and the oldest and strongest kind of fear is fear of the unknown."

— H. P. Lovecraft

Except for Edward Cullen of the *Twilight* series, a vampire has been defined through the ages as a demon that nightly preys upon its victims to suck the blood from the living. A woman's vampire dwells within her and drains her of self-esteem. We each have our own personal vampire; a demon that makes us struggle with self-esteem and sucks the very life out of us.

Did you know that often your fear is an illusion, a distortion of reality, and most fears are about a future event and most fears never materialize?

It took me years to understand that who we are and what we become evolves from both our successes and our failures. Today I get it; how the losses of my youth stunted my emotional growth. At that time, when youth and innocence were on my side, I never learned the basics of developing healthy relationships and never developed into a fully confident woman. I had a women's body and a teenager's lack of self-esteem.

Because the scars on my legs from the acid accident remain very visible, to this day, I cannot wear the cute LBD, little black dress, without very dark nylons. I could never wear shorts in public. I had a horrible fear of rejection, ridicule or just being different. But those scars also remind me of what I am capable of enduring. Instead of dwelling on the physical scars, I now choose to focus on what I have achieved despite them. I reflect upon the strength of that 14-year-old girl who endured and survived. I think about the woman I have become and not old fears.

Unfortunately, I have found that many people let fear rule them; fear of being laughed at, fear of being inadequate, even sometimes fear of success. These people live passively... limiting their life to areas they know. They may be afraid of change

or of making a better life because they don't feel prepared to handle the changes. They feel out of control.

Look at all of the excuses you use for not moving forward to change your life; both the excuses you use with yourself and others and see them for what they are; offshoots of a deep-seated fear of the unknown. A big step is to recognize and name the fear — get to know it — and then you can meet it head-on. When dealing with fear, you have to admit that it often controls your actions. If you don't acknowledge this as a fact, you may not be able to move past it.

Who hasn't felt a fear of being embarrassed by their actions, of doing something "stupid" in front of others? But how many times have your fears stopped you from doing something, that, in retrospect, would have been a good step for you? How many times has your fear of failure gotten in the way of forward moving steps taking you closer to the life you really want?

I sincerely believe that in order to conquer fears, it is important to figure out what's keeping you so frozen. What's the fear? Name it. Think! What stops you from taking the next steps to bring change into your life? And the next thing to explore is to determine what you do, what are your actions when you feel vulnerable. What is your armor? Do you protect yourself by being a cynic and overly critical of others? Or, is your armor that you protect yourself by isolating yourself? Are you afraid to tackle something new because you are constantly "*striving for perfection?*" Or do you simply stay static, doing the same thing over and over, not trying anything new because the Vampire of Fear is hovering over your life? Only you will have these answers. And when you have your answers and identify your fears, you are gaining abilities and strength to control

and silence them, so they don't interfere with, or stop you from getting the life you want.

HOW OTHERS SEE YOU

While I advise you to not make your decisions based upon what you think someone else may think of you, I also acknowledge that there are times when someone's opinion of you does matter. In those instances, if you want to change the perception, you can begin with your **Power Tool of Control**. As I told you earlier, you do not need anyone's approval to enjoy a full and rich life. Why does it feel good when those closest to us approve of us? Often, we see that as an affirmation of their acceptance of us. Acceptance by others is a nice feeling, I agree. That is why we often worry, perhaps excessively, about how others see us. In the world of work, business, community interactions, how others see you can impact the results you achieve. In those instances, you may want to be the author of how others see you.

Creating Your Image

It is possible to create your image and how you are viewed by others. I developed a simple method to help me create, along with control, how others see me. So can you, but you first need a plan. Take a piece of paper, and a pencil or pen, and make a list of how you wish others would think of you. Make two separate lists. One for those closest to you, your loved ones and friends. The other list is for your work environment, those with whom you interact at your paying or volunteer job. Think. What do you want others to say about you? How do you want others to describe you?

Maybe you want to be described as kind or generous or witty or friendly or smart — maybe it's fun or creative or "a great

friend." At work, do you want to be known as a team player, the person who can be counted on, the smartest one in the place? The most loyal one? The one with the most promise? Write down whatever and however you want people to think of you.

For some women, this creates a difficult exercise because they just don't seem to take the time to think about these things, and yet, these issues are far more important than decisions about what to wear to that upcoming wedding. We put so much time into those things, don't we? If you want a better life, more success, more happiness, more peace, then you must take the time to do tasks that can truly change your life. So, don't rush through this exercise.

On my list, I wrote that I wanted others to see me as caring. So, I had to be caring. I created the image, through actual actions of being a caring person. I wrote that I wanted others to see me as patient, so I used control to hold back a response of annoyance and become more patient. I wanted others to describe me as intelligent, so I further improved my vocabulary and knowledge base by doing some research before I went to a meeting, listened and learned, and gained knowledge. I listened to audio to improve my vocabulary. I read books that would increase my knowledge. As I improved others' view of me, I was also improving my self-image.

On my list, I stated I wanted others to look up to me; to gain their respect.

I wrote that I wanted to lead change within several community organizations. Through my accomplishments, I gained recognition for being a person who could make things happen, who could achieve results. Time and again I was asked to be part of organizations undergoing change and that allowed me the

opportunity to bring about strong, positive transitions in those organizations. I earned the right to have others look up to me. I created, through multiple avenues, an image of success based on real successes which generated the respect that I wanted.

If you use control and respond gently when faced with challenging situations, others will see you as gentle. Respond kindly rather than being mean, and you'll be described as kind. Find out the real details of a situation before you shoot off a response, and others will see you as smart and informed and in control.

Faced with a tough situation? Control your response during a difficult situation, and others will describe you as "composed." Control your response and don't get crazy when things go wrong, and others will describe you as "stable."

Being known as someone in control in your work environment is critical if you want to advance your career. I often say that, as a business leader or manager of a department or project, large group or small, we are not allowed to drip with emotion when things go wrong. Our role is to identify the problem, the solution and ensure the implementation. We can guide it all, by being in control of ourselves.

If you learn how to control your responses to the smaller issues in life — the everyday little bumps in the road we all encounter, then you will be fine-tuning the **Power Tool of Control** for use when major issues arise, like the day your boss tells you the company is going under.

Your first reaction in a situation like that might be to panic and drip emotion all over the place: "Oh my gosh, I am going to be out of a job. How will I pay my bills — what will I do?"

Screaming your panic at your boss will not help or change the situation, though. You need to react calmly, with confidence, even if you feel deep internal concerns. You may need an important reference from this boss. Someone else in the company may notice your reaction and think, "That's the kind of person I'd like to have on my team" when he or she starts his or her own business or thinks about you transferring to her department. You never know. Plus, if you react calmly and look at the situation with control, you will be more able to see possible solutions and new avenues to explore without the cloud of emotion.

Although control is important in the **Work Circle** and the **Self Circle**, we cannot forget relationships which many times deserve the maximum use of our control. If we lose control at work too often, we may soon be out of work or owe a string of apologies. Or continue to stymie our personal growth. If we lose control in any of the circles, our **Self Circle** suffers, as does our self-respect and self-image as a mature person. Yet, the **Relationship Circle** (remember it is inter-linked, interwoven with our Work and Self-circles) is the place where control is so important. Your relationships, especially those with family members, will be part of your life for a very long time. If you lack control when something goes awry in the **Relationship Circle**, then the impact on a relationship can last for a long time.

This is ironic, because our **Relationship Circle** is a place where most of us want to relax and bask in the good feelings associated with the people we love. Yet, strife, and disappointment, enter this circle often because of our own actions if we lack control. Control may count the most in this circle because the relationships matter so much. I hope that by using my

Power Tool of Control, I have become a better parent, a better mate, and a better friend.

When I started my business and suddenly began attending Chamber of Commerce meetings and business meetings, filled mostly with already successful people, control helped me keep my mouth shut when I needed to. Control helped me focus on completing my work when enticed by a mood to goof off. Supported by the **Power Tool of Control**, I gained the regard of the business community, which in turn helped me build my business and become more successful, gaining respect and financial rewards. By applying *Take 5!,* I could avoid confrontations and achieve the goal I wanted instead of wasting energy on a conflict.

Your **Power Tool of Control** generates the *intermission* you may need during a difficult situation. *Take 5!* Pause, breathe, go for a walk. Get a cup of coffee or use the exercise machine or take the elevator to a different floor. Seriously. If it is a treasured personal relationship at risk, go take a shower or read a book, or turn on your favorite music. If it is a work relationship, work on another piece of business to get your mind off the immediate situation for a while and go back to it when you have more self-control. Consider your response, develop a *measured* response. You can even tell someone, "I'd like a little time to think about this before I respond."

That is using your **Power Tool of Control**. It is all up to you... you hold the power to control so many aspects of your life in your hands.

How Others See You: Social Media and Your Image

Social Media — that world of community-based input, one-on-one or group interaction, networking, content-sharing sites. Yet

another place where control is vitally important. I have read some things online that have caused me to blanch at the ugliness or inappropriateness of the posting. I wish the person who initially posted it had learned the **Power Tool of Control** before hitting that post button.

Basic common sense: Think before you post. I assume you have heard this advice already, but I cite it again because I have seen the damage that an inappropriate post can do to someone considering a new job and being rejected for the interview, or skipped over by the Perfect Partner who found a profile on a dating site with very inappropriate tags or posts. All you have to do is listen to the news and see how these social media accounts have brought down important and prominent people. Careers plummeted. Emails from yesteryear destroying families today. No one is immune. Going job hunting? Clean out those social media accounts of anything distasteful. Being considered for an important community role? Take a look again at your social media accounts and control what people will see. Single and dating? Review your accounts and the accounts of your friends. Text and photos!

Control the urge to participate in heated political conversations; control the urge to post an ugly or truly negative reply on someone else's post. The Internet is forever. Same issue with emails. Forever. Control what you say and how you say it in person, at the computer or on your cell phone.

The Power Tool of Choice

"The first step toward change is awareness.
The second step is acceptance."

— **Nathaniel Branden**

In this section of the book I am going to share how Ilearned to make better choices. The choices you make on a day to day basis, as well as long term life choices can trip, you up on your journey to success or move boulders out of the way.

Acceptance of Self

By ditching the **Life-Balance Hoax**, I hope that you have come to realize that you shouldn't set unrealistic expectations of yourself, thinking you can be all things to all people or live that perfectly balanced life. Perhaps, just like me, you make mistakes and you have shortcomings. Let me share with you how Choice helped me improve my life and take it to remarkable levels.

From the time I was very small I loved the news. I wanted to be a journalist and work in Washington D.C., reporting on the exciting international news scene. You know my story and why that did not become a reality. However, I made a fabulous life for myself in a different career, and created a life filled with peace and love too. I accepted the fact that international journalism was not a viable career option and that I needed to find a different career. Instead of focusing on what I did not have or what I was denied, I had to accept the situation. I tried to focus on where I could go with the talents and education I did have. Yes, I had other choices, fewer than I thought while growing up, but somewhere, somehow, I would be able to find a job and earn some money. My choice was which, where, how. And the

first choice was to accept myself for who I was, acknowledging that there was room for improvement and accepting the fact that I was going to take some life-changing steps to a better life.

We need to explore what parts of ourselves are good and what parts we may want to improve. We must stop judging ourselves for every action or response we take. I am, as you have learned, a real advocate for self-improvement and the positive impact on all parts of your life it can generate. However, if you are constantly dissatisfied with yourself, you won't be able to embrace all the positive advice in this book. If you constantly badger yourself with thoughts that you are not *good enough or nice enough* or *successful enough,* those thoughts become very weighty. Then you will be unable to lift the bar even a little bit to reach out and grab these tools which can improve your life.

One of the hardest things for me to learn in life was simply to accept myself. Often, I would drive myself too hard, set unrealistic standards. As I have shared, I have never been the weight I wanted to be; I am tall and found that a very undesirable feature of my physical self. I could go on and on listing my physical flaws but there were other areas of defect. Was I smart enough? I did not get to go to college, so I always felt terribly inferior when it came to discuss classic literature or my favorite college professor. I never felt smart enough. I read a great deal, and learned much, but never gained that college degree. Honestly, my **Self Circle** was so filled with a focus on my defects, and my shortcomings, that it was often the biggest circle stopping any progress. It limited my ability to effectively apply myself in my other circles. Self-criticism and disappointment in who I was often far outweighed my self-acceptance. A big movement forward to overcoming that neurosis came when I accepted the fact that it was **The Hoax** and I could

truly never achieve balance. I wasn't a failure because I did not live the perfectly balanced life, so I began to take the steps to embrace *acceptance* of me, Donna. With self-acceptance, I went through all the steps and advice in earlier chapters and was able to establish my own goals, larger goals and then apply myself to achieve them.

Now is the time for you to do so also. Embrace this concept of Acceptance! Accept who you are and realize you have the tools to make the visions dancing in your head a reality. Accept that you cannot be, nor should you choose to be, all things to all people. You choose not to strive for a level of perfection that is simply not possible. You choose to accept yourself, improve the you that you are today, reach higher than you have reached before, and therefore be able to attain your realistic goals.

ACCEPTANCE OF OTHERS

We judge, we critique, we criticize, often concluding that person X in our life does not measure up. These unreasonable expectations can put too much pressure in your **Relationship Circle**, causing it to grow to enormous disproportionate size.

I made mistakes. Some were larger and had more far-reaching consequences than others. I have concluded that most of our blunders in life are simply because we are human: limited, vulnerable, sensitive, and prone to trying too hard, sometimes in the wrong ways. I had to learn to accept being human and accept my Human Errors, learning from them to avoid them in the future, yet accepting my imperfections. And after acceptance was the step to go forward and learn how to accept others, who like you and me, are limited people striving to do the best that they can with the means that they have available

to them. People need to be allowed to find their own way, by their own lights.

Acceptance of others does not mean that you are waiving your rights to an opinion or having a voice. Accepting others does not mean agreeing with them or their behaviors or beliefs. Rather it means you accept that those are their beliefs without judgment. It is difficult to know what is going on in someone else's life, so don't try to judge others.

It is particularly important to not judge others for their political opinions, race, cultural beliefs, religion, ethnicity, sexual preference, etc. Try not to get annoyed at the coworker who is loud or annoys you in some other way. I had to share a workspace with someone who constantly slurped her sodas, very loudly, all day. But she was kind and considerate and loyal and did her fair share of the work assigned. And she once covered for me when I was out sick, too. Tolerance earned me a work friend.

Every individual is very different. My niece just had twin boys. Cutest and most energetic kids ever. One is shy, cries at a loud noise, and the other one bangs and yells and makes the loudest of noises ever. Same womb... different children.

Life changes constantly and so do our own needs and our relationships with others. Often, when we judge critically, we sentence that person to an identity that may not be who they are at all and we may miss out on a potentially promising relationship.

Have you ever thought that a person was haughty and aloof only to find out they were shy? Have you ever ignored the new person in the community because of how they looked or

dressed only to find out a year later that they were totally in sync with you regarding the proposed library for your community? And fun. And you lost a year of friendship.

I attended a major fund-raising cocktail party at a very posh country club where all the people in attendance were dressed up, many in the latest fashions. Into this event walks a gal with hair in disarray, in a wrinkled dress, scuffed shoes, and frankly appearing out of place. I thought to myself "who is this mess at this significant event?" (Yes, I was being terribly judgmental.) While we stood together in line at the large buffet table with the most amazing display of foods, we began chatting. I found out she was the new doctor in town who had just had an emergency room patient. Yet she wanted to come to support the fund-raising effort. Thus, she did not have a great deal of time to "fluff and buff" as I call it when getting ready for a big event. During our conversation we realized we shared a mutual interest in health care for the future and especially seniors. I am most embarrassed to tell you that I could have missed out on this most interesting new friend with my initial judgments. That is a clear example of learning that stereotyping is lazy and ignores the human potential and robs you of many potentially stimulating relationships.

Choosing to accept others as they are can allow you to enjoy those in your life as they are. And it may be that you will benefit greatly from those slow-starting relationships in unexpected ways.

Accept others for who they are; take the good with the bad. Put forth your efforts to be sure you're getting more good than bad but remember that you will be continually disappointed if the standards you set for others (or yourself) are nothing short of perfection. You'll begin to appreciate people a whole lot more

once you begin to *Accept*. People can be great even though they may be imperfect. The people in your life can be great friends, great spouses, great co-workers. There are great neighbors, and even great in-laws. And even if they are not "great," they are part of your life and, for you to live it peacefully, the message again is: Acceptance.

This "acceptance of others" in your work environment may be one of the biggest challenges you face. What to do about the coworker who is basically lazy? Or the one who is just not up to the job? Or the one who simply aggravates you? If they do not have a direct impact on you doing your job well, then you can simply ignore them. Accept them for who they are.

If, however, they interfere with your ability to do your job well, then you must use the tools you are learning in this book to change the situation. You will choose when you need to take control of that type of situation and change it so that it no longer has a potentially negative impact on you and your job.

Your **Relationship Circle** is going to be filled with the wonderful neighbor, the not-so-nice person across the street too; with the smiling clerk at the grocery store comes the grouchy guy at the gas station. Those are sometimes easier to accept than the spouse who is always tired or the brother who wants to borrow money again, or the aunt who always needs a last-minute item from the store. Acceptance: your spouse works hard, maybe things at work are not going well and he is depressed or worried. Acceptance: yes, your brother borrows money but always pays you back. He needs coaching in money management, but does that mean you don't love him, and he doesn't love you? Acceptance: the aunt simply does not plan, maybe she is old or forgetful or simply not a great planner. But

she does bring you and your family joy. Acceptance. Tolerance, Forgiveness.

My book includes this section because I learned that acceptance is so critical to living well. If your relationships are fraught with disappointment, then your relationships will be distressed, and you are more than likely going to allow your **Relationship Circle** to evolve into a large balloon that can POP at any moment causing total mayhem. When that happens, it can then interfere with your true-life goals. Instead, let acceptance and tolerance minimize those instances which may have started because of you and your own responses.

CREATING THE ALBUM OF YOUR LIFE

I would like to share with you a technique I adopted to attain higher levels of peace in my life.

Can someone choose to be happy? Sure, some of us naturally have a very positive attitude, the "glass is always half-full rather than half-empty" and that can ease some of the pain we encounter. Happiness is a complicated topic, but certainly we can choose how we view our own life.

I believe we do have a role in creating our own happy life beyond that of the physical accoutrements. We can choose to focus our energies on the happiest parts. I was involved in making a 30-minute infomercial for my women's empowerment product. We filmed for two full days. Two days to make 30 minutes of material. The ultimate authority on the final product was from the editor. Extensive editing; creating the best visual product. Did you know that in order to make a 2-hour movie the people involved often film for months? Why? They are choosing the very best parts of what they filmed and

editing out those that are not up to par. The value is in the best parts of the film. They spend a great deal of time editing out the parts that just weren't right. I believe you can do that as well in your life.

When you go on vacation, do you usually take a lot of pictures? Some photos turn out great; others are too light, too far away, they are blurred, et cetera. If you are like most people, you discard the bad photos and keep the good ones so you can savor the memories — the good memories.

I learned how to make a real difference in my ability to master the proportions of my circles, to be the master of my unbalanced life. So, let me teach you to use your **Power Tool of Choice** to remember only the best memories.

After three decades of marriage, I can tell you that few long-term relationships go smoothly all the time. Yes, my mental photo album has joyous times recorded. But in the interests of full disclosure, I honestly admit there have also been some very difficult days and weeks. One seemingly small item almost disrupted my joy in marriage for a long time.

Like most women, I am a romantic. All the forgotten anniversaries — not one, but *several* — hurt me. I used to wonder how Jeff could forget even to get a card. Then I realized I had to consider the other 364 days of the year when he is there for me, being loving and caring. How about the days he helped with the dishes and the groceries? What about the days he attended the kids' baseball games in the rain, the days when he gave me a card, just because? What about the time Ryan was sick and Jeff jumped in and took over all aspects of the home and our other children? I plucked out the photo of him forgetting to

get me an anniversary card. I don't need that among my many good memories of our marriage.

Instead, I keep a mental photo of Jeff the time I cried with joy as he danced with my daughter, Erica, at her wedding. I remember his face glowing with love for her. I keep a mental photo of the time he filled our house with roses from the garden we had planted together. *Every relationship is fraught with challenges, serious and petty. Why focus on those?*

If you truly want strong, long-enduring relationships, both platonic and romantic, then you must let go of anger, resentment, and unreasonable expectations. The dynamics of our family relationships are often the most challenging. Our memories of our parents, our brothers or sisters can be cherished or cause angst. You are in control of the memories you accumulate. Choose to look at the beautiful ones and you will create a happier life. And you will attain a mental freedom that allows you to focus instead on the future. Your future.

This same technique applies to your professional work life as well. My corporate board room has always been filled with plaques and awards my company has received as well as magazine covers and articles where I am featured. A wall of accolades. I chose to put them there, not necessarily because of ego, yet I admit it feels good to look at that wall.

I did not want to focus on recalling times when I felt my business was "on the ropes," all negative experiences that were overcome so finally I was able to achieve the goals I wanted. You can choose to remember the negative work experience, the lousy boss, or the sabotaging coworker, or you can choose to create a professional mental or physical album of your life

including all the good experiences, the copy of the check with the raise in it, the great coworkers, supportive bosses.

By using this approach of an album of good experiences you keep the door open, actually your mind open, to new experiences, ongoing progress of your professional life. You will not have that closed mind that stops so many women from moving to the next step of happiness and success. Your good memories become a solid foundation upon which to continue building.

STOP, THINK, CHOOSE

My advice is to use your **Power Tool of Choice** to make the wisest choices. But it took me a long time learn How to do just that. Before I learned how to make good decisions, I would tend to second and third guess myself constantly, never sure of the decision I had made. Often, it was because I made most of them impulsively without using the information I am sharing in this section.

For you to be in command of your life, you need to master an important skill — *Decision Making.*

I told you about a few of my wrong decisions and there were many more. When I made these wrong choices, the result could be a minor blip in one of the circles of my life, or it could have a very dramatic impact that disrupted my entire life. When I rushed and made the wrong choice, the clean-up to fix things often consumed me for weeks on end. After one mistake and then another, finally I realized that in order to improve my life, I had to do things differently. Gaining wisdom, I accepted that my life would never be in perfect balance. Acknowledging that allowed me to grab onto the tools in this book and gain

the strength to push back and create a life more in line with my ultimate goals.

Do you remember the jingle we learned as children, to apply when crossing railroad tracks or the street filled with cars? "Stop, Look, and Listen?" Well, I changed that a little bit to remind myself how to make good choices: "Stop, Think and Choose"

It is easy to remember.

- **Stop**
- **Think**
- **Choose**

Here's my "how to" in three easy steps:

THREE EASY STEPS TO GOOD DECISION-MAKING

Step 1: STOP — Refuse to decide until you have taken the next two steps. Things will wait. I don't let anybody push me into a decision until I am ready to make it. Too often, I responded to people pushing to decide right away, only to later realize that I had not made the best decision. There were unexpected ramifications I had not thought of in my rush to choose. Most things can wait. You owe it to yourself and your loved ones to take the time to make the best decisions.

Step 2: THINK — Make sure you take some quiet time — that means alone, without answering the phone, texting, and usually without music or TV blaring — to really analyze the options before you.

Think: What is the choice to be made? What are the possible results? Are there other options? What are they? How will it impact you today? Tomorrow? Write it down, draw a simple line down the middle of the paper. On one side record the pluses of making the choice you have targeted as the possible right one and on the other side list the minuses.

Another way to say this is to consider the pros and the cons of whatever decision you must make. Perhaps you are thinking that this is too cumbersome an exercise for every decision. Perhaps you are right. But you know, in your heart, which issues are going to have a significant impact on your life and those are the ones that require these 3 steps.

Have you ever made a decision based on the desire for revenge or jealousy? Ah, an emotional decision. I'll bet that was probably not the best decision for you long-term. Have you ever hung up on someone abruptly because they made you angry? What happens when you slam down that phone? Well, you could be on track to terminate the relationship. I have known cases where people don't reconnect for a long time after an angry phone hang-up. Is that really what you wanted?

What about women who, because of love for a friend, have found themselves caught up in a mess? A client of mine took up her best girlfriend's cause against that friend's husband. The girlfriend and her husband were fighting, to the point of a pending separation. Accusations had been flying for weeks. It was a real mess. My client chose to become an advocate for her girlfriend. She publicly and harshly criticized the husband. Can you guess the end of this story? The couple made up. They got back together, but my client was on the outs with the husband. He would never forget what she said, and her over-involvement

in that bad time reminded the couple of a time they'd rather forget.

I have provided a personal example here, but this same advice applies to your work life. I had a business friend who, in support of his business associate, joined the bandwagon of negative reviews and comments about a regional business. It went on for a long time, but eventually his business associate and the regional business mended their issue. Great, right? But then my business friend had to scramble to retain or actually regain a professional mutually respected relationship with each of them. He placed himself and his career in jeopardy by getting involved when he did not have to be. He did not stop, think, and choose his actions intentionally. He acted impulsively. Now he needs to rebuild with both parties.

The life skills advice that I am providing is to be applied to your relationships, both personal and professional. These are the kinds of things that happen when we make choices out of emotion or passion. Instead, tread carefully, make carefully thought-out choices.

Step 3: CHOOSE — Make the decision and implement it. Don't waver or change it unless you go through this 3-Step process again. If you have taken the time to do the first two steps properly, then Step #3 should be easy. If it isn't, then go back to Step #1. Yes, it is as simple as 1, 2, 3, but so often we make extremely important decisions on the fly... don't even pause.

OVERTURNING A DECISION

Watching the presidential election of 2000, and all the legal cases on popular television shows, many women have learned

about court decisions and overturning those decisions. Our interest in the mechanics of the legal system has spawned a myriad of TV judges, although, because I am married to a retired judge, I can attest to the fact that often their conduct on the TV show is truly entertainment and not the way the judicial system REALLY works. Today's media makes many of us more aware of the steps in the judicial system that bring a case to trial, of decisions, appeals, and the overturning of decisions. My dear reader, you have the same power over your life. You are the judge and the jury.

Sometimes a decision you have made needs to be "stayed" or "overturned."

Can you do it? I did.

I had developed strong enough clerical skills to go from data entry clerk to secretary and then forged my way into the legal field, where with great pride I became a legal secretary. There came a time while working as a legal secretary that I was overwhelmed by the workload. I didn't know how to communicate well back then, and I let my emotions dominate my responses. One day I blew up because I was overworked, burned out and tired, and I just quit. Although I quickly found another job at a nice law firm, it was really very different from the other office. I was not comfortable there; it was not a good fit for me in a myriad of ways.

I realized I had made a bad choice by quitting my other job. I had left a job I really liked because of a temporary overburdening with the volume of work. I felt foolish. I struggled for about a month with this bad decision. What should I do? Quit this new job and go searching for another? I mulled this over for a few weeks and then it dawned on me that I still had the

ability to choose. I did my 3 steps. Stopped what I was doing, took some private time to think, and the decision I made was to reach out to my prior employer and talk the whole situation over.

I admitted that leaving had been a mistake. I calmly explained that the workload had just become overwhelming. With relief, I discovered they wanted me back as much as I wanted to come back. I was rehired and returned to my old desk. Interestingly enough, because it was now a well-thought-out, carefully considered choice, my perspective on the entire work situation improved.

Whenever there were again days filled with a massive workload, I did not feel any resentment or that old familiar knot in my stomach. I said to myself, "I chose to work here. I chose to be in a job that has some days when I'm just overwhelmed with work." Or conversely, I approached my boss and explained that the volume was getting out of control. Because they wanted me there, we would find solutions. Together. Sometimes, when you think you have made a bad decision, revisit it. Don't be embarrassed; don't let false pride or ego get in the way. Be your own judge and reverse the decision.

Here is a small word of caution. When I finally realized that I should not have divorced my second husband, there was a little problem with reversing that decision. He now had another wife. I couldn't reverse that one, could I? It took some effort, some painful days and time to heal, but I learned to accept it and live with it. I had to forgive myself for this horrible mistake. I didn't wallow in self-pity; it was a decision that couldn't be reversed. I had to go on, and I did.

Know there are some life choices that are not easily changed — marriage, divorce, having children, a large purchase on the spur of the moment and others of that magnitude.

Take the time to stop, think, and choose and the right choices will be clearer to you. The first choice you must make of course is to acknowledge that you are now living in a new reality and that a balanced life is simply not realistic.

Looking back over my life, I find a few scenarios that now make me cringe. I confess that, as a result of my bad decisions, I made my children the product of a broken home by embarking on a divorce that could have, and should have, been avoided. And the consequences of being in an abusive relationship that took place after I was divorced were oh so many. Mistake after Mistake... stumbles and stupid decisions – all of those happened on my journey.

I hired the wrong people, fired the wrong people. I trusted too often and got burned with two thefts. I did not use these 3 steps of good decision making when opening every office. Most did very well. The one in Arizona which felt like the biggest risk was actually well thought out and therefore a well-structured decision. The one in Connecticut was a tad of a rush, not thoroughly enough researched and it struggled. Our business practices were the same, we had continuity in providing services, but our market research was rushed in one case and we paid for it too. Good decision making is critical to success, personally and professionally. Take your time.

With acceptance of my life as being mostly unbalanced as my driving philosophy, I was able to finally focus on the most important things in my life... my children... my own self... my finances. Remember the basic concept of Prioritizing what

needs attention now? To choose what I wanted my life to be... to take control and make it happen? I found a new career and security. Eventually I fell in love, married, and reinvented my family. It was often difficult, admittedly. But the result... well look at me now, as they say.

EVALUATING CHOICES

Hopefully, you now understand how some of the choices you make can be the cause and effect of what is happening in your **3 Circles**. Sometimes, you may be the catalyst that creates the imbalance. Maybe one circle is overinflated and overshadowing all other parts of your life because of a choice you made. Perhaps you did not anticipate the severity of the impact on your life when you made that choice. I am not implying that when your life has gone out of control and the unbalanced aspects are driving you crazy that you and you alone were the impetus or cause of the craziness. Not at all, but I have learned that there are times when my own decisions created life's havoc.

Exercise: Is this life working for me?

So how do you know if you made positive, well-needed changes or poorly made choices?

Here is an interesting assignment to implement: you need to reassess where you are with your life currently. You will need to determine "is this Life working well for me?" Is My Life okay? The assignment is to take an in-depth analytical look at each circle, evaluating what works well in each circle and what doesn't. Write them down, don't try to do this without answering these important questions.

Sometimes a job, although it has great pay, may cause you to make so many sacrifices that all the other areas of your life suffer. Or, conversely, the job is a "going nowhere" situation, with less than adequate pay. And that causes stress across many aspects of your life. Maybe a relationship is just not meant to be. Using evaluation strategies, you need to consider how your life can be improved, what choices can you make to create a life closer to your dreams. Maybe you focus too little on yourself or conversely ruminate about things in your **Self Circle** to the point of sacrifice in one of the other circles.

Think: How can your life be more rewarding, more fulfilling, and thus create a happier you? Is your life just so full of demands from others that you cannot actualize the life that will make you happy? Reassess what you do in a week, a month — is it what you want to do? Need to do? Are you sure? Need to shed or get rid of some things? Some People?

In Its Simplest Form: Life Is Like a Pocketbook

Yes, I admit that this is a little hokey and oriented to my female readers, but I have often viewed Life as a pocketbook. Whichever interchangeable word you use, pocketbook, purse, handbag, have you ever tried to put something back and it just wouldn't fit? Or it takes up so much room, there is not space for anything else? You push, shove and struggle, using all your strength, and it still doesn't close. It needs to be rearranged. Take a few things out, reassess whether they should be in there, or thrown away or left on the dresser, and then rearrange the contents.

Life is like that. Often you need to take a second look, move things around and rearrange your life. This is where your **Power Tool of Choice** gets put to work and can make a most

remarkable difference. Again, it may seem as though it is a silly exercise, but I guarantee you that the results you achieve can make your life better. The power of wise choices is in your hands.

Reassess how you spend your time and with whom; does it need to be rearranged? Removed? Reduced? When you look at your **Work Circle**, do you find you are using all your strength trying to force things to go a certain way? Perhaps you should take a second look. Is it worth all the effort? Is there a different choice? Don't be afraid. Maybe it's time to find a new job or move to a new city and explore your opportunities. Maybe you just need to go on interviews, to see what is out there, to explore and perhaps you will view your current situation in a better light. That happens far more often than you may think. The old "grass is greener, but not really" theory.

Do you want to make a job change or a career change? That question is significant. I hope you understand there is a significant difference. Is it the job you want to change because of management, location, coworker, etc.? Or is it the actual job itself? That you don't like the industry you are in, your daily duties, the particular career? And what is the realistic choice? Do you want to make one of your work relationships a bit more pleasant? Get more recognition? You can choose to do whatever it takes to make your goals a reality. You are the one who must make these determinations: to assign value to all the aspects of your life. You can discuss your options, talk to your closest friends, your co-workers, your lover, but the final decision must be yours based on your needs and wants, not clouded by the influences of others.

Maybe you'll decide to work a job with a second shift so you can go on interviews during the day. Maybe you'll decide to

risk your savings to start working from home in a new venture. Maybe you'll go in and have a heart-to-heart with your supervisor to see if things can get "rearranged." Maybe you will choose to have a discussion with your Perfect Partner about sharing more of the household responsibilities, or who walks the dog first thing in the morning, or whether to keep driving the car that gives you weekly headaches, or is it now time to... choose... new or used car, lease or buy. All choices, some big, some small, but all of which require you to stop and think about what the right way is to go.

Maybe a choice you must make is to stop trying to cure every petty grievance of your longtime friend. You can still be her friend, listening for the truly important needs, but decide to manage the relationship better. Only you can make these decisions because this is your life. You can chat up a storm with a friend or spouse trying to figure it all out but let me say very loudly here... this is your life and you need to make the best decisions for you. And this recommended reassessment should be done not only when you feel some potential uneasiness or crisis; I try to take the time to do it every six months. Life goes by quickly and I don't want to waste time and energy in the wrong direction.

Once, I was struggling to pay the rent, struggling to pay for childcare... the struggling in my life had to change. There were lots of days when I was very tired between children and work, work and children, children and work. A draining cycle, and that is another one of the reasons I decided to pursue a way to make lots more money. But how would I make more money?

I put the **Power Tool of Choice** to work. The question of "how" figured into every choice I made from then on. Instead of a shiny new car, I chose to continue driving a beat-up car.

With the money I saved, I chose to invest, with professional advice, in a savings account. I chose to limit my spending. I live 9 miles from one of the biggest outlet malls in the world, filled with designer stores with luxury goods that made me drool. But I chose to save money instead and I just didn't go there.

I did reassess and rearrange my life, choosing a new goal of making more money to relieve the financial stress and being able to enjoy my life with my family with less worry about my monthly bills or a car payment. And those efforts began with taking on a second job or an interim job as described next.

PROGRESS THROUGH MY CHOICES

As I was working my way up (and out of the depths of despair), I was noticed for this dedication and promoted to a role with more responsibility. Which was another step toward my desired goal of increasing my income. My career was moving upward. I stayed late whenever needed, I showed initiative, and really pushed myself, hoping to build my career and my value. There were some unpleasant aspects, but these were indeed my choices and I never let anyone's agenda or resistance get in my way. I kept my eye on my own goal. I chose career and financial success.

I think that when a man aims for financial success, as I was aiming for, they say he is "driven" or "ambitious." When a woman does it, they often say she is "money-hungry." Or worse. I encountered a lot of friction, but I could not let go of my dream because of this resistance. I chose to keep doing the best job I could. I had to be true to my dreams and myself.

I am often asked how my work relationships helped or hindered me in achieving my goals. The answer is that it depended on

how I handled each one. For example, I had to make a choice in planning how I would achieve my goals. Here I was a woman in a man's world wanting what they had, success, recognition and money. I felt confident in my abilities, but what about the other factors I would encounter. Some I anticipated and others were a big surprise.

I knew I would meet the misogynist during my travels. That was a person I could not convert to respecting women, so when it happened (often) I simply tried to minimize my interactions with that person. I am sharing what I did on this topic; you determine what your reactions and path will be.

I had several instances when attending a meeting and was the only woman present and a peer, not a supervisor but a peer, would direct me to take notes/minutes. I always pushed back with a great smile and a statement no, not me, not today. Generally, a pause, silence and someone else would offer. If you begin that role of note-taker, it will follow you throughout your career and define you in a manner you will not want. I recall a meeting where a male coworker said I was being emotional about a topic. Quickly I pounced on that comment and said "no, not emotional, just passionate because I care about the outcome." Can you see the hidden push back to him? If he did not display a high level of passion or commitment to the project, perhaps that meant he did not care about the outcome.

Every day I would encounter some type of sexism and I had to choose would I take on that battle on that day or would I stay focused on my own goals of success and money? The off-color joke, the men at the table talking amongst themselves, very inappropriately, about the great body of the new receptionist, the calling me honey or sweetheart. Sometimes those situations required action on my part and sometimes I chose to let

it go. These are choices you will have to make. Do you take up the battle cry of sexism at every turn or do you evaluate the individual situation and then put your energies into your own goals? If the grievance is a terrible one, then we, as sisters, need to speak up; but some of the little, "stupid" maneuvers of our male counterparts should not deter us from our own goals.

SPECIAL TIP FOR SUCCESS

Here is an added morsel to help you take the big career step or achieve that much-desired goal if that is your definition of success. All the goals and dreams in the world cannot replace hard work. I have noticed a lot of people think they work hard, but they get easily distracted. They socialize way too much, they're on the phone with personal calls, and they watch the clock thinking: "Is it time to leave yet?" I always counsel people who want to really advance their career to examine, with intensity, how hard they work. What about you? What kind of commitment to your work have you been making? Do you procrastinate? Are you truly dedicated to your goal?

I am also amazed at the number of people who view a Monday morning, or generally the beginning of the "work-week," with such disdain. Begrudgingly, they head out to work. Is that you? Then you need to change something, beginning with your attitude. Work is a means for you to take care of yourself, be independent, and provide for others, as needed. If your own situation is so unbearable, then I most sincerely encourage you to reassess, rearrange, follow the advice in this book, and choose change. Realistic, attainable change. Not an impulsive action but making a choice after you go through the steps above.

I've told you about some of my choices and particularly my desire to apply much of my energy to achieving financial success. I've given you advice on how to identify and chose what is on your wish list. Are you wondering, "Won't all those efforts throw my life out of balance?" Remember, I believe that there is no true Life-Balance. Could you have stress from a time management point of view? Yes, but not because you are disappointed in your efforts to achieve your goals. Emotionally you will be stronger.

Your life will be not be particularly pleasant because the energies you are putting forth are not in pursuit of what you truly would choose to do. That is why this **Power Tool of Choice** is so important. You must make decisions on your life's direction not by acquiescing to the demands of others, nor by default. You must make your life choices by the three steps I cited earlier. That's the foundation of Choice: Stop, Think, Choose.

CONFUSED ABOUT YOUR CHOICES?

Lots of women are a bit stymied when they consider the concept of cleaning out their "pocketbook of life." Are you confused regarding what should stay and what should be tossed? Or left aside?

Living successfully means living well in all areas — emotionally, physically, and hopefully, financially. However, let me remind you that the definition of success can be very different for each of us. Some of us think of it in terms of money, others in terms of accomplishments, others in terms of love and happiness, others want to embrace the hippie style or stress-free lifestyle, and then still others want the right to be in control of all aspects of their life. To some, success means never having to work another day of their lives. To others, it is

being able to afford a new house, or a boat, or to be a jetsetter. And some want it all.

It is my belief that success is a journey; whatever your own definition is, it becomes a journey, an ongoing process, a continuous experience. It means setting specific goals, and step-by-step marching toward achieving those goals. It means keeping the circles working together to accomplish those goals. Not sure what your goals are? What they should be?

Let me share my journey to achieving a certain portion of my definition of success. This journey is about one part of success only... the financial part.

As you know, there came a point in my life where I needed to think about success in financial terms. I had three children, with lots of debt and worry. I wanted financial security and peace of mind. Perhaps a bit of money in the bank and the ability to send my kids to camp. What did I need to do to make more money, — a lot of money? What were my options? What choices could I make?

Option one was I could move to a more urban area where salaries were better. But I was a single mom, and having my family and friends nearby was important. Even more importantly, my children had already experienced so much disruption in their lives from the divorce that I didn't want to uproot them.

Option two was to commit to a long commute — over an hour each way — to get closer to a larger city, an urbanized city where hopefully I could earn more money. But that would mean hardly seeing my children after adding on the commuting time to my workday.

Option three was to stay local, work harder and smarter than others to gain visibility, to secure promotions faster, and earn the recognition and the raises, to be as successful as I could be without having to relocate.

I chose option three. Then I had to consider and make a lot of other choices. I chose to read every self-help book I could get my hands on, improve the way I walked, the way I looked, and improve my vocabulary and presence. I chose to invest time in my personal development. There were no courses online, as there are now, so I spent a great deal of time at a library coming home laden with information on how I could become a better Donna.

The journey to my goal continued. After a few years, the opportunity to have my own business presented itself. It was tough to know what to do, but I used the 3-Steps in the **Power Tool of Choice** to help me decide if this was the best way for me to go. Three Steps. I considered all aspects of such a venture. I considered things such as the hope of more freedom to enable me to be a more participating parent; the hope that having my own business could enable me to increase my income. I considered all the complex ways this could impact my family and me personally.

I took my time, I tried to be very thorough and made my choice, looking to the future. In the future, I wanted my children to enjoy a certain lifestyle and I wanted them to be able to have a college education. I wanted them to have many choices I did not. So many things to consider, so many choices, and it took a great deal of time, but I finally faced the opportunity to own my own business, I decided "yes."

I chose to accept the added stresses of running my own business and to risk what little money I had. I borrowed every penny I could and signed my name on loans. I chose to forfeit any free time, to be very vulnerable, to try something I had no idea I could do — and to risk failure.

All those choices were made because I aimed for my goal to make more money, to gain financial security for me and my children. Fortunately, over time, I succeeded. The sacrifices were often far more than I had anticipated, so throughout the process I had to re-evaluate my direction and reaffirm my goals. I had so much to learn about general business, entrepreneurship, managing of staff, client development, customer services, and financial matters. It was a scary path, but I decided it was what I was going to pursue, and I did it.

Don't be afraid to take a few risks. Not just business risks, but also other types of risks. You must risk heartache, or you will never know true love. Risk ridicule or you will never offer a creative idea. Risk rejection or you will never champion a cause. I'm not suggesting you should embark upon a path of foolhardy behavior. There's such a thing as taking carefully considered risks and there's such a thing as being stupid. Accepting a job with a young company because you're impressed with its founder and you believe in the company's future, even though the pay is low to start, well, that is a carefully considered risk. If you leave a job interview where you feel this offer is "too good to be true" and then accept that job without conducting research, that could be taking a stupid risk.

Agreeing to serve on the local school board is a risk but could be of fantastic benefit to others and you too. Agreeing to join a team putting together a fundraiser for a worthy cause could create some time management challenges for sure, but the

rewards could be stupendous-both for the organization and for your visibility, new connections, well earned respect.

You don't have to own your own business to be successful. You need to decide your own personal definition of success and what you wish to achieve and then plan to achieve it. Don't let the fear of failure stop you from succeeding. Be willing to take risks, even knowing they may not all work out the way you want. Enjoy the journey; be enthusiastic about the changes in your life. It can be fun and invigorating too. No matter what is happening, remember, in every cloud is a silver lining. A positive, enthusiastic approach to life makes gold at the end of the rainbow. Not always money gold, but sometimes the gold of love or friendship or simply personal satisfaction that you tried and did your very best.

Don't Let Others Choose for You

"To be yourself in a world that is constantly trying to make you something else is the greatest accomplishment."

— Ralph Waldo Emerson

I know it is difficult not to be influenced by what others want us to do, or not to do. I've been there too. My father was not very happy when I made the decision to go into business. We are talking three decades ago. Wow — a woman owning her own business — what a daring concept! Sure, a beauty parlor would have been acceptable, but a business that would have me competing with men was not embraced.

If I had made choices based on his expectations, neither one of us would be very happy today. Long-term, my choice really worked out great for me. And if I had continued to follow **The**

Hoax, I would never have become strong enough to accept myself living an unbalanced life. And that decision, that choice allowed me to focus on my life's big picture of financial stability, happy home, well-cared-for children. My goals, my dreams.

Sometimes the desire to please everyone in our lives takes on more significance than our own needs. You don't want to hurt your parents. You don't want to "embarrass" your family. Those are very real, human concerns — and they're okay. It's natural to want to have your parents, friends, and neighbors like you and to seek their love and acceptance. But if you do what "they" want, will the result be resentment? Will you compromise being all that you can be? Will your life be filled with disappointment because it is not the life you really wanted for yourself? Will your ***Self Circle*** be so small day after day that your self-worth shrivels up as well? Don't let that happen.

If you make your choices based on what's important to you, you'll never wake up in the morning resenting others. It has been my view that relinquishing the power of choice to someone else happens far too frequently. Often the actions of another person, indirectly or not, cause a woman to choose a path she really did not want.

As you may recall, I addressed earlier some of the issues you will face, unfairly for sure, but face nonetheless just because you are a woman. There can be obstacles placed in front of your forward movement by men who are either threatened by a woman or have a preconceived idea of superiority. Or the example where you are harassed or put down or put upon repeatedly just because you are a woman.

If those instances are happening at work, try to be strong and not give up your power of choice by letting them force you out

of the company. You can make the choice to stay at that job and work to change the situation, regardless of how difficult that may be. You can make the choice, how to handle it, how to handle him, how to handle them. There are lots of options if you choose to go down the path of fighting for your rights. There are resources and avenues you can explore to get help, both within your own work environment or, if necessary, outside help. It may not be the easiest way, but you are not giving up your rights, your power to make your own choices. Try not to relinquish your power because some xyz feels it is his right to treat you unfairly just because you are a woman.

Perhaps that is the time to consider being the change agent who makes it better for other women who follow. That is often what I had to do. I used to have my cell phone ring as Pat Benatar's "hit me with your best shot" song because I felt strong enough to take the proverbial hit so others would not have to, so I embraced being a change agent on issues of importance to women.

I know an important part of making our choices is to consider those we love and how our choices will impact them. Yes, it's okay to make a choice that might benefit someone else more than you at the time. The point is the choice must be *yours*. It comes from within you. It is not forced upon you, or it cannot really be called a choice.

Many times, even though your life is out of balance, it is so because of choices you are making. By making the choices yours, you are living a life out of balance but creating it because you want it that way and it feels so much better than always acquiescing to the demands of others.

Identifying your goals of success is important. Working to achieve them is life changing.

CHOOSING CHANGE

Here is another important fact that I learned. Sometimes we relinquish our power of choice through habit because it is **so** comfortable. We follow the same predictable schedule every day because it is easy. But habit can be a *prison*. It can keep you in a rut, doing the same thing, day-in and day-out. I am not telling you that the changes I made in my life were easy.

Change is very difficult, and I want to remind you that it has been explained that behavioral change is rarely a discrete or single event; however, we tend to view it in such a way. So often, we procrastinate because change is uncomfortable. We have personal behaviors we wish we could adjust, stop, or start. Yet we often find ourselves resisting change.

Where you are in your personal development determines the degree of change you will need to make. Let's start with some basics.

Right now, take just a minute to think through your typical day — your average week. I bet that there are quite a few things you do *all the time,* just because they are expected or out of habit. After all, it's the way you've *always* done it. For years, there was no question in my mind that no matter what, the dinner dishes had to be done the moment we got up from the table. It never occurred to me that I had a choice to leave the dishes there and go off and spend time doing something else important to me.

Start changing habits with a small choice — a completely different hair cut or hair color, for instance. Or wear a color you have never, ever worn before, or a different length shirt or go Bohemian in your style, even if for a day. Go to different stores, go to events at your local library or join a discussion group on topics totally new to you. Change around the furniture at home or at work. Change desks with someone. Maybe today you'll choose to start reading thirty minutes every morning, and soon the idea of taking a course and having homework won't be so scary. Take action today. Make one small change in your day right now. Instead of watching TV, choose to go to the open house at the local church or college, or check out a health club or an organization that you have been "thinking about."

For the next levels of embracing change, perhaps it is time to look up that course you were considering to find out if you can still get into the class.

Why is this important? Because we grow from new experiences, from meeting new challenges head on. You will become a stronger woman, a more stimulated woman by changing your habits. You grow. You enhance who you are. This allows you to become a better, stronger you.

I now not only look at my activities differently, but also at my relationships differently. There are relationships that I continued out of habit that weren't good for me: people who I no longer shared anything in common with, friends I had grown away from, for whatever reason, but who still demanded a lot of my time. It can be a hard choice to let a relationship go, but sometimes it's the best choice — a necessary choice.

If you are making the same bad relationship choices over and over, it means you are not using the power you have within you. Get out of the rut and choose to break the pattern!

Exercise that muscle of choice. Make small choices for change that can make life more invigorating, exciting, and new. Break the pattern. Kick the habit.

We live in a whirlwind world filled with speeding superhighways, faster Internet and text messages by the hundreds. We have planes, trains, emails and cell phones all urging us to go at a faster pace. Every choice has a ripple effect not just on our own lives, but on others as well. We must think, "What impact will my choice have on others?" Some ripples are very small, but in major choices, life choices, the ripples can be huge. Take the time to think of the impact of your choice on your everyday, on your family and friends.

Perhaps you will not understand the impact of your choices until many years have passed. The questions could linger for a long time. You may always wonder whether you made the right choices. I've wondered how my choice to be successful affected my loved ones, especially my children. Were they understanding about why I worked so much? Did they feel neglected? Would I have stayed single for ten years or gotten remarried sooner, if I had put as much time into finding Mr. Perfect as I did into being successful at work? What about the impact in my **Self Circle**? I struggled to find time to work out; I often lived rushing... from place to place, task to task. Does the stress show? Would I have had such an up-and-down battle with my weight?

While these are all interesting reflections, and while I may still have some concerns, I don't have a lot of regrets regarding my

choices. I made them as wisely as I could at the time. I set goals for myself and made my choices with those goals always in mind. I pushed back at times of imbalance and made sure I was taking care of the most important circle at the time so that I would be on the right path to my personal goals. And I revisited those goals constantly, thinking "Are these still the goals I want? Has anything significant changed?" On reflection, I believe I made good choices for me and for my family.

And most importantly — they were my choices.

And, most importantly, you must make your own choices.

Remember, you need to stop and think, and only then, choose.

GOAL-SETTING

As I began this section, I was searching for a visual to emphasize the importance of setting goals. I initially thought about the example of building a house. When you build a house, you need detailed building plans, preferably certified by an architect. Next, I thought of our friend Andrew who is a very talented painter. He begins every painting with a blank canvas and a plan as to what goes where, colors, textures, the works — and creates masterpieces. And that is what you must do. Create a Life Plan. Your colors, your textures, your foundation, the people you want in this life, how you are going to pay for this life. All of it starts with setting your goals.

Think: What are your goals in each circle?

Relationships? Write them down.

Work? Write them down.

Self? Write them down.

Next is to stop, think, and choose and make sure those are truly your long-range goals, not some whim or an unrealistic dream.

Now you must think about and create the action plan. If, for example, one of your long-term objectives is better financial security, contact a certified financial planner as your first action step so that you can 1) become educated on this delicate topic 2) have a "pro" help you achieve that goal.

If in your *Self Circle* you want to become more organized, recognize the desire will require some additional tools beyond the ones you have read about already. Think, do you know what task is truly important, what one is urgent, and what can wait? Create your list and limit your commitments by choosing those activities that you enjoy and, importantly, are consistent with your goals. Create a tasks list or to-do list and use your computer, phone, or the old diary route to reorganize and allocate your time to those actions that, one by one, bring you closer to those goals.

And, of course, your action plan must be incorporated into your **3 Circle** "default," knowing work may swell if that has a larger importance in your goals, or relationships if that has a larger importance in the goals you wrote down.

Your life is undergoing change; change that will require action and conscious choices.

Dreams are not goals unless there is a plan of action to bring them to life.

Wishing without action is of absolutely no value.

You need an action plan. Into that plan must come consideration of the fact that your perfect balance mix, the size of each of the circles that creates your own living happily mix — even though it's living an unbalanced life — will change, simply because life is dynamic, not static. There is an ebb and flow that may be impossible to control, but we can definitely control our responses to the changes.

Learning the material in this section took me a long time because I had some difficultly piecing it all together. During my many years of counseling people on careers, I discovered that people often set goals that are not compatible with the reality of their own circumstances. Or they don't even think about goals. Or, even worse, they allow their goals to be directed by outside influences. Again, the *habit of living* the same life over and over again. My techniques can help you massage a circle that has consumed your life, but first let's think about what you are resizing it to and why.

As you embark upon using what you learn in this book to make changes, let me caution you about setting realistic goals. The key word here is "realistic." If you want to be a famous professional singer, hopefully, you know it will not realistically happen unless you have lessons, a manager, agent, and a willingness to travel, etc. If you have a goal of being an interior decorator, realistically it will not happen unless you are willing to get professional training, work under an established professional, then if you want to go to the next step, have the necessary funds to open your own shop.

If your goal is to live in a delightful European city, do the necessary research to evaluate if it is truly realistic. How would you support yourself? Are you willing to leave family and friends? Do you speak the language there or can you learn it quickly

enough to be comfortable living there? Or should your goal, the realistic goal, be that you want to be able to travel more often, one beautiful foreign city after another?

If one of your goals is to overcome shyness or improve your ability to do a presentation, realistically neither of those may simply happen on their own. You may need outside resources. Courses? Coach? You must set realistic goals, with a plan that is identified and lists the steps and resources needed to achieve them. If your goal is to move three levels up in your career, confirm first that it is realistic. Confirm you have the education, knowledge, and intangibles required for those next levels, or go get them and then trigger your plan of action.

When I began to set my goals, I took care to set realistic goals and, as you know, one of my priorities was financial success and stability. I certainly did not expect to be the owner of a multi-million-dollar company, but as I have said I wanted to be able to pay my rent, have food on the table for my family, adequate and proper child care for my children, and to finally have a car that started in the morning. Oh, and the all-important money in savings as the basis for some peace of mind.

I hope I don't sound too immodest if I admit that I am proud of my accomplishments. They were ambitious goals and I was willing to make the changes needed to make my success happen.

Yet, here's the most important point. I didn't have to sacrifice a personal life or good friendships or abandon parenting or romance to have success. I discovered I could have it all — with the "all" being defined by me in proper proportions for me.

For me, having it all meant not only achieving business success and the financial rewards that accompany that, but also being in a loving relationship, having and raising my kids well, enjoying good friendships, having fun, and waking up happy each day.

If you are thinking right now, "She found a way to balance work and private life," you're wrong. "Balance" is the idea the media puts out as the magic formula for happiness, but it is a **Hoax**. Accepting Life's reality of living unbalanced each day and it being okay allowed me to manage the sudden disruptive changes. That acceptance allowed me to prioritize what was important to me that day, that week, and in the future months. There were certainly times that my relationships took a back seat to my career goals. There were certainly times that my friendships were impacted by my striving for financial independence. However, the goal of financial independence was very important to me because, as I explained when my mom died, the financial burdens forced me to forgo a college education and assume a parenting role in the house as well. So, I placed financial stability very high in my personal goals. There were times when the **Work Circle** became so out of balance that I knew I had to take control and push back. Then I would arrange to go bowling or to a movie with friends and family. There were other times when the birthday party, or family BBQ pushed back on the **Work Circle**, bringing my life into a synergistic flow. At least for that day!

50 CENTS AN HOUR

While aiming for my goal of financial security, I never put a price tag on what I had to earn, such as I must earn XX per hour or so much per year. Truly, I just worked and worked as best I could, with a *positive I can do this* attitude. At the time

I owned a recruiting company, and I remember working on one project to help a company hire three senior staff members. We quoted a fixed price because that is what the company insisted upon and we had the approach that the customer was always right. We successfully completed the searches, but when I conducted an analysis of the time invested and the dollar return, the result was that we made less than 50 cents an hour.

The point in sharing this is if you want career and financial success, the road to earn it may come at a price of sweat and very hard work and little financial reward in the beginning. The more tangible benefit may come later. In this example, my client only knew that we successfully completed the tasks for him. He knew nothing about the realization we had worked for about 50 cents per hour. But he hired us again and again over the years, becoming a valued repeat client generating far more over the years than 50 cents per hour!

Women today have more opportunities than ever before. We have a stronger, united voice, and we have greater participation in our country's political, social, business, and spiritual life. Yet, it appears to me that millions of women feel stymied or stopped by a fear that making their lives what they want them to be may be more than they can handle. Suddenly, there's a realization that, if you do that, you will have full responsibility for your own happiness. That can seem scary.

As a woman who successfully changed her life, I tell you that you can climb the steps one at a time, with each step taking you closer to the top, to the goals you have defined for yourself.

Maybe your goal is to develop wonderful friendships, or a special one-on-one relationship. Maybe it is being successful and earning a lot of money, or achieving an artistic goal, having

a book published or getting rid of your anxieties. Maybe it is just finding peace. Or maybe it's all of that.

For the woman who is employed full-time outside the home, forty hours a week times 52 weeks in a year equals 2,000 work hours a year! A decade of 10 years means 200,000 hours. No, I haven't deducted for vacation or sick time, but you can see that, if you are employed full-time outside the home, it is quite a large chunk of your life. I urge you to really consider your professional goals, whether you work in an hourly job or a full-blown multi-level career. Whatever level of responsibility you have, it is important for you to think about you, your career, and your goals. Are they realistic? Is it truly what you want? Look online or seek out certified career counselors for advice. And of course, there are always mentors or people who were successful in your industry or your desired career path who would be glad to help you.

The most precious gift you can give to yourself, especially in your **Work Circle**, is to stop and think, then choose your definition of success and your definition of what your work life should be. How will you be most satisfied during the time spent in the *Work Circle*?

THINK: DEFINING WHAT YOU WANT

- Are you willing to go to work for someone else?
- Would you rather not work for a salary?
- Rather be a volunteer and rest of the time be a stay at home?
- If you do go to work, what type of job do you want?
- How much money do you want?
- Why is money so important to you?

- Is recognition important to you? Why?

- Do you dream of a life of luxury?

- Is power important? Why?

- Would you take a reduction in salary to start a new career?

- Would you be willing to go to work and school at the same time?

- Would you forgo a social life for a year to get ahead?

- Is it more important for you to have a stress-free job?

- Do you want to climb a career ladder? Which one? How high?

- Do you want a job where you are challenged?

- Would you prefer a job where you just coast?

- Would you prefer working from home?

- Would you miss co-worker interaction if you worked only at home?

- What would you do with the extra money you got via a promotion?

- What price in time, energy, effort is your goal worth to you?

- How much stress are you willing to endure?

- What do you like about your current situation?

- What do you dislike about your current situation?

TO ME, SUCCESS IS: (write it down) _____

Ask yourself all these significant questions and more. Dig deep and make your own list. Find other questions through research. Take the time and be honest with yourself. Remember, your definition of success today might be far different from what it was eight or ten years ago, or what it might be five years from now. You must "reassess and rearrange" your life to pursue your current goals. I cannot tell you how many times people have pursued a goal in their **Work Circle** for *years,* only to finally reach it, and realize it wasn't any good anymore.

WEALTH

Since so many people have the goal of being wealthy, let's take a closer look at the interesting topic of wealth. Each of us has a very personalized definition of wealth. There is financial wealth and of course the wealth of good health, love, richness of relationships. In this section, I want to talk about the financial wealth. My choice for financial wealth was predicated on my desire and hope that my children would have more choices than I had. I wanted them to have the option of going to college and that our family would have enough money for frivolous things like trips or movies and a beach vacation. I did not need the palatial estate, the private plane, or full-time maid. I did not need a closet of designer clothes. However, I did want the family financially comfortable. I did not want to worry every day about money. That was my goal and definition of success.

It is quite interesting how once I attained that goal of financial security, my eye reached for a new horizon. Now I am most interested in health and wellness and longevity. The same will happen with you as you attain certain marks in your life, your goals will change. That is why I encourage periodic evaluation, reassessment and rearranging of your goals.

Susie

Not so for everyone. A few years ago, I had a several long meetings with someone regarding her pursuit of wealth. Susie worked very hard, was always tired and distressed, and came to me about moving up the career ladder. She shared that she was very driven to be wealthy. Probing, I asked "Why so much energy for this pursuit of wealth?" "Well, I really like nice things," she responded.

I had a different observation. She did buy a lot of nice things but didn't seem to have the time to enjoy them. She had the fancy apartment, clothes etc., new car, but they didn't seem to make her happy. Session after session, we worked to reassess where she was and where she was going. After weeks of introspective evaluation, she realized that wealth wasn't her dream. Wealth, she had thought, would allow her to live a certain lifestyle that she *dreamed* of. For her, that dream was living on a beach in a warm climate, kicking back, tending to a garden, swimming... see the picture? But she had been working only for the material things she could buy, forfeiting her actual life's dream. The place on the beach didn't have to be fancy. It was living on the beach that was her goal. She could have had it years ago. Within 6 months, she rearranged her life to have that beach property. She moved to a smaller, less glamorous apartment and sold the fancy car, replacing it with a sensible one, changed her work situation to have more time off so she could have the property on the beach that she now enjoys. Her new goal was to be able to have more time at the beach property by either working less via a job change or working from home.

When considering your goals, I remind you to *stop, think, and choose your personal definition of success.* Is it the same as five years ago?

Some of you may have that epiphany, that you have been striving for success... but using the wrong definition. That's okay — take the necessary steps to make the changes now. If you have found success and prosperity in the rewards of material possessions, but not inside with how you feel about yourself, then you are not truly successful. Think about the millionaires who have lives filled with boats, trips, fame, and material things. The tabloid cover stories often tell us about someone who seemingly had all of that and the fame associated with it but were in and out of drug rehab or behaved in a bizarre fashion time and time again. Almost a cry for help. Hopefully you know that money doesn't buy happiness and that fame is often a prison.

We, the ordinary people, observe their lives in awe, but so often they are not happy. These "superstars" have achieved the wealth and status they thought they wanted only to realize that they did not want to continue living the life they built. So please be careful not to pattern your definition of success only on material things or the value other people place on those things. Clearly define what will make *you* truly happy and what can bring peace and laughter to your life.

CHOOSE WISE INVESTMENTS

No, sorry, this is not a section with advice on making wise financial investments. This is what I learned about investment to protect one of our most important commodities: Time. Often, the trigger to one of the circles enlarging is that small word: Time. How frequently does the lack of time throw your life tremendously out of whack? How often do you think there is simply not enough time in the day? Perhaps you are not making a wise investment of the time you are given. So,

this section is all about Time and helping you make the right investments with your Time.

Hear this loudly please: Putting your energies into mastering your own time is the best investment you can make. Isn't it interesting that we use the terminology "spend time?" We say that because time is indeed as precious a commodity as money. There is only so much of it, and we need to spend it carefully. With the **Power Tool of Choice,** you can choose to create more free time, can choose when and with whom you indulge your time, and now you will learn how to make time work for you, to have the best possible results in your daily life. *The Hoax* gives us a message that we must spend time equally in various segments of our life to achieve Balance. I say you should "spend your time" to achieve the reward of living well.

EXERCISE

There are many time-management seminars and books available, but I found they generally addressed the topics of keeping meetings short, or multi-tasking or using a diary or calendar more effectively. So now let's explore the topic of Time in a different manner with this exercise. This requires pen and paper. Please don't simply read, participate. And be honest. No one is judging you on how and where you spend your time, but until you truly analyze this precious resource you will not know what types of changes you may want to make.

Exercise # 1: *Spending Time List:* How do you spend your time? What do you do with your precious time during the week? If you spent three hours watching television at night, write it down. When you wake up, what are your actions? Are you slow to get going or ready to attack the day with vim and vigor? The purpose of this exercise is to help you and you will

gain the most benefit only if you are honest with yourself. No judgments. This is merely an exercise, so you can see where you spend your time. Might be a good idea to keep a journal for one week and write down the choices you made with your time.

If you are truly honest with your responses, some answers as to where you are "wasting time" will literally jump off the page. Often the changes you may need to make will become crystal clear.

Exercise # 2: *The Someday List:* How would you *like* to spend your time? Have you ever started a sentence with "someday?" "Someday, I am going to learn how to play the piano" or "Someday I will go visit Uncle Harry." Or "Someday I am going to visit that museum or Someday..." What would you like to do more of? Less of? What new things would you like to do? Write them all down. What is your Someday List?

Exercise # 3: *The Good Life List:* Create a list – not the trendy "bucket" list we are told to develop before we die. I want your list for living a better life... a great life... a Good life. What is on your list? What brings you pleasure? If you can't reach out and grab the answers, simply apply the reverse technique on what makes you sad? If you see a friend on social media at the beach, horseback riding or at a local happy hour... does it make you feel sad? Envious?

Well then you have identified something you would like to do that goes on your own *Good Life List. When I did my list, I didn't call it a life of perfection, but a Good Life. And the things I learned in making these lists gave me so much insight* that enabled me to create a very Good Life.

Remember I told you *my motive for writing this book* was not simply to help you dispense with **The Hoax** but to help you

replace it with an action plan to set you on your way to living happier and in peace.

Look at your answers to the above exercises. Can you see a few changes you need to make in how you use time, what you do with your life daily? Weekly? If they don't jump out at you, share your answers with someone close, a mate, a friend, a parent. Discuss it with them and perhaps they will have insight as to changes you may want to consider.

Life cannot be balanced as I have said, but it can be very livable and enjoyable. Allow me now to share a few "Time Tips" to help you use your time more wisely. Then you can invest your time in what you consider fulfilling and worthwhile, whether it is a joyful event with family, dinner with friends, or putting energy into your professional goals, aspirations, and dreams.

DONNA'S TOP 3 TIME-MANAGEMENT TIPS

A big step is for you to embrace the thought that even though time flies, YOU are the pilot. Therefore, it is logical that, to manage time, you must manage yourself.

Time Tip # 1: Time management is self-management

No matter how organized we are, there are always only twenty-four hours in a day. All we can do is manage ourselves and what we do with the time we have. The action plan for time management is *self-management*.

You have twenty-four hours each day. No one else should decide what you do with those hours. I know this is not easy. I have wanted to go horseback riding over the last few weeks, but I have also wanted to finish this book and fulfill all my other responsibilities. I managed my time to have a few extra hours,

which I could choose for horseback riding or book writing. You can see that I decided "book."

One technique I found to help me manage my time and myself was to handle projects in blocks of time. For example, I would work on a project with detailed numbers from 9 to 11 and take no phone calls, no news show, no wandering mind, no visits from a coworker Or I would work on another chapter of this book or an HR report right after lunch, again focusing only on that as much as possible. Using your time in blocks to focus on and thus complete something during a specific time of day can make you more productive. And you will feel much better about yourself too. There was no way I could carelessly juggle all my responsibilities to attain the levels of success and wealth I desired. No, I had to manage my time as a most precious resource because that is what it was.

Time Tip 2: Identify your Time Bandits

It is not always easy to identify a Time Bandit, I understand that. Sometimes they lurk in the background of our lives. Look over your notes. Do you spend too much time net surfing, reading email, or making personal calls? Watching TV? Social media? Stupid dog tricks? Or the crazy cat videos? Do you hang out with the friend who steals your time by spending hours complaining, and never changes? And the result of that time is one where you become depressed or lack the energy to pursue what you have to for you? Or do you allow yourself to be with someone just because he or she wants to be with you, but you would rather be someplace else? Yet, you acquiesce and by so doing surrender your own desires. So, they have stolen the time you needed for something else.

Stop giving up your time and rights to others so easily. Stop letting boredom create a spiraling cycle of depression where

you sit listlessly, and waste valuable time immersed in feeling sorry for yourself. It may only be a small change that you need to make to improve, for example, your health, but the seeds that you plant will begin to sprout results. One of the biggest Time Bandits may be your phone. Do you check it often? I understand the need to check for an important incoming call. But so many people use the phone as a source of entertainment when they could do something else much more invigorating, more stimulating, more fun and that fun creates happier days, a happier life. As you sit at your desk working on a task that needs to be done, the phone rings and it is a call from a friend to just chat. You must manage this part of your life. First ask whether the incoming call is very important and if not, tell them you will call them back and finish your task. Manage your time to take care of the most important thing first. Take charge of this most precious commodity and manage your time bandits.

Time Tip 3: Plan & prioritize – YOUR action plan

Using a time journal or a calendar, plan what you are going to do with your days so they do not slip away. Go ahead and be ruthless in prioritizing. Remember, time is as valuable as money. Don't spend it frivolously. You have things you must do with your time; and then you have time that you invest by choice.

Choose what you are going to do today, this week. Plan where and with whom you are going to spend your time. You **can** be in control. You **can** find those extra hours you need for yourself. You can take care of your responsibilities *and* accomplish your desires once you accept that Time is yours to control.

As a single mom with 3 young children, time management was always an enormous challenge for me. I knew I was in control, but the 24 hours simply did not seem enough. I had to reach for

help. As I was building the business, I had to travel to our eight offices regularly. Certainly, on those days, I was not about to be home in time to make dinner, so I had to find (hire) someone to greet the children when they dashed through the door from school, create an easy dinner we could heat up when I got home and most importantly, implement the message of "homework time." It cost some money, but I had to buy some time, the few extra hours I needed in order to guide my business forward. And most importantly, to make sure my children were safe and sound and cared for by someone competent. My action plan included putting money toward buying time and forgetting about the new outfit or shoes. Not citing it as sacrifices, but sound decisions based on my own goals.

Think about how Time is used in all your circles. Maybe you want that promotion at work but know it will require you to spend more time at the office, or to answer emails on weekends. How will your **Relationship Circle** deal with that? Do you want to spend more time with your family? Will that make you less available to your boss? Understand what is most important to you right now and plan your schedule accordingly.

When one of the circles explodes, you may have to modify your plan until, via use of the **Power Tools**, you can make some adjustments. However, don't drop the plan! You simply are on temporary hiatus until the circles come back to a more reasonable scale. Remember, time flies, but you are the pilot of where your time flies to. Make sure it is a destination you want.

Is now the time for your Transformation? For example, if you have a very sharp mind and are often in meetings where you feel you could contribute something but hesitate to speak up, then you need to choose to make a change. I'm not necessarily talking about a job change. I am talking about having enough self-esteem to go

speak to your supervisor and suggest *one-on-one,* sharing your thoughts or asking for permission to have open dialogue at those meetings. It is a mistake for you to hide the intelligence you have or the insight you have to offer; it is Time for your Transformation from being afraid to be an active participant.

What is it *you* want? Consider your strengths and establish realistic goals. What do you do well? What *could* you do well? What do you *really* want — not just what you think you *should* want? Not sure? That's okay. Perhaps try out different aspects of life so you can determine, "Wow, I felt the best when I was there... or with her... or doing this or that." Introspection... Reflect on you and your life today and where do you want it to be next year, and thereafter.

Do you want to lose weight? Are you frustrated because you haven't been able to? Don't give up. The most important step in accomplishing this desire, however, is to set a realistic weight, and then find a way. Select a plan to get you healthier, not a plan to become a magazine model. Remember, realistic goals. Or go back and retry one. Ask around — read every article you can on the topic. Get on the Internet. Have you heard of any new promising health or active living programs on the horizon? Look them up. Don't give up. Take responsibility, take control, plan and take action. Fly your plane.

Do you want to learn another language or skill, like photography? You can find a way. There are many ways — tapes, a course, a coach, or club. Do you want to start or finish that college degree? Call some schools. Ask what programs are available. Are there grants or scholarships available? Weekend or evening courses? Online? Places that accept life experience in lieu of classroom credits? Just don't give up.

This is your life and you have the right to make it be what you want it to be. Think about who you are, what your dreams are, your goals and talents. Think about who you are *today*. And your tomorrows too.

How Long Is Too Long?

If you were to do an Internet search on "How long is too long," you would see a myriad of responses to a wide variety of subjects posing that question. Some examples are: How long is too long to be engaged? How long is too long at the same job? How long is too long for your resume? And others that are broad in scope, such as how long is too long between haircuts and how long is too long to go without sex.

Let's explore how long is too long to let one circle *dominate* your very existence.

Here is an important point to remember: *All instances of "too long" in one circle do not necessarily have a negative overtone.*

Think for a moment of the story of Amy who is planning a baby shower for her close friend. Good times, right? Except, Amy finds herself immersed in the **Relationship Circle**... consumed for weeks on end by the **Relationship Circle** — the invitations, the reservations, the decorations, checking the baby registry, the food, and the lists go on and on. Amy starts to feel more than a tad annoyed. How long is too long?

Once Amy *feels* annoyed and overwhelmed, she needs to act, to take control. She reviews the guest list to find others she can reach out to and ask for help. She asks for help with a specific task, not whining, not complaining, but with a smile in her voice and her continued excitement for the upcoming baby. She

got the help because most people are quite willing to help. Amy just had to ask. That is how you handle "too long" in that type of an example. Amy took Control. Amy chose to reach out for help to make a change.

Let's move on to a discussion of your **Work Circle**. How long is too long in your **Work Circle** depends on your master plan for your life. In the section on Choice, we covered a few exercises that should get you thinking about what type of work life you really want. If it includes a *super* successful career, then perhaps you will be willing to spend more time in your **Work Circle** than the person whose master plan is more focused on beach days or golf or PTA meetings or a job that simply brings in an adequate paycheck. If you are in pursuit of a specific goal, such as a promotion, and are pushing the **Work Circle** beyond normal limits to earn that bonus, then perhaps you are willing to stay in what others might view as too *long*.

But if you find that you are living with the **Work Circle** being the dominant one for too long because you don't feel you are in control, and if you feel you are incapable of reining it in, then it is *too long for you*, and you need to make some strategic moves. The tools in this book for control, choice, and communication will allow you to manage your life to reap the utmost benefit for you.

An immediate remedy for your **Work Circle** could be as simple as learning how to speak up professionally and positively. If you are burdened with extra work because someone else is not carrying his or her fair share, then you need to speak up. If you feel you are being put upon by your co-worker or your supervisor day after day, then you probably are. Prepare, think about what you are going to say, how you will present it and, especially, select an appropriate time. You must find a

way to speak up. Scary in a way, perhaps, but why give your life away to your **Work Circle** if it is not what you intended for yourself?

If you are on the track for promotion or a raise based upon some prior conversations and your knowledge that you have done an excellent job, but now are not hearing about anything formally and it feels like it is too long, then you must develop a plan to speak up. Arrange a meeting with the one who can make it happen, do a formal, positive request for an update and try to push the timeline out of the too long category into the right now category.

This is your life and you only get one chance at making each day what you want it to be. If you are in a job that is not well-suited to your talents and you are crashing and burning day after day, then it is too long, and you need to make a change, either in how you handle this job, or a bigger change. Maybe it's time to seek one that is more in line with your talents, or one where you can go to work with rewarding feelings of self-fulfillment.

How long is "too long" in your **Self Circle** is often determined by how you are feeling about yourself, day after day. No, life is not a promise of happiness every day, but when considering how you want to live and especially how you want to feel in your **Self Circle,** then you need to sincerely choose what makes you feel happy and at peace. And, if you find that, regardless of how much effort you are putting forth now, you don't feel happy and at peace, then you need to explore your options for change, now, before too long becomes way too long.

The signals that it is too long in our **Work Circle** are generally pretty obvious, the ones in our **Relationship Circle** can

be easily identified, but the ones in our **Self Circle** are much more difficult to discern. Do you find yourself frustrated day after day by something happening in either of the other two circles that is causing you real anxiety? Perhaps it is impacting your ability to function. Perhaps you feel that overwhelming sense of failure that you cannot handle life or that you absolutely never have time for yourself. Perhaps the angst and resentment you are feeling about others, work responsibilities or thoughts of anger that you must deal with situation "a" or "b" consumes you. Those are some of the signals that you have spent too much time on other circles and need to take time and energy to invest in yourself to rebuild your feelings of self-worth, to recognize that this circle is indeed as important as the other two. Often, more important.

Maybe you have a specific self-improvement goal such as a change of image, learning a new language, or taking up horse-back riding, or becoming a master gardener, embarking upon a personal learning experience or some other *I want to do this for me* personal goal.

Why give up or surrender your precious days on this earth to sadness, self-pity, or regrets? I could have certainly stayed in my *"poor me"* **Self Circle** with all I have been through, as could so many countless others who have endured so much. Instead we decided to create a life that worked best for us, living an existence that was oriented toward the future, not the past. And so can you.

> *"The purpose of life is to live it, to taste experience to the utmost, to reach out eagerly and without fear for newer and richer experience."*
>
> **– Eleanor Roosevelt**

POWER TOOL OF COMMUNICATION

One of the biggest discoveries I made was learning how to use this tool. I could never have achieved one fifth of what I did without it. As you are navigating this new reality of life, this power tool can make an enormous difference in how well you get others to adjust to your new way of thinking and to respond to you in a positive way. This tool will allow you to guide your life in the direction you want to go. Sadly, the mistakes we make in communicating can create a flurry of unsatisfying interactions. Perhaps, a fight erupts because of the way something was said or responded to and then the stress on the uneasy relationship dominates our days, stealing our time and energy.

We do a lot of talking. Almost from the moment we are born, our happy parents coach us to say, "Mama" or "Dada" as our first words. We babble and learn our ABCs. Next, it's the teacher's turn. We learn proper grammar and correct pronunciation. We learn to read, spell and write book reports.

But do we learn to *communicate*? Do we ever learn how to manage our words, our expressions and our tone of voice to get the results we need? Some people are naturals... you've heard the term "natural-born salesperson?" But for many people, communication is a responsive action, and they struggle to find the right words, often with unsatisfactory results.

Highly successful people in the business world know the value of effective communications and frequently attend seminars to enhance their skills. Many of the senior players in Corporate America hire coaches to help them refine their communication skills, thus their ability to lead and therefore their value. During the last few years, some colleges have begun to offer communication courses covering the use of emerging media

technology and social media and the understanding of these technologies for communication. But if you don't have the opportunity to participate in such programs, how do you improve your ability to communicate?

It can be tough. Have you ever asked someone to do something — perhaps a friend, or a co-worker — and explained it thoroughly, or so you thought, and then it was done completely wrong? It happens all the time.

Sometimes it can be the simplest thing, like agreeing to meet at a certain time at a certain restaurant. One of you winds up sitting alone at the table for a very long time because of some misunderstanding in communication. Or have you ever had a "heart-to-heart" with your significant other, only to realize three weeks later, they did not come even close to getting your message? Have you ever been completely surprised by the intense response of a friend to a seemingly casual comment? Did you ever cry yourself to sleep at night, confused about what sparked a fight with a loved one?

We automatically assume that talking is the only way of communicating, but there are lots of different ways. For example, has anyone ever growled at you? It may not be talking, but it sure is communication. You know you have a problem brewing if this happens.

The *tone or volume* of our voices communicate our emotions. We communicate with our entire bodies by the way we move, our posture, the pace of our walk, the way we sit. Are we comfortable or do we fidget on the edge of the chair? If your shoulders are slumped and your head's hanging down, what's the message? Sadness, vulnerability, insecurity? Those are obvious examples, some are more subtle, but indeed

our physical demeanor can often speak volumes. All this is communication without a single word being spoken.

And then there are the people who can command our attention just by their presence. Before they even say a word, something in the way they stand or look, or the way they enter a room, or the way they begin a phone conversation, says: Pay attention.

Communication is our link, our connection to others; how well or poorly we communicate determines how well we'll connect.

Miriam Webster defines communication as:

> *"The act or process of using words, sounds, signs, or behaviors to express or exchange information or to express your ideas, thoughts, feelings, etc., to someone else: a message that is given to someone: a letter, telephone call, etc. communications: the ways of sending information to people by using technology."*

Sounds simple enough, but communication is undergoing amazing changes now, every day. The many types of electronic communication reduce the number of face-to-face interactions which were the predominate ways we communicated before. Millions of people now conduct transactions through the internet and no longer see the person at the other end of the transaction. The changes in communication in the workplace boggle the mind. At home, how many phone calls a day do you get from someone selling you something, urging you to vote for a candidate, or announcing you have just won a 60" wide screen? Or that FREE vacation? Often, they are done by robocalls... not even a real person but a robotic voice to entice you to answer

yes, you want to learn more. But is that communicating? No, of course not.

"Telecommuting" is a word that didn't exist a decade ago. A co-worker will be working there, while you're working here, and yet you'll be working on a project together. And together you can be either very effective or not depending on how well you truly communicate... through the computer. And yes, in those cases, that is communicating.

Yet what will remain constant through all these examples is the connection between you and others and its critical importance in enhancing your life. Whether it is your co-workers, your loved ones, or the person who handles your credit card inquiries, all will be much more effective once you learn how to use communication as a power tool to achieve the results you want.

Once our words are received, we can't take them back, can we? Whether they are said personally or sent over faxes, text or email, once the message is sent, that's it. There's no undo or delete button to save the day. But, boy, aren't we careless about what we say? Why do we throw out words, written or spoken — before we think?

Why? Because we are human — and we let emotions get in the way; we get angry. We're hurt, and we try to hurt back. Because we make assumptions, bad assumptions. We rush to judgment; we rush our responses.

In the past, when something bothered me, I immediately let words roll right out of my mouth without thought or consideration of the result. Then the day would be filled with angst: had I ruined a good friendship? Was my **Work Circle** exploding

minute by minute because my boss had that disapproving look on his face and I knew I had crossed the line? If I had the **Power Tool of Communication** earlier in my life, I could have prevented those instances where my own actions threw my life into disarray. I told you that I wanted to be "successful" and make a lot of money. Fortunately, I realized I couldn't do that by communicating poorly with others. I *had* to stop the negative communications that were destroying my links to others. Negative communication leads to resentment and enemies. Can you be truly successful if you leave a trail of enemies behind you? I doubt it.

I am not expecting you to suddenly obtain superior verbal skills simply because you have this knowledge of the **Power Tool of Communication**. My desire is to help you learn how to wield this power tool to your maximum benefit.

Let me teach you a few key phrases that I have learned to use to create an" *intermission"* in stressful situations. These phrases will help diffuse a situation that appears to be headed to disaster mode. These are phrases that will allow you to be kind to people in turmoil and be more effective in helping them solve their problems and in keeping the door open so that you can create a positive level of communication. Phrases that, once learned, can be used in your daily communications. Try to memorize them.

- "I can appreciate that."

- "I understand you may feel that way."

- "What can I do to help?"

- "So sorry to hear that."

- "Thank you for telling me."

- "Let me see if there is anything I can do."

I once attended a week-long entrepreneurial management course run by Harvard University and taught by a brilliant professor, Jeffry Timmons. When writing his book, *The Entrepreneurial Mind*, Professor Timmons defined **entrepreneurship** as "the ability to create and build something from practically nothing." From personal experience, I can attest to the fact that I, a successful entrepreneur, could not accomplish all that I did unless and until I learned how to control my actions and ensure my words were communicated and understood effectively.

And don't forget how valuable the *Take5!* method can be in diffusing a conversation that is headed in the wrong direction. That is a fine example of the **Power Tool of Control** — providing you time to put the ***Power Tool of Communication*** to work!

I am also a believer in the validity of the old sayings that are passed on from decade to decade, from generation to generation. I take the adage, "You can catch more flies with honey than you can catch with vinegar" to heart. I apply honey to my communications, not falsely, but genuinely. Just like myself, I realized other people wanted to be spoken to politely, to be treated kindly, to have positive exchanges, and not go to war with words.

This realization helped me to make another highly effective discovery which I want to share it with you next.

BOOMERANG COMMUNICATIONS!

This was one of the most amazing discoveries I made during my journey. You know what a boomerang is, right? It's a curved piece of wood designed so that, when thrown, it returns right back to the thrower. Boomerang communication goes like this:

- The way you deliver a message is the way in which you will receive your answer.

- How you speak to someone else is how he or she will speak to you.

- The non-verbal communications that you send out will be mirrored and sent back to you in the same way.

- What is sent out comes back in the same manner and tone as it was delivered.

This part of the **Power Tool of Communication** is one of the strongest pieces of knowledge I can give you.

You begin it... you are the one who tosses out the boomerang with gentle, kind, respectful words, words that will be so effective at eliciting a response that you want to hear, both in your verbal and written communications.

What a difference this made in my life! I began using the Boomerang delivery method first at work. I used "please" and "thank you" and complimented others, whenever appropriate. My co-workers would smile and respond in kind to me.

Whether it was by phone, text, email or letter, I was courteous, respectful, and gentle in my communications. Topics that were potentially negative in content were handled with the Boomerang in mind. I delivered the message nicely and

respectfully, and that's the answer I got back. Work evolved into being a more pleasant place to be.

I began using Boomerang in a very positive manner all over the place. For example, if the food at a restaurant wasn't quite right, I wouldn't get upset with the waitress; I would smile, thank her for her service, and ask if she could please change the meal. She would respond to me the same way — with a smile, an apology, and willingness to happily solve whatever problem there was. Often, she took the initiative to have the bill adjusted as well. Same response with the harried retail clerk who was mishandling my inquiry. I would gently, in a soft voice, deliver my request and he responded the same way. Boomerang Communications.

Let's consider the dreaded calls you must make regarding a computer problem, or a product which was delivered broken, or the loathsome calls about the poorly done car repair job, or the bill you received in error. These calls often start electronically, with instructions to push # for service, and then again and again before you can speak to someone. And in today's global society, there is the likelihood you will be conversing with someone far across the world, which may present another set of challenges. Here come Boomerang Communications to save the day. I understand you may be terribly frustrated waiting ten or even twenty minutes to get to speak to a real live person. Perhaps your initial impulse is to take that annoyance out on this person; annoyance loud and clear as you present the reason for the call. Let me remind you that the person you are finally talking to has no knowledge of that fact that you've already been on the phone so long.

Here's how Boomerang Communications will help. You begin the conversation with a *request,* not a demand. "Do you think

you can help me with my problem?" "I am having a terrible problem with my X; can you help me?" IT WORKS. Boomerang, a nice request, not a demand and the other party will jump through hoops to help you. He will be as kind and understanding as you have been. I know from many experiences that you can expect that he will be diligent in obtaining the info you need. Frankly, in today's society, where respect seems to have evaporated, yours may be the only pleasant call of his day.

I found this approach is particularly helpful in your work environment when dealing with the delicate issue of delivering bad news to someone.

As a boss, I've often had times when I needed to deliver bad news — maybe to criticize an employee's performance and hopefully encourage her to step up her work. As an experienced employer, I have learned that criticism can backfire. However, coupled with a plan for improvement, that employee review can generate some substantial positive results. By always remembering to use my Boomerang in communication, I have been able to talk to the employee calmly, in a kind, but positive manner. Since the initial conversation has a negative overtone, Boomerang guides me to be particularly sensitive and respectful. It has been my experience that the result is that the person responds with renewed enthusiasm to do the job better.

Throughout my career, I have said "Thank You Boomerang" time and again. Because I could effectively communicate, I was able to bring teams to work together in order to accomplish goals. It truly helped me be successful. I used the Boomerang of enthusiastic communication and inspired enthusiasm in others. The more I increased my communication skills, the more valuable I became in the business world. To this date, those skills have helped me guide many successful businesses

including a $90 million organization as its chairperson. I believe one reason I am repeatedly asked to serve in these prestigious roles is because I have learned how to use this **Power Tool of Communication** quite effectively, guiding consensus within these groups. I think before I speak and use this power tool every day, supported by Boomerang Communications.

Regardless of how you initially feel about this Boomerang concept, trust me and begin using it all the time. I guarantee, yes, I said guarantee, you will see positive changes in your relationships and interactions with others

WORDS NOT SPOKEN

Here is an eye-opening story about communication through words not spoken. Earlier in this book, you learned about the tragic loss of my mom and the void it created — that cavity in my soul. For years afterward, I was disappointed because my father never seemed to appreciate me, never told me that he loved me. Our relationships with our parents, deceased or alive, are so very complex, aren't they? So often they are at the very core of our **Relationship Circle**, serving as the paradigm for much of our behavior in other relationships. I always yearned for my dad to say, "I love you, Donna." He never did.

It came to pass years ago; my father was in the hospital to have open heart surgery and he called me bedside just before he was to go in for the procedure.

He whispered in my ear, "Donna, I just want to tell you that I love you."

Here, amid this trauma, when one is normally in despair, I felt conflicted because I was flooded with feelings of happiness and joy. Sure, the fear for his health was still there but, frankly, my heart took a happy blip because I couldn't remember a time when he had ever said that before.

During the hours of surgery, the family anxiously waited for reports from the doctors saying that he would be okay. We had hours and hours of waiting with little to do but think. Perhaps the time to think gave me a special opportunity because it occurred to me, with a sudden jolt of awareness, that even though I had always wanted him to say, "I love you," it turned out that all of these years, he had always been saying it in his own way. He's always been telling me, "Donna, I love you." He used non-verbal communication.

How could I have been so unaware? Didn't I know he loved me? Didn't I know that every time he picked up one my kids from school when I couldn't, every time he called to remind me that my car needed an oil change, every time he worked with the plumber to fix the leaky pipe in my house, didn't I know that he was telling me he loved me? All those times, he was saying, "I love you" in his own way, hundreds of times over the years.

Let me visit words not spoken in the **Work Circle**. During my years as a certified career counselor, I interviewed thousands of individuals seeking to make a job change. Certainly, career advancement and increases in compensation were discussed, but so often there was an underlying motive: It was that the individual did not feel appreciated at work. She would share her views that she worked very hard, was dedicated to the company, and yet never heard a word of thanks. That often was the catalyst for her to be seeking a new job or worse, for

her to become unhappy at work, which then spilled over into all aspects of her life.

Here is a bit of work advice for you: Look for the words not spoken in your life, both at home and at work. Does your boss allow you some flexibility when you need it? Does he or she say okay when you must leave a bit early to handle something personal? Looking for the thank you but don't get it? Please recognize that some employers are simply not good at people management. Some bosses are not capable of conducting reviews to give the feedback that you may be seeking. This is particularly prevalent in smaller organizations. A company that has growing pains or is in stress due to business competition often may absorb every thinking moment of your boss. Many employers often apply the philosophy that "if it isn't broken, leave it alone" philosophy.

So, if you are performing adequately, yet your supervisors just leave you alone, yet at the same time you are seeking affirmation of your worth and value, what can you do? I want you to learn how to use your communication tool to seek out what you need. Request a short meeting, when it is convenient for him or her. Your goal initially is to verify you are doing all that needs to be done and secure a confirmation as to your abilities and the acknowledgment that you are an asset to the company. Explain you don't need daily recognition but want to make sure they are as happy with you as you are with them. It should open the door to some very interesting conversations.

I also recommend that you try to be more understanding of the challenges your boss may be facing. By being tolerant and empathetic, you become the employee of choice and you are the one who will be recognized as an asset.

Taking my life from despair to millionaire meant that I had to, often, put myself in my boss's shoes and recognize that he had more on his plate than taking the time to pat me on the back. I worked hard to become that truly valued employee. I didn't seek out constant affirmation as to my worth. Instead, I did the best job I could and with each paycheck heard the words unspoken, hey you are doing a good job. I figured that if I was not doing a good job, I would not continue to be employed there. Would I have liked the "pat on the back?" That would have been a bonus, but frankly because I was not the troublesome or needy employee, my value, my worth increased. Once I became a boss, I realized how valuable that quality (not needing constant reassurance) was in an employee.

COMMUNICATION AND TECHNOLOGY

Did you know that more than 281 billion email messages are sent every day, according to the Radicati Group's recent report?[5] That's about 74 emails for every one of the estimated 3.8 billion email users in the world, and by the time you are reading this, those numbers have probably increased significantly.

I wonder how many of these billions of emails sent each day achieve what the sender set out to accomplish? We text and email multiple times a day to a co-worker, the other PTA parent, our significant others, children, strangers. Ever have one misinterpreted? Misunderstood? The nuances of personal communication are lost among a flurry of words sent without scrutiny or second thought. Yes, I know you have heard this before, but allow me to give you a "how to" on this topic because if I had known then what I know now, I would have salvaged

5 https://www.radicati.com/wp/wp-content/uploads/2017/12/Email-Statistics-Report-2018-2022-Executive-Summary.pdf

a few lost relationships. And I have watched careers blow up because of technology mishaps.

THE LIFE-CHANGING SEND BUTTON

I expect that you have heard this advice before, but I feel it is so critically important to your success, that I want to reinforce it here.

In a hurry? Have you ever hit the *could-be-life-changing* **Send** button only to realize you replied to "all" or included a person on the response who should not be included?

In the world of electronic exchanges, whether a text message or email, it is imperative that you apply all the advice in this section regarding your ***Power Tool of Communication***. Miscommunication happens so quickly and can be so damaging. You should use the same communication power tools in your electronic communications as in your verbal ones. Using these tools will keep your message focused and ultimately save you from spending your time doing damage control. These electronic communication mistakes happen at every level, from the newbie in the company to the most senior staff. And automatic spell correction has brought a few people to tears. I urge you to pause before you hit that button. I urge you to pause, review the voice or text message you are leaving to make sure it is what you want the message to be.

Communication has become concise and short, and the adage "brevity is the soul of wit" finds widespread implementation, though unintentionally. But if YOU want to rise above your competition, if you want to avoid having misunderstandings that create trauma in one circle or another, you must use the same careful, thoughtful Boomerang communication

techniques in your electronic transmissions. All the increased access to blogs, online chats, live coverage of news, and other such media-related initiatives have created global access and participation in news and information for almost everyone. Twitter, Facebook, Snapchat — all of those and many more can be fun and certainly provide access to people and topics not easily accessed a decade ago. But please approach those with caution. Think before you hit the ever-powerful, could-be-life-changing, "Send" button.

Keys to Successful Communication

I've given you some features of this tool of communication in the above advice and examples. Yet there is more to learn in order to become a great communicator. Here are some additional skills and strategies I teach as keys, because I most sincerely believe they can and do unlock the door to powerful communications. The three keys to start maximizing the *Power Tool of Communication*:

1. **Listen**
2. **Be clear**
3. **Communicate positively**

The First Key: Listen, Listen, Listen, Listen

Really listen to the other person. Try to understand his or her needs and concerns. So often we break in or interrupt someone. Far too often, we are more focused on our own responses than what the other person is really saying. Please take the time to listen.

Here is an interesting note. I have attended many seminars and I've asked highly successful salespeople, generally the top performers in their industry, "To what do you attribute

your success?" They tell me time after time, it is their listening skills. They are experts at listening — listening to the other person's wants, listening to how much the prospect can afford, listening to their problems and concerns. These sales professionals make hundreds of thousands of dollars a year and they tell me they were able to make the sale because they listened.

The same approach is also listed in almost every leadership book I have read. Interviews with high achievers also include references to their excellent listening skills. This is an easy skill to enhance. A simple change in your behavior to enhance your life. A simple change to bring you closer and closer to your goals.

You don't always have to be talking. Do you know that silence is okay? Silence is a form of communication too. Be silent before you rush into a response. Stay silent — to think.

Listen and listen carefully and you'll know what's going on with the other person and determine how to respond. If you listen, you won't be confused about what to do next or how to respond. Just remember, that sometimes the other person needs no response. They just want you to listen to them. "Hear me out," they say, because in today's fast-paced world, it seems we just don't slow down to listen often enough. Remember to pay attention to the tone of their voice, and if in person, to the slope of their shoulders: are they leaning forward to reinforce that they want your undivided attention? Grab this first key to the ***Power Tool of Communication*** and listen.

THE SECOND KEY: BE CLEAR

It's easiest to explain this key through examples.

Here is an example of unclear communication: "You wouldn't want to go out to dinner tonight, would you?" This communication leaves open several possibilities for interpretation. One is that the person asking the question really does want to go out to dinner but is afraid the other one doesn't. The other is that the person asking the question really doesn't want to go out to dinner and is hoping the other one doesn't want to either. Clear communication would be: "I would really like to go out to dinner tonight. Does that sound good to you too?" Or, if she didn't want to go, she could say, "I really don't want to go out to dinner tonight, but I have a sense that you do. Am I right?" Or, "is that okay?"

Now for a common example of unclear communication: Have you ever heard someone say, "Get back to me as soon as possible?" That can be confusing. What does it mean? What is "as soon as possible?" Is as soon as possible based upon you devoting one quarter of your time to retrieving the requested information? Will it take half your time or all your time? Is this to be a moderate priority in your life or a full priority? Or is it something you can get to whenever you can? An example of clear communication would be: "Please get back to me on this no later than Friday the fifteenth by noon, or even sooner, if possible."

And then the individual with superior communication skills will perhaps add to that above sentence with, "if you think that you cannot complete this by the time I cited, please let me know now and we can talk about it to determine options."

That's clear communication. Clear communication means exactly what it says. It means being clear and concise about what you want, what to expect, what you feel, and what you are thinking. Be clear.

Are there times when you are not sure if the other person has heard you correctly? Then you need to restate it or recap it. It is amazing how much gets lost in both the delivery and the translation. In my business, I have been responsible for training many people. As a matter of fact, one of our divisions offered training for employees of outside clients, so we were involved in enhancing the skills of a wide range of employees, from the greeter at the front door to senior managers, including those technical types who often don't always see the value in enhancing their communication abilities.

Often, I found that the new person on the job would be particularly nervous and wasn't able to focus as effectively on the information given in training; those first weeks or so can be overwhelming.

We taught with charts and videos and the standard one-on-one. All were well-received but the one method that really stood out from the rest for gaining great results was using our modern technology in a rather unique way. We would record the entire training session either on a recorder or smartphone. The individuals being trained would then be asked to listen again to the recorded material and prepare a written summary of the session. What a wonderful help that was to both parties, to be able to see in black and white what they heard or thought they heard! There were times when my manager and I apparently had not effectively followed the key to "be clear" and we would get more than a chuckle reading what the newbie had prepared.

If you only use the first two keys — "Listen" and "Use clear communication," you will already see a remarkable difference. Here's a third key that will help even more:

The Third Key: Communicate Positively

Communicating positively means do not communicate to hurt, offend, or belittle others. We live in a society that celebrates and revels in bad news. The sensational news media shout headlines of negativity. How about all the gossip columns or the talk shows? People are shown being cruel to each other on national television. Screaming! Name-calling! Reality TV is not an example of how we should interact with one another. These shows exist only for the sensationalism. We have become susceptible to thinking that's how we should conduct ourselves. *It is not.*

Make yourself a promise. Never use words as knives — to cut someone — even if that someone has hurt you very badly.

Promise: I will never use words as weapons.

"You're useless!" "You're stupid!" "How could you have done that?" "It is all your fault we lost that account." "If only you had been more careful." So many times instead... the hurtful words and names are used as a hatchet. With those closest to us — our friends, our lovers — we have the most ammunition. We know them and their secrets. We know where they are vulnerable. And then, so sadly, we use words as weapons, to hurt and often destroy.

Words used as weapons have pierced my heart like an arrow. I learned from those arrows. They led me to make a promise. The very essence of Key 3 is to promise absolutely, "I will never use words as weapons."

Words, whether thought or spoken or written, are one of the most powerful life tools we have.

Words can be beautiful gifts or brutal weapons. How you use them is a choice only you can make. Whether they stay in your mind or in your heart, or whether you share them by speaking or writing, please be very careful.

When on the job, or on the phone with a friend, or having a heated discussion with a loved one, choose to be gentle, kind and sensitive. You are the winner in the end. You are the one who feels good at not violating the space of friendship with nasty words. You are the one who is building her self-esteem by being in control.

When you commit to using the three communication keys, you will marvel at how much happier your communication exchanges can be, how much more successful you will be at making good things happen for you and those you love, how much more loving your relationships will be.

Miscommunication can inflate a circle creating a fire — like spontaneous imbalance. But if the right tools are used all along, then miscommunication can be avoided. Use your **Power Tool of Communication** to create effective exchanges, to resolve issues, and intelligently to avoid creating problems. It will have very positive results in your personal life and your career as well.

PACKAGING

Often when I conduct a seminar, I have a table with two packages sitting side by side. One is wrapped in brown plain paper, no bow. The other is in a white sparkly paper, with a huge white bow affixed to the top.

Identifying a winner, we call her to the stage and ask her to select one of the packages. Ninety-nine percent of the time, she will choose the white, attractively wrapped package; it is far more appealing. Inside, the contents for both are the same. Same prize, different packaging.

This applies to conversations as well. Focus on offering your message, your conversation in an attractive, positive, friendly manner.

Along those lines, have you ever heard that people like to do business with people they like? I offer another version of that. *People like to do business with people who like them.* In that example, when the interaction is ended, the other person feels good about themselves, they feel liked, appreciated. The thought process is "she/he likes me... they are such fun to talk to," and then they are likely to be responsive the next time they are going to interact with you. People will remember what you do, and what you said, but they remember the longest how you made them feel. I built my career on this approach. Never be a phony though, because people can see through that. I think that is the reason I liked going to work so much because, often, I ended up dealing with people I truly liked, and they liked dealing with me.

BEYOND THE WORDS

Smile, smile, smile — a smile can communicate more than hundreds of words. Before a word is spoken, your smile can set the tone – a positive tone.

Even though some of the communication you have in today's ever-changing world will be over the phone, you should still

have a smile. You've heard it said that there was a smile in her voice.

Want to know how you sound? Record a few of your conversations with close friends. What do you hear? Are you constantly whining and complaining? Are you somebody you would want to listen to all the time? Do you sound open and welcoming? Would you want to talk to you? A lot of people are very concerned with how they look, women make sure their hair and nails are done. Men polish shoes and other personalized appearance tasks. They examine themselves in the mirror, wondering how others will see them. Do the same thing with how you sound. How do others hear you?

As I said previously, we communicate not only with words, but also with our faces, our eyes, and our bodies. And in today's global interactions even the pitch or speed of our voices communicate emotions. Very often, someone's words may say one thing and their non-verbal communication says just the opposite. You've heard people say, "She told me everything was okay, but I could tell by the coolness in her voice that it wasn't." Or "He told me he wasn't angry any longer, but I could tell by the expression on his face that the anger was still there." The look on your face — a look of anger, a look of fear, a look of happiness, a look of joy and understanding — communicates a lot. Have you ever just looked at someone and said, "Wow, does she have a bad attitude." Or "Boy, is he annoyed." Sometimes a look of gratitude on someone's face says it all. In each of those situations and thousands more, not a word was spoken, and yet communication took place.

When someone is very excited, words come spilling out, faster and faster, almost seeming to tumble over one another. Maybe the person is excited because he or she is happy, having good

news to tell. Then the joy and the enthusiasm expressed through the tumbling words would reflect an upbeat tone, communicating positive feelings. On the other hand, if they were excited because they were angry, the words that came tumbling out would increase with the intensity of the anger, communicating negative feelings. The speed of the words increased in direct proportion to the increased anger, so the words and actions were communicating together.

Sometimes when people get excited, they tend to yell. The volume of the voice goes up. And what happens? Often, it sparks a mirror reaction from the other person If you raise your voice while speaking to someone, they will very likely raise theirs to you. Lots of screaming matches start this way and end up with hurt feelings and a ruined relationship — or a blown opportunity or a messy situation at work. It is the boomerang used in reverse. Thrown with anger, it initiates an angry response.

I have a little rule regarding the tone, pace, and volume of my voice. I apply this rule particularly when communicating negative information or news. If I am communicating negative information, with negative emotions involved, like anxiety, anger, or annoyance, I speak slowly and softly. Speaking slowly keeps the pace under control. Speaking softly keeps the volume down, under control. Slowly and softly helps avoid those situations where the negative responses explode, taking over, ruining all chances for a productive conversation.

Is someone yelling at you in person or on the phone? Speak slowly and softly and you will begin to change their tone too. The Boomerang applies to your responses too. Our words, our actions, our silence speak volumes.

I achieved my trek from despair to happiness, to financial success, to family love because I reached for this **Power Tool of Communication** over and over again. Embrace this advice and you will see astounding changes in your relationships both professional and personal. It will take you on a path of continued success in all aspects of your life.

Resolving Conflicts

One of the most disruptive situations in your daily life might be the sudden ballooning of a circle because of a conflict. Sometimes this happens because of something you chose to do or say, other times the situation lies outside your control and the only choice you have is in the way you respond. I learned it was up to me to fix these conflicts. I called them conflict zones and eventually learned to recognize some warning signs that something or someone was about to erupt.

If there is an issue with one-on-one communication, the warning signs can be verbal; the tone of the person speaking, how loudly they are speaking, or the nonverbal communications such as facial expressions or body language. Those are warning signs that you may be entering a conflict zone. Do they keep interrupting? Or conversely, are they now quiet? Withdrawn? Body language is defensive? Oh yes, extreme silence sounds a warning clarion too. When a person shuts down their communication, look out, often it can be the calm before the storm!

Are you aware of your own reactions when you see these warning signs? Perhaps your heart starts pumping faster and your mind races trying to imagine, "what is she going to say?" How should you respond? What are you feeling? Anger? Fear? Confusion? By now, I hope you realize you will never resolve

the issue by allowing your anger or fears to take over. These are the times when you must reach for your inner power and turn on those **Power Tools**!

It is up to you, always you, to take the initiative to resolve the situation. It does not matter who is right or who is wrong. The conflict, whether in full bloom, or about to happen, needs to be handled and the resolution started by you.

Here is a small, but valuable tip: whenever you begin what may be a volatile conversation, lower your voice. Speak more softly than ever. I am not a linguist, so I don't know why it works, but it does. Many people think that a linguist is someone who speaks many languages and works as a language teacher or as an interpreter at the United Nations. In fact, these people are more accurately called "Polyglots." While many linguists are polyglots, the focus of linguistics is about the structure, use, and psychology of language in general. My first step is to dramatically lower my voice, speak softly.

The next step is to use your **Power Tools** of *Control* and *Communication* and don't let your words become weapons. Focus instead on these keys:

Listen to resolve the conflict gently:

- Separate fact from emotion.

- Agree to an action plan.

- End the exchange with a smile.

Let's discuss them one at a time.

KEY # 1: LISTEN... TO RESOLVE THE CONFLICT GENTLY

Yes, I am emphasizing this listening skill once again. Listen and let the other person tell you his/her point of view. You won't be able to resolve the conflict by thinking about your next comments while he is trying to tell you his point of view. Listen and don't interrupt. Take turns talking. Listen thoroughly to gain understanding of the other person's point of view. No one wins if a conflict is left unresolved. It's not a competition. The goal is **resolution and agreement.** Speak softly and slowly, be gentle, and use all your new skills including positive statements to open the dialogue. Stop talking, *Take 5!* or longer, and listen.

KEY # 2: SEPARATE FACT FROM EMOTION

Use this key to remove emotion from the discussion. Emotions just cloud the real issues of the conflict. It is important to be honest with yourself — what are the facts, not how do you feel, not your emotions! Emotions will distract you from listening.

Emotions such as:

- He hurt my feelings.

- She makes me so mad.

- I get so angry when he acts like that.

- Her uppity attitude makes me feel so small.

- I resent him interfering.

- How dare she?

If you allow emotions into this communication, you cannot be honestly focused on resolution. Discuss the facts of the situation. Focus on those issues. If the other person brings their

emotions into the conversation, listen politely, don't interrupt, but once they have finished, say I am sorry you feel that way, let's discuss what happened or the issues here.

Key # 3: Agree to an Action Plan

Then, discuss possible solutions. What needs to be done to fix the conflict or to prevent it from recurring? Each of you needs to agree to what will be done. The conflict continues until a plan is designed and agreed upon. If the solution does not appear clear, push the other person to keep talking, let them vent and listen carefully, because often the answers, the ways to resolve this, are in their words.

It's important to make every effort to resolve the conflict and to put a plan in place as quickly as possible. Don't try to just sweep it under the rug. This just creates a bulge in the rug over which someone inevitably trips, and the fall will be a hard one for both of you.

Key #4: End the Exchange on a Positive Note

I also refer to this as end the exchange with a smile. If it's a face-to-face discussion, give the other person your best smile, handshake, affirmation that all is okay. If the discussion is over the phone, put a smile in your voice. I realize that suggesting a smile may sound silly. Some people feel... Oh this is kid's stuff... smile? But I am telling you that it works! I believe the adage "If you see someone without a smile, give him one of yours!"

And the final word of caution: Remember that the goal is to resolve a conflict. Don't get caught up in winning an argument just for the sake of winning. There is no winner when conflict

goes unresolved and a relationship deteriorates. Resolve and close the door on it. And keep it closed.

One of the people working with me to proofread the book suggested I think of an example of a situation where I used the four keys cited above in my work environment. I laughed out loud. One example? I have had to use these conflict resolution keys almost weekly. Sadly, our personal lives and our work lives often overflow with conflict, some large and some small and I am sharing with you the methods that worked the best and that I used to resolve them.

CONFLICTS AND RELATIONSHIP REPAIR

During high school, my armor, my defense mechanism, was a smart mouth. I created conflict far more often than necessary. No one exists on this earth without an occasional conflict with another person. Just the way it is. So, what can you do if a conflict has been in full bloom for a while? Is there a way to stop the conflict? Is your life spiraling out of balance because of this conflict? Can you repair your relationship after a conflict?

Have you ever spoken this sad sentence? "We were such good friends once, but then we had an argument over... well I really can't remember all the details... but we were really good friends once." If you have ever been given the gift of friendship, care for it, nurture it. Don't let conflict deprive you of these special life gifts. Once I learned to resolve conflict, all my relationships became stronger. Today some of my closest friends are those with whom I had a conflict, which, when resolved, allowed our relationship to grow to the next plateau.

The ***Power Tool of Communication*** is the same tool whether dealing with a lover, friend, family member or

co-worker or neighbor. Of course, once a conflict begins, it poses a bigger challenge to halt and begin the steps to resolution. But if you take the initiative in a soft voice or manner and are forthright that you want to resolve the conflict, I believe that you are more than likely to find a positive solution.

It is quite possible that a relationship may suffer long-term consequences from a conflict. Therefore, you should try periodically to see if you cannot get that relationship on a more even keel. In your personal relationships, a conflict once resolved can perhaps be more easily forgiven because of the love and generosity of those in your life. The major piece of advice here, however, suggests that you should not allow a conflict to stay unresolved and should make every effort to begin conflict resolution using all of your power tools and most sincere effort.

Unresolved conflict in the work environment, whether a coworker with whom you interact daily or the occasional person on your committee, should be addressed as soon as you can. Otherwise the long-term potential for it to grow beyond repair festers daily. What can you do to fix it?

Certainly, there are those times when it cannot be truly fixed, but I encourage to try to do so in every instance even when you may be more than 50% right in your stance.

SURPRISE BENEFITS

HERE IS SOME exciting news that I discovered-when you implement my advice, you will reap some surprising benefits. Real life benefits. Benefits are such an important part of every employment negotiation and the job perks are the extras or add-ons we get as compensation for our work. Well congratulations, you will reap benefits from your efforts too!

CONFIDENCE!

One benefit will be an increase in your Confidence. There are many career options and unlimited opportunities for personal development. Yet, millions of women feel stymied or paralyzed to make the changes they need to create the life they want. Why? They lack the confidence to take their lives to the next level.

Once you accept and begin applying my advice and techniques, you will gain confidence because you will finally realize there are actions you can take to achieve the life you desire. No longer confused or at the mercy of outside forces, you will gain confidence in your own abilities to make the necessary changes. As you evolve and adopt these practices, you will be able to remove the handcuffs that bind you from making forward progress.

As you use these 3 power tools and the other methods I have shared, you will feel less vulnerable and therefore more confident in dealing with these situations. As you choose what is right for you, not letting others choose, you will feel more confident in each step because these are choices you made. And as you learn to put the tools to work, you will be more confident because you will not be pushed into situations you don't want, you will manage confrontational issues, you will be able to more effectively communicate your wishes and wants and be more confident in achieving them. The result? A more Confident you. A hidden benefit to this program.

As you gain confidence by implementing the advice in this book, you will grow your levels of self-confidence to even higher peaks.

As babies, we had innate confidence to explore, to try new things. We didn't think of failure... we didn't worry about ridicule. We were propelled forward... trying ... experimenting. As a youngster, your mind yearned to soak up information. You were curious about what was new, and for most of us, the world then was a positive place.

We wanted to walk, so we tried. Our parents watched for our first step and encouraged us, even if we stumbled and fell. They said" Wow, that was good." Yes, I know we did not have awareness of this and that's part of the point. It was natural, innate for us to have a certain degree of confidence. We didn't say to ourselves, "Boy that was clumsy of me... falling down in front of all those people. From now on, I'm going to be carried or I'm not going anywhere." No, we were confident, we focused on the prize, and we believed it would be great to walk. **We had confidence**. We kept at it and eventually we walked. We didn't give up.

And think of your first word! A garbled noise only a mother could interpret and yet, when you said, 'da da,' it was music to her ears. Your inner self didn't say "Oops I meant to say Daddy, but it didn't sound right so I'm not going to try that again." A small child learns by trying. Most children will keep at it because, in their minds and hearts, they know what they want and they're not afraid of making mistakes until they get it.

What happened to this confidence? As we got older, maybe we noticed people watching us and realized they weren't always on our side. Sometimes it even happened in our own loving home environment. Maybe a big brother or sister pushed us or laughed at us. Or maybe mom or dad did something to wreck our confidence.

Once we hit school, we certainly had challenges to our confidence both on the playground and in the classroom. Ever have the experience of a teacher correcting you in front of all your smirking classmates and you were embarrassed? We'd cringe at their criticisms and a bit of our natural confidence fell by the wayside. We tasted failure — some small, some large, and it would eat away at our confidence. A bitter taste staying in our mouth for years, sometimes a lifetime.

"School days, school days"— that was not a pleasant nursery rhyme for me. I've shared the fact that I was just a toddler when I was scarred forever in a terrible accident, so it was difficult being "different and ugly" on the playground. My high school years were horrible too, although I would never want to confess it. I was tall, felt gangly and, after my mother died, I was a social outcast, a label imposed because I could not attend the football game or dances, so that made me "different." I was convinced no one liked me then, and I never felt I belonged — I was the outsider! Have you ever heard the term "defense

mechanism?" I developed one — a chip on my shoulder — and a smart mouth! I could roll off a sarcastic, cutting response so fast I could stop anyone in their tracks. In almost every conversation, I *imagined* rejection, so I would come out shooting as they say with cynical, biting comments.

A few years ago, I attended a high school reunion where the committee had compiled an alumni directory with information on each graduate. As I was talking to a former classmate, she remarked about my many accomplishments and the other notable comments listed on my page. She was really impressed with the success I had achieved. She said to me, "You've really done well for yourself and in a business dealing with lots of people. You never would have thought it back in school; you always were so unfriendly and clearly didn't want to be bothered by anybody." I was floored! I wonder — how many other schoolmates thought the same thing — that I didn't want to be bothered? They never knew back then I was so lonely for a friend, for someone to like me.

How sad... without confidence, my image of myself was really low... so low that I didn't offer friendship. Instead I wore an armor; I protected myself from imagined hurt by pushing them away before they had a chance to do it to me. I've learned over the years of counseling other women that so many of us feel rejection, real or imagined. And it destroys our confidence levels. Fortunately, I was able to embrace change and grow. I worked at self-improvement and used the power tools and techniques I am sharing with you in this book. As I said they gave me increased confidence, a hidden benefit gained during my journey.

As you too start to feel more confident, you can embark upon the next level of transformation. It did not happen overnight for

me, but I learned by implementing some basic steps. They may seem simple in some respects, but it has been said that often the solutions to our greatest challenges are the simplest ones. The next section of this book includes actions you can take to build your confidence to the highest levels. Please remember that no one is confident all the time. We all still work on it. I have days when I, yes even now, get shaky about a task I have. The first time I was on TV it was so scary. And yes, when you are on TV, you do look 15 lbs. heavier than you look in regular life. And yes, there are no retakes, if you stumble or say hmm hmm...then it is recorded forever. Therefore, I use these ABCs and shall throughout my life.

THE ABCs OF GAINING MORE CONFIDENCE

A — Ask yourself

One important step to building more confidence is to ask this question, "What's the worst possible outcome?" Once you consider how you would handle the worst possible scenario in any situation, everything else usually seems small in comparison. The fear fades, and self-confidence can build. I have used this technique *many, many* times in my life. Asking this question became one of the critical steps to having the confidence to start my own business, to take my goal for financial success to an expanded level. To reach for business ownership seemed to be reaching for the stars.

I was working in an employment agency at a commission-driven job, just beginning to earn the amount of money I needed to support my kids, and I really loved the work. I seemed to be blessed with unique insight for helping people identify the right job for them. It was quite satisfying. My corporate clients were also pleased with my ability to target the individuals best suited for their needs. Since it seemed I had a

real talent or strength in this area, I became very confident in my abilities at this job.

Yet, much to my dismay, I learned that the business was being seized by the IRS and would be closed. I was so distraught. Where would I get a new job — one with the opportunity to earn commissions at this level? Would I need to work two or three jobs to match it? Then, when would I have time to be a mom?

Frightened and confused about my options, I was so scared. Yet I admitted I still loved my work. My initial motive for going into business for myself was to simply keep my job and continue earning a decent paycheck. I was not a visionary who saw myself as the multi-millionaire I became. I just wanted to keep my job and earn enough to take care of my family. Yet, beneath the confusion and lack of confidence, under the lack of any entrepreneurial vision, lurked the tiniest spark of hope. Thus, my journey into being a business owner began.

Passion and desire spurred me on. I would try to take over the business. I figured if we could just keep the doors open, we would be able to make it through. I made call after call, looking for financing, but had no assets, and thus was not credit worthy. The IRS wanted to be paid and yet recognized that closing down the business wouldn't get them a dime. With the help of a wonderful attorney friend, we worked out a deal with the IRS for a 100-year payment plan. I'm kidding; no, it was not 100 years, but it felt that way to me — that I would be forever chained to the IRS. The attorney also found some private money I could borrow so I would have some income the first six months.

The voices of doubt in my mind were very strong: Could I do this? Could I run my own business? Dare I dream that I could be financially independent? Could I finally stop wishing for some prince on a white horse (a rich one) to come galloping in and take me away from poverty? Could I make my children's lives a little bit easier?

The dreams seemed great, but my confidence was so shaky. I had no experience in running a business. Yet, I knew I had an exceptionally strong work ethic and a willingness to always go the extra mile. I had been a smart kid in school, and I felt I could learn quickly.

After days and nights of confusion, I connected with my number one confidence-building step: **Ask**. I asked myself, "What's the worst possible outcome?" Then I carefully considered the answers.

I could fail. What would happen if I failed? What would some of the fallout be? The main answer was that I would have to deal with it and would once again have to go to work for someone else. What was so bad about that? I was doing that now.

What else would happen if I failed? I would probably owe some money and have bills to pay, but after I found a new job, I could pay them over time. I knew I was a good secretary and had solid skills.

That is the confidence I built upon to get me through making this most remarkable decision. I don't think I even knew how to spell "entrepreneur" at the time. By asking myself, "What is the worst possible outcome?" and carefully weighing the answers, I concluded that I would probably survive any difficulties and learn from them. This question helped me to take

the monumental, life-changing step of starting my own business. When faced with a decision big or small, consider that simple step: **Ask** and evaluate the potential results. You will be able to remove some of the fear, enabling you to get a clearer view of the situation, the potential risks and rewards.

I realize that not everyone dreams of owning her own business; nor is "financial success" a universal goal. I share my story so you can understand that, whatever your dream, it can become a reality. Yes, many days of my life at that point became terribly unbalanced, but because I had already discovered the **3 Circles** and learned how to navigate living an unbalanced life, I could handle it.

I also used the first step, **Ask,** when I met Jeff and was falling in love. With two failed marriages and a relationship with an abusive man, I was afraid. I didn't have confidence in my own judgment, and I was afraid to trust again. I used **Ask** and evaluated the worst possible outcome. A wide range of answers brought me to acknowledge that I'd survived heartbreak before. I would get through it. So, I let Cupid do her thing.

There is no reason to go through life full of fear. If you need more confidence in helping you make decisions large and small, start by asking yourself what's the worst that could happen and determine how you would get through it. More than likely, the worst possible outcome will **not** happen, but if you are prepared to deal with it, everything else that follows is quite manageable.

B — Be bold and be brave

"Always do what you are afraid to do."

– Ralph Waldo Emerson

You must be bold and brave on this journey toward confidence. You cannot fear rejection. You cannot fear failure.

I attended a seminar once where a well-known speaker strode up to the podium, looked over the audience of over 2,000, and gave a moving and highly motivational presentation. The content of her speech included an admission of her fear of heights and how she still struggled to find enough courage to go to the top of the Eiffel Tower. I thought to myself, I've done that — stood on the top of the Eiffel Tower and enjoyed the view of Paris. But at the time, I certainly did not think I could stand at a podium and present to over 2,000 people. Shortly thereafter came an invitation to speak to a relatively large group about career selection, a topic I knew well. I applied this step: I told myself to **be bold and brave.** Having knowledge to share transported me from being powerless to powerful, and I aced the speech.

Each of us has our own private demons, (remember the Vampire?) the things that shake our confidence. Identify your demons, and then be bold, brave and silence them. I have since been able to speak to thousands, and I most sincerely hope the speaker has enjoyed the top of the Eiffel Tower.

I was also off to a shaky start the first time I was offered a seat as a member of the board of directors of a large, prestigious organization. My *Work Circle* was huge. My *Self Circle* and self-confidence were tiny. I needed to walk through the door of this boardroom, with all these experienced men sitting at the highly polished wood table — me, a novice... and a woman at that! I supported my confidence by conducting research to learn as much as I could about the organization, its goals and challenges. I learned that knowledge can help equal things out, build confidence, and chase away uncertainty. I asked for the

agenda a few days ahead of time and researched everything before the meeting. This helped me become more confident that whatever I had to contribute would be of value.

As my interest in entrepreneurship grew, I realized my path would always have its twists and turns. I would need to have courage and employ the steps to becoming more confident to make a better life for my children and me. I did and succeeded. I had not, for one second, ever imagined that I would go into business and become a millionaire. Especially in my early 30s!

You are the only one who can make the changes to become more confident. Go for it but do understand that you may have some pain in your life as well as disappointments. Each time you fail, you are in fact building your confidence. Be bold and brave.

Eleanor Roosevelt said, "Nobody can make you feel inferior without your consent."

C- Condition your mind

I once attended a session that stated that neuroscience has found that the human mind cannot distinguish between real and imagined experiences. If you imagine yourself going confidently up to a microphone to make a speech, a part of your mind registers it as actually having happened. Your mind logs this in as a victory you've already achieved. It registers as a "win" in your subconscious, bolstering your confidence. The power of conditioning your mind allows you to think about that upcoming party and see yourself walking confidently into the party alone. You can also think about the behavior of others and plan to expect the smiles and warm friendly greetings of those at the party. The incredible power of thought will work in

your favor, helping you to exude the self-confidence of having already done it in your mind.

The "C" step **condition your mind** allows you to change the world you live in. Condition your mind to see, to really focus on the positive in your life. By having certain thoughts, concentrating on them, and infusing them with positive emotions, we can direct our reality.

Think of it this way. We don't change our apartment by wishing we had a nicer one. We can, however, change how we view things, and that can impact our world. Try this: look around your home or apartment and find the things you like. Maybe it is the big window, the crown molding or the comfortable sofa where you can settle in to read a good book. Condition your mind to focus on the good aspects of this living space. This allows your energy to be focused positively. Your apartment or house hasn't really changed, but how you see it, has. You've conditioned your mind to look at and embrace all that is good there.

Can you change the way you view where you spend eight plus hours a day? Yes, absolutely. Suppose you've been given the task of converting your company's health care provider. Mountains of paperwork and hours of drudgery. Condition your mind to focus on the 132 employee families and how they all will benefit from the new enhanced health insurance plan. Know that you are making positive, real-life changes for hundreds of people. Now the monotony of filling out those forms seems to disappear.

Focus on the positives in your life.

I conditioned my mind to embrace a positive attitude, looking at every situation from an optimistic, upbeat point of view.

I wake up and condition my mind to be positive every single day. First, I am grateful I woke up. With so many members of my family dying young, I truly am grateful for each day I get to live. Emphasizing the positive and diffusing the negatives of life is like using a magnifying glass while reading the newspaper or increasing the screen size on your phone or computer when reading news reports You can place the magnifying glass over the good news and feel great, or you can take that magnifying glass and place it over the bad news and make yourself miserable.

Have I had failures and disappointments? Of course, some of them very big and very traumatic and life-changing in ways I don't really like. Yet, I love my life because it is a life I designed. It is filled with treasures: 9 grandchildren, loving friends, children who are doing well and, yes, the financial stability I so longed for. My mind is filled with gratitude and joy.

The subconscious mind is a powerful influence. You can take charge and discipline your mind — to focus on the positive experiences in your life. Think of all the things you have done well and moment by moment, your confidence will increase. Again, pause and reflect on the positives, the things that you have made happen that have had great results, both at work and at home.

Why is it that some people "drag" themselves to their job every day and others "bounce" merrily into the office? Barring illness, it can often be a matter of attitude. The ones who "bounce" focus on the positive job factors.

When thinking about your work life, find that positive morsel, the gem of something good, regardless of how small. Why did you take the job or agree to be on that committee in the first place? Is that reason still there? Then focus on that. Condition your mind to be tolerant of the people at work, the duties you have to perform and the company or organization itself. I encourage you to do this because, if negative thoughts are crowding your mind, the result is that they end up eating away at your confidence.

Maybe you want to say, "Things are too terrible. There is nothing to be positive about." I ask you right now: Are you so sure? You need to try to find one thing today, just one thing, that you can be happy about and grateful for. Unless you or a loved one faces death, there **is** something in your life about which you can be positive. Come on, you can think of one thing. Then find two things ... three ... and so on.

I know many women (and men) work harder in today's world. Often, they worry less about confidence, or asking for a raise, than about keeping their job. They worry less about getting the new computer and more about health care coverage. The uncertainty of those types of issues can be a real drag, but those situations will stay the same unless you take the steps to change your view of your world.

Conditioning and Mirror Mirror...

Mirror, Mirror on the Wall... a childhood rhyme that continues to ring true as we become adults. Generally, we apply it to the bad hair day or an opinion that this dress makes me look fat. I am suggesting you apply it to your life. Don't like what you see in the mirror when you are looking inside yourself? It can be changed! If the conditioning of the mind seems awkward,

remember it is very similar to visualization. I used this method to help me with scary challenges in developing my career. I distinctly remember sitting in my family room and mentally imagining myself in a large, plush office, in front of all my talented and supportive employees as we enthusiastically reviewed the annual sales figures for our first year in business. We were beaming about our financial success, which was due in part to my great leadership. (Modesty has no place in the realm of dreams!)

This is not a new science. Athletes use this technique to see themselves vaulting over a bar or making a putt or hitting a home run. Like them, I adopted this approach. When I looked in my mental mirror, I saw a very successful woman.

However, I can still recall how frightened I was when I accepted the chairmanship of a business organization with a membership of over 1,000 companies representing about 30,000 people. Remember, I am a small-town girl! Augmenting my fears was the fact that I was the first female chairperson in this organization's 102-year history. The first female! There was a lot of fuss in the regional media. Some days I felt like a super heroine with my cape helping me soar to the highest levels. Then the next day, I would realize once again this was a major responsibility with awesome challenges. I knew I was paving the way for other women, and there was little margin for error.

I can still recall how my heart pounded, my palms perspired, and fear silently screamed in my head during the first few meetings. I was the only woman in a boardroom filled with 32 very successful businessmen. And now I was the Chairperson, responsible for guiding this organization to success. My fear wasn't just for me personally, but rather I was so afraid I would look, do, or say something foolish and those mistakes would

close doors for the women in the wings. My small reservoir of confidence evaporated the first few times I walked into that boardroom. Let me emphasize who I faced in this scenario: a room filled with well-known, highly successful business leaders (men) of the region, and I was this unproven woman invading their territory.

It makes me smile today. But I had to begin somewhere, so I used the ABC's technique and confidently saw myself in the boardroom, seated at that long, highly polished conference table (intimidating by its very size). There I was in my mind's eye, masterfully participating in this meeting earning the respect of everyone there. I focused on making what I saw in the mirror a reality and it came to be just that. Me, as a strong, successful leader. A confident me.

Eventually I learned how to lead, became less intimidated and achieved at most remarkable levels. I used my continuing volunteerism as a vehicle to gain high visibility and growing respect. I was able to conquer my fears by over and over again doing what I feared most. If it was leading an organization in transition, I went right at it and when achieving success in doing so, the fears went away. If it was public speaking, I forced myself repeatedly to walk to that podium. Sometimes the presentation was excellent, other time mediocre and once or twice fell into the realm of horrible, but eventually I was able to conquer that fear as well.

Audrey

Let's review the life of a lady named Audrey who had ongoing battles with confidence. She felt beaten by life and her self-esteem was in the basement.

Audrey was in emotional pain, unable to find peace, constantly worried and frankly a very sad woman. Her future seemed so dim because she never had any confidence in her abilities to change her situation. So, day after day, she continued to be unhappy, believing herself a powerless victim. She had ambition but could not get past the struggles in her personal life, so her dreams of professional success were snuffed out.

Her first burden was that she was in a marriage situation that was ugly. She had three young children and her fear of the unknown paralyzed her, so she just stayed where she was in this horrible marriage, thinking she could not change anything. She was a prisoner existing in a life of unhappiness and abuse. Together, over time, we worked to help her gain an understanding of the **3 Circles** of life. Step by step, she began to believe that her life could be different. As time progressed, she was able to take some forward steps but still struggled with finding the courage, the real confidence, to make dramatic, and much-needed changes.

Eventually she progressed to the point of those 3 steps of **ask** yourself, be **bold** and **conditioning her mindset**. She found inner strength, her inner confidence, and finally took the necessary steps to legally get out of that horrible marriage. Her fears regarding finances were silenced because she was given enough financial support to supplement her income and care for her 3 children. Those changes allowed her to focus on being a good parent and doing a better job at work, to become more capable and happier in all **3 Circles**.

By constantly exploring new ways she could change her life, she guided her life to higher levels of happiness.

She loved where she worked, but each day, as she got in touch with increased levels of confidence, she recognized she was gaining in skills and capabilities that could help her advance to another position, one with higher rewards. She felt she could meet the new responsibilities and challenges capably and confidently. She explored new job opportunities and achieved one with more money and even more quality time to allow her to be a better parent. Let me share a very exciting update: Audrey is now happily remarried to a most wonderful man; she has been able to develop her career as an international compensation professional, traveling the world and earning six figures plus while confidently co-parenting a most adorable little girl. I am so proud of her and personally feel such a sense of satisfaction that my advice helped her grab onto the life she wanted and deserved.

She believed and she *made it happen.* So can you!

Once Audrey decided to stop the abusive relationship, she was able to focus on her goals and made it happen. Now an admission, which might surprise you, coming from a woman who seems so fulfilled and in control now, but it is a true and sad admission. There was a time in my life when I kept dreaming about finding my Prince Charming, straight out of a romance novel. He would be someone who would make me happy, offer endless love, be movie-star handsome, funny and wealthy. I thought that if someone like that loved me, it would finally confirm my worth, that I was someone special, and I would be happy. Wrongly, I was searching for someone to make me happy. And then my wish upon a star came true. There he was... I finally met my Prince Charming and he chose Me. And it came with affirmation of my worth... Look, he chose me.

Once we became seriously involved, however, my Prince Charming showed he was really a Frog. He emerged as a cruel and violent man with emotional problems galore. Over time, my dreams of quiet, candlelit nights alone, changed into nightmares of physical and mental abuse.

For others of you out there, it might seem hard to believe that a woman wouldn't just pick up and walk out the door the very first time someone hit her. Yet, if you consider how vulnerable and powerless a woman can sometimes feel, perhaps you'll understand why the number of women involved in spousal abuse continues to grow each year. Regardless of how rich, pretty, or successful they are, millions of women are battered and abused. I have been called the "Fixer." People come to me with problems and I guide them to find the answers to fix what is wrong. Well I thought I could fix this Frog. No... *the only solution was to end the relationship.*

Yes, I finally looked inside myself and found the reservoir of strength I needed to get my act together. I can never remove the pain and guilt I have about this time in my life. And, I can't tell you that by just deciding to end my abusive relationship... bam, it was all over. No, it took some time. Finally, I had the courage to end a most embarrassing and painful segment of my life.

I share this embarrassing personal story in a book about changing one's life and achieving success because I wasted so much energy on a relationship that was damaging. If your life includes such a relationship hear this: Abusive relationships must be ended. As quickly as humanly possible.

These horrible abuses can happen in a work relationship as well. It may not manifest itself in physical bruises, but it

can stop you from doing your best work and thus having the confidence to pursue career advancement. Have you ever had a co-worker demean every idea you put forth or find fault with every report or project you submit? Have you ever had a boss see every minimal mistake but ignore major accomplishments? Does your supervisor berate you in front of others? Does she ignore your value and worth? Does she take full credit for your positive work results? Those relationships are abusing you. Well you don't have to suffer those fools anymore. You will be strong enough to end them, report them, take whatever action stops the emotional abuse.

STRENGTHENING YOUR CHARACTER

"Reputation is the shadow. Character is the tree."

– Abraham Lincoln

Another surprising hidden benefit of this program: "character."

Good character means doing the right thing because it is the right thing to do, regardless of context. Generally, we know the right thing to do — we can choose to do it or not. If we do the right thing, we usually feel good about the action we have just taken. Sadly, we are sometimes pushed by others' influences not to do the right thing. Character: the ethics we follow, the moral path we take, regardless of circumstances. It is easy to do the right thing when there is no risk to us. But what about doing the right thing when there is a possible negative effect on us?

When I have conducted seminars and introduced the topic of character, inevitably it prompts a lively discussion about the definition of character. Some people think that character is the group of qualities or tendencies within a person that makes him or her distinctive from everyone else. Others think it is only the good qualities within a person.

We speak of the "character" of public figures when we try to decide if someone is trustworthy or untrustworthy. Of course, there are "characters" in books, movies, and TV shows, with their distinctive qualities that make us interested in what they do or don't do in a story. And we have all known a "character" — someone who is a real card — a comic, unusual, or eccentric person who stands out from the crowd.

Are you wondering why I have a section on Character in a book about saying goodbye to the **Life-Balance Hoax**? And listed it in the Benefits section? Because a strong relationship exists between character and confidence. As you increase your awareness of the life you are living and your confidence increases, so too will your awareness of your character. And when you are in touch with your character, you can make wiser choices about what changes will work for you and truly improve your life and the lives of those around you. Feeling good about yourself and your impact on others then increases your confidence. It is like the drop of water at the top of the fountain that continues to run down to the base. A single drop of goodness can create many positive ripples. Character forms an important element of living well.

EXERCISE: CONNECTING WITH YOUR CHARACTER

Let me help you to connect to your *Character.*

Let's start the conversation on character by applying it in friendship. I believe that to have a good friend, you must be a good friend. If you want to be loved for who you are, then you must love others that way. If you want a friend to be tolerant and forgiving of your flaws, whatever they may be, you must call upon your inner strength of character and be tolerant and forgiving of them first.

Furthermore, you can build your character to fantastic levels if you embrace some of these practices.

- There is much truth to the statement, "You reap what you sow." What you give comes back to you tenfold or in even greater proportions. Treat others like you would like to be treated, for what goes around comes

around, in a boomerang effect. (Yes, just like Boomerang Communications).

- Respect: Almost everyone who writes or talks about Character agrees that it includes a high focus on respect. I urge you to respect every other human being with whom you come in contact. Regardless of race, ethnic background, social status, social issues, no matter how "weird" or different they may be — give them the respect you would want others to give to you and your loved ones.

- Never treat anyone in a way you would not want your parent, sister, or child treated. If you conduct yourself this way, your own self-respect will increase. You become stronger and less vulnerable to situations that create imbalance in your life.

- Be dependable. Do what you say you'll do; be where you promise to be, and honor your commitments.

- Tell the truth, because the truth will always come out. Blend the truth with *kindness*. Truth is never a valid excuse for cruelty or for betraying a confidence.

- Tolerance, forgiveness, enthusiasm, patience, love — let those and other similar feelings fill your heart, mind, and soul. Remember, how you feel is entirely up to you. No one has the power to make you feel anything you do not want to feel.

Let's now do this exercise to connect you with your inner character.

TAKING INVENTORY

Begin your own personal inventory by answering the following questions:

- What three words would you use to define character?

- What was one of your happiest days last week? Why?

- What was one of your happiest days last month? Why?

- When did you last feel jealousy?

- What five words would your spouse/mate use to describe you?

- What five words would you use to describe your character?

- When was the last time you told someone you loved him or her?

- When was the last time you sent a friend a card for no reason?

- How do you want to be described at your funeral?

- How many years have you had your closest friend?

- When was the last time you stuck up for someone, when others were talking about her?

- How many times a week do you tell a lie?

- When did you last do something courageous or outside your comfort zone?

- Do you know how to be a good friend?

- What can you do to improve yourself?

- When was the last time you looked in your "emotional" mirror?

- Are you guilty over something you've done recently? Fix it.

- Do you owe someone an apology? Do it.

CHARACTER IN SELF

What do you think? Is character shaped by how we are brought up or is it part of our DNA, our genetic makeup? Hard-core criminals are often recalled as such cute kids growing up, but then a significant incident turns them into a person capable of bad actions. Likewise, there are people who have turned the corner and gone from bad, uncaring, and unkind people to devoting their lives to helping others. Surely, we all have known someone who changed for the worse right before our eyes, and we have said "I never knew she could be like that!" I told you my own encounter with that. The same goes for converting a person without good character or a weak person into one who is powerful and with good character. A person's character can be changed. The secret? The desire to do so must come from within.

A person's observable behavior is an indication of their character. A person of character does what is right to do regardless of the circumstances. At work, an employee of good character will consistently perform at their best, often without supervision, and always strive to do the right thing. Character also shines through a person's interpersonal relationships. A person of good character has a healthy mind and spirit and is compassionate and empathic and conscientious about their impact on the world. You can see how good character permeates all **3 Circles** of life: it shows up in the **Work Circle**, the **Relationship Circle**, and the **Self Circle**.

I believe that character is the engine, the foundation and core of why you do what you do. Your inner character connects you with the power you have inside — it can be your most potent source of strength. Character is personal, but it is not personality. It is the set of responses, strengths, weaknesses, and

tendencies that make up a unique individual. It is your beliefs, your morals, and your value system.

While there are many different opinions about what constitutes good character, there is much agreement too. Most of us would agree that dishonesty, backstabbing, corrupt financial practices, and other similar qualities are components of bad character. No one likes people with those qualities, and you certainly don't want them in your life.

Don't you agree that if you have more good qualities than bad ones, you are generally liked and sought out by others? Having good character, being a fine person, is not a guarantee of being loved, but it will draw others to you; you will have a life surrounded by supportive people. And then, when times do become a bit unbalanced, you have the support and love of those people.

Certainly, you do not have to face tragedy to get in touch with your own character and I don't expect you to go build housing in Africa either. There are so many more women of character with inspiring stories a person can look to for motivation. There are biographies of women who have changed the world; there are stories in my own small community that have touched my heart. One is Donna Ponessa who has been living with multiple sclerosis since 1982, now paralyzed from the chest down and breathing with a ventilator. I was filled with great admiration when she competed in the 2012 Paralympic Games alongside 78 horse and rider combinations from 26 nations around the world at Greenwich Park, London. Such a remarkable woman of great courage and supreme character.

We all have read the stories of women who live in cultures where women don't have any power, or even decent human

rights, and they tear at the soul of "sisterhood." Many of these women found the inner strength — her own power, her own courage — to overcome heartbreak, to fight for her rights and the rights of others, to spur and achieve societal change. I mention these examples with the hope that you become aware of the fact that, regardless of where you are in your life, regardless of whatever challenges you may be facing, change can happen, and you will be the one to make the change.

I sincerely believe "Improve yourself and your life will improve." A boss likes a punctual, honest, conscientious employee (wouldn't you?) and a wife likes a considerate husband who is a man of his word and willing to turn off the game, go outside in the rain, and pick up their child from evening basketball practice on time. Conversely, the spouse likes a partner who is honest and true to him, who doesn't reveal his vulnerabilities behind his back, and who works hard and conscientiously to keep the family healthy and prosperous.

The friend likes the person who will be there loyally for him or her, even at three in the morning, investing effort and care into the relationship. Inside our *Self Circle*, we respect ourselves more — in fact, we experience a natural "high" — when we diligently do that volunteer work or hold back those hurtful words and demonstrate the finest qualities we can. Character impacts our **Work, Relationship,** and **Self** circles in big ways and, when they are in touch with your best qualities, can be highly rewarding as well.

We can improve our personal character with effort and desire. That is why you are reading this book — because you want change. We can train ourselves to be more patient, kind, self-controlled, diligent, and to bolster all the good character

traits that make for success in the circles of life. You will find that, as you implement these changes, your character changes.

Are you inclined to be asking yourself, "What does it matter if I have good character as long as I can look at myself in the mirror?" Or are you thinking, "You told me I wasn't perfect, so why do I have to worry about this topic?"

You don't *need* to have good character in order to make millions. Sadly, that has been proven over and over again. And you don't need good character to have love in your **Relationship Circle** either, because there will be a select few in your life who will continue to love you despite you being unkind, your temper tantrums, selfishness, and other behaviors which reflect your lack of good character. However, I can tell you that good character is the quality that distinguishes you as someone truly worthy, someone to admire, someone to emulate. That's worth having. And it can make you feel really good about yourself.

CHARACTER IN RELATIONSHIPS

Your good character is the centerpiece of the woman within you. If you reach within, you will find that you do have the qualities of patience, diligence, kindness, friendship, and other virtues. All you must do is bring them out, exercise them, and develop them. Character then becomes a link to continue your evolution into a wonderful woman with a rewarding life. Having Character in Relationships means you don't betray a confidence, you don't gossip, you are loyal, you are willing to give more than you get, and you are tolerant, forgiving, supportive.

Have you ever had a particularly lonely day? Month? Wished someone would "understand" you? Wished for a friend to just be there without passing judgment on you? How do you get to a place in your life where that support is within reach? I told you the adage that you will reap what you sow. If you are a person of good character, then you will be accessible when someone in your life asks for help. You won't respond based upon how convenient or inconvenient it may be for you at that time; you will simply try to help, as someone others can count on, a person of good character. Then, when you likewise need to talk, to cry, when you need a ride or an opinion or help with something important to you, I assure you that help will be forthcoming.

CHARACTER AT WORK

I've tried to emphasize that character is an important ingredient in creating your dream life and living well. As I mentioned before, employers seek to hire people who have good character as well as talent; people who are efficient, dependable, enthusiastic, trustworthy, considerate, et cetera. While technical skill remains important, I have repeatedly watched as the person hired is often the one who shows "promise," the one who the hiring manager feels will bring to the company not just specialized training but a myriad of good personal attributes allowing this person to grow professionally as the company grows and be a tremendous asset. Those qualities fall under the description "good character."

Let me tell you about some rewards of having good character that happened to me in my *Work Circle*. You've read about some of the awards I have received. Most of those were given not because I became a self-made millionaire in my early 30s, nor were they given because of my rags-to-riches story. No.

Many of those awards were given because I gave back to my community. My volunteer work on economic development projects created thousands of jobs. My citations from the U.S. Congress and from the N.Y. state government and from other organizations — each award, dinner in my honor, and each standing ovation — were recognition of the work I have done for charitable organizations and for my heartfelt commitment to helping others. Character made that happen.

I share these comments not to toot my own horn but rather as an affirmation that, by forgetting about myself, my own painful issues and focusing on the needs of others, well, the best aspects of good character rose to the surface. My motivation was to give back to my community and the rewards made me feel so appreciated. I didn't do it alone. I could not have achieved at the levels I did over the years without the hard work and support of hundreds of others who worked on each of those committees with me, who helped me build my businesses, and who also gave their time and energy and unfailing support. These amazing people showed remarkable character and I am forever grateful for their help.

Yes, people without good character do succeed. That is capitalism and sometimes greed. But I most sincerely believe they are flawed. I would rather be me than a Madoff.

Often the work environment is one of the most difficult places to demonstrate the qualities of good character. You see something taking place that shouldn't, and what do you do? Your co-worker is taking advantage ... *everyone* knows it; should you speak up? I've always felt that if it is an action that can hurt the company, then you need to speak up. Embezzlement? That's easy; report it through the proper channels as soon as you can. But what about someone you perceived to be a lazy co-worker

slowing down so she can get overtime? Hmmm. Can you prove it? You must be careful to not be too petty and recognize that there may be a price to pay if you speak up about what may appear to be small grievances. Search your heart. Make sure it is good character, caring about the company that motivates you and not something else.

Character is the most profound barometer of who you really are — especially when no one is looking. Remember, how you feel about life, about the day, about any situation is entirely up to you. No one has the power to make you feel anything you do not want to feel.

No, I am not naïve, and I am not saying to you, "Oh, even if terrible things are going on in your life right now, if you just think happy, you will be happy." No. I am telling you that I know from personal experience that you can change your life, you can change your circumstances with the tools I've told you about. It does not happen overnight; it does take work and perseverance, but it can be done. I am a flesh-and-blood woman, an ordinary woman, and I created this most remarkable life. You can too!

THE COURAGE TO CONFESS

Do you have a confession to make? I'm not suggesting you should confess to clear your soul and burden someone else. No, I mean do you have a confession to make to *yourself?* Perhaps a long overdue acknowledgment that the time you got fired was for a valid reason? You don't have to tell anyone else but find the inner courage to admit it to yourself. Do you have a confession to make that you were more than a bit jealous when Sue got the promotion and you didn't? Again, don't tell anyone else; just 'fess up to yourself. Have you admitted, confessed

to yourself that you got into this financial pickle because of shopping, not because you lost overtime?

I'll confess! I think I finally found the answer to my self-image challenges. I've figured out that it probably came because I was damaged as a child. I've mentioned the accident I had as a toddler and was left with terrible scars, so that from a very young age, I worried about people looking at me. Why were they looking at me? Did they see the scars on my face? Were my socks tall enough to cover the scars on my legs? As I became an adult, I overcompensated and worried about every other area of my appearance too. Was I too tall? Too fat? Was my posture okay? I couldn't get it through my head that I was simply "Donna," who some years was in a skinnier body and some years in a wider body and most years looking older regardless of whatever makeup technique I used. I made a big mistake. *I had made my outside more important than my inside.*

I admit I dealt with the fanaticism of concern about my appearance well into my 40s. Then two things happened. One, I finally had the scars on the side of my face removed, but not the rest of my body. They are still there. But that step allowed me to no longer cringe when people looked at my face. And two, I learned to accept and live with the ones on the rest of my body including the new ones from a few major operations that now have my body looking like a Zorro canvas. Yes, they are all there. The more difficult challenge has been accepting the other ones... that I have continued to have *hidden scars* throughout much of my life... the emotional scars. Those are the ones that are so difficult to put to rest. I tended to hide those from most people.

Finally, I found the courage and character to share with others the story about the scars on my body and in my heart. I found

the courage to tell others, as appropriate, about those hidden scars on my heart too. I told them how much Mother's Day still hurts or how I still have nightmares, even at this age. I found the courage to confess that I had made some terrible relationship mistakes, some rather foolish business decisions on and on. Now I have found the character to confess to the world.

All this was so difficult, but I could do it because I realized that a scar means the hurt is over, the wound is closed and healed, over and done with.

"Out of suffering have emerged the strongest souls; the most massive characters are seared with scars."

— Kahlil Gibran

I encourage you to have the courage to confess. Do you recall when I shared that I made a mistake divorcing my children's father? When I share those thoughts with others and my Jeffrey is around, people will swivel their heads with concern to watch his reaction. Jeff is comfortable with my love for him. He knows that the combined experiences in my life, both good and bad, have made me who I am today and that in many instances we grow from our mistakes. Having made that mistake of not taking care of a good relationship, I am not likely to do it again. I cherish my marriage and have for several decades. I will do all I can to protect my marriage, giving more than I get whenever necessary. I know from my life experiences that one can love more than once. The widow or divorcée who remarries is blessed to have the capacity to love again; it does not mean she has to negate the intensity or good quality of her prior marriage. That is how it is with me. I confess I made a mistake; I grew, I learned, and I am in love again.

Find the courage to confess your mistakes to yourself. Stop kidding yourself; face the issues and then put them away so they don't haunt you over and over again. Having the courage to do this means your character leads the change in your heart and your soul. You will feel better about you; there is power in knowing — knowing what you should have done, could have done, and will have the power to do "next time." Your increased personal power will allow you to take solid steps toward the success that you want and the personal goals you have.

As I said, I made some terrible mistakes in business too. Over-expanding, making impulsive choices, not appreciating a certain employee enough, trusting another one too much. I have confessed those to myself and when given the chance to the people involved as well. That step, my friend, can be a real character-builder.

ARE YOU MY ONE PERSON?

It took me many years to write and develop these ideas. It invaded every part of my life. I had many years of getting up at 5:30 a.m. to work on the book before going to work to my regular job. Saturdays, Sundays, precious time spent on finding the right way to phrase things, to be sure I was clear on the heart of the message. I shared with you my painful intro-spection, opening wounds I hoped had been healed, to share my story, my pain, and — finally — my triumphs. A close friend asked me, "Why? Why do you want to do this?" My answer was, "I want to make a difference. I want to help someone else avoid the depths of pain that I went through. I hope and pray that one person uses this advice to make her life better. Even if it is only one person, I will indeed have made a difference."

Is that one person you?

I've given you the tools to have it all. I've given you my heart, my soul, my life experiences, my pain, my mistakes, the steps I've taken and the tools I've learned which have allowed me to create this most fantastic life, a life where I'm happier than I ever dreamed I could be. If I made the journey from that horrible place, so can you. It will take work, and won't be overnight, but aren't you worth it? Craft the life you want for yourself — a life of hope, goals, and dreams achieved. I most sincerely want you to be my legacy.

HAPPINESS AND PEACE

"Happiness is not something ready-made. It comes from your own actions."

– Dalai Lama

Often one of the most frequently asked questions for me is: "How can I find happiness?"

The answer always is: You cannot find happiness, you create it and you can never do it through someone else. It must develop within you, and the definition of happiness is different for everyone. Remember how I asked you whose description of happiness are you chasing? I wonder, do you know what really makes you truly happy?

A lot of people have this perception that being happy is an exciting feeling, a state of ecstasy. I cannot deny that could be a momentary feeling, such as when the new diamond hits the ring finger or when the pregnancy test reads positive, or the new job offer comes through. But I think True Happiness is more serene. It is a tranquility and lasting peace that allows your mind to be relaxed and free.

So many women tend to define happiness through a circumstantial happening such as finding that perfect partner, more money, better job. When you take an honest look at what happiness truly means to you, perhaps you will find you are completely wrong in your thoughts. Survey after survey is done, with scientifically formulated, data-driven conclusions, yet can we point to one absolute, non-controversial definition of Happiness? No.

For me, happy days are the days I feel peace and gratitude and awareness in my heart for what is good in my life. It is when my state of my mind is relaxed. Your mind plays an amazing role in your individual happiness; how you view a situation, a day, an opportunity.

Let me share a few names: Robin Williams, Anthony Bourdin, Kate Spade, Whitney Houston, Philip Seymour Hoffman, Cleopatra, Vincent van Gogh. All famous in their time with worldly possessions and lifestyles envied by millions. Yet all struggled with this search for happiness, for peace, and for love. They struggled so much with a conscious and subconscious sadness that prevented them from enjoying all the fabulous people, accomplishments, love and even material things in their lives.

They had fame, fortune, respect and yet... they were not happy. Their state of mind drove them to the horrid step of ending their own lives.

Your mind is your best ally and your worst enemy.

Peaceful, placid, serene, tranquil refer to what is characterized by a lack of strife or agitation. *Peaceful* today is rarely applied to persons; it refers to situations, scenes, and activities free of

disturbances or, occasionally, of warfare: a *peaceful life*. Yet this is what I suggest we seek. A peaceful Life = a happy Life. My discovery is that if I am peaceful, not obsessively worried, not fearing, not wasting energy chasing elusive balance, accepting of myself and others, then I am generally Peaceful, relaxed and happy.

As a divorced woman, I had to believe that I would someday meet a man to share the rest of my life with, and yet, if I didn't, I would still be okay. Before my marriage to Jeffrey, I was single for almost ten years, and it was a wonderful opportunity for personal enhancement in my **Self Circle**. I learned to be alone, to depend on myself, to think for myself. I charted a course for my life that would not include a Perfect Partner. Instead, I focused on my children, my business, self-improvement, my friendships and enjoyed each day. I now have a wonderful partner in my life, but I know that no one else can make you happy until you are happy with yourself.

If you allow yourself to be happy, you can then journey up the path you have defined for yourself as a life goal. You can dwell on all that went wrong or you can create that album of the good life happenings.

Here's a great example of peaceful happiness or her mind being her best ally or her worst enemy. Our newspaper carrier broke her leg, so the distribution company assigned a substitute to cover for her; it was a veteran carrier who added our route to those she already handled. One morning I was outside when she came by. I walked to her car to thank her for covering for our injured carrier. During the chat, she revealed several things. She told me that she gets up at 1 a.m. each day to go to the distribution center, sort the papers, load her car, and then begin on her rounds. She puts 200 miles a day on her car and

has been doing this for 27 years. That is not a typo. 27 years at 1 a.m. She sighed that she was happy with her "choice" because "happily" she then had lots of time for her seven children during the day. I know she did not make a great deal of money.

Happy!?! A schedule many would call grueling, a family responsibility many would bemoan, yet she embraced it with joy and happiness. In her mind, she had the perfect life. Her mind defined happiness as being able to be an available parent to seven children, and she made whatever choices necessary to be able to achieve her happiness. Were there days her life was totally out of balance? I am sure. Were there times she had to push back to get things under control? Again, I am sure. But she lives a happy life because it was her personal definition of Happy.

I aimed for financial success — the millionaire status — and yes, I achieved it but, as I have told you, the million-dollar moments — those are the ones that make you feel like a million. Yes, living with money is better than the struggles I encountered when money was always short. But it is funny in a way what happened as I attained real wealth. When I used to walk into a store, I wished I had the money to buy that cute top or those shoes or whatever caught my eye. Once I had enough in my wallet to buy all of those things, I realized I did not need them. So, it wasn't the actual dollars in my pocket, but the peace of mind achieved by no longer having money problems.

Here is a very important point to remember:

LIFE CHANGES; Your state of happiness changes.

Let's think of the Bride who utters... "This is the Happiest day of my Life." Or the new mom who holds her newborn in her

arms and says, "This is the Happiest day of my Life," or the hard-working, driven career lady who finally gets that promotion, and she says the same thing.

Many of those are circumstances creating the moments of happiness. But surely it won't be the last Happiest Day for them. There are times when I have felt happiness and it was not caused by a circumstance but rather an aura of peace finally attained. Nothing mystical, simply an awareness that my life was okay; that I was okay. I can find this peace because I have looked inside my Self, been truthful about the things that are important to me, and then used my power tools to control and communicate my choices.

Cognizant of the fact that this feeling cannot last indefinitely, I keep my power tools at hand with the anticipation that something may temporarily remove that feeling of peace and unrest will charge through my door. But I know I have the power and ability to prioritize, and take care of the biggest item of burden first. And now so do you. Happiness is in your power to have and to keep in your life. The choice is yours.

A Life of Promise

"If you don't like something, change it. If you can't change it, change the way you think about it."

<div align="right">

—Mary Englebreit

</div>

You can create your own happiness but season it with a dose of practicality and realism. Your attitude toward life is your own decision. You can choose to create a life of promise. It is up to you.

Living with Power

WHEN I USE the word "powerful" throughout this book, what do you envision? I envision a person who lives his/her life in a way that is fulfilling, no matter what are his/her circumstances. Being powerful has nothing to do with being a public figure, a multi-millionaire, or a politician. Any person can be powerful if they seek self-actualization and nurtures themselves. A Person of Power is kind and caring but makes sure to take care of his/her own needs as well. Living with power means living her life in the light of your destiny, as you perceive it.

A regional publication in my area periodically publishes a list of Power Players: the most influential people around. They write the biographies of these select few, citing their formidable

accomplishments and offer accolades about this prestigious group. I have been on that very exclusive list, and there have been times when I have not been. From my perspective, I was not any different the years I made it and the years I did not make it. My selection was all in the perception of the reporter composing the article. In fact, I sometimes felt very powerful and more influential during years when I was not on that list. Which year was I a Woman of Power? Every year because the power is within me.

EXERCISE: PLEDGE TO EMBRACE CHANGE:

I promise you that, if you follow the recommendations in this book, you will be able to handle those days when life becomes unhinged and start guiding your life to where you truly want it to be. In return, I would like you to promise me — but mostly promise yourself — some things. Please take these pledges seriously. You deserve every one of these promises to come true and to be real for you.

YOUR PLEDGE (SAY THEM OUT LOUD):

- I promise to shed the **Life-Balance Hoax**.

- I promise to live by the **3 Circles** concept.

- I promise to create my million-dollar moments.

- I promise to shatter the myth of perfection.

- I promise to forgive myself for my shortcomings.

- I promise to be tolerant and forgiving of others.

- I promise not to expect others to make me happy.

- I promise to take responsibility for my own happiness.

- I promise to accept myself physically as I am, improving myself for reasons of health, rather than in a vain attempt at physical "perfection" as defined by magazines.

- I promise to treasure and invest in my good relationships.

- I promise to weed out the toxic Relationships.

- I promise to take care of myself in my *Self Circle*.

- I promise to invest in my *Work Circle* so that I am successful by my own measure and always in an ethical way.

- I promise to find the time to give to others and to myself.

- I promise to make my own choices and be in control of my own life.

- I promise to stop chasing the **Life-Balance Hoax.**

- I promise to find my power from within.

You are embarking on a journey to rebuild your life to make it better for you and those you love. There will be love, joy, and victories, and, realistically, there will be challenges, disappointment, and stress. I have given you tools that will make the days of love, joy, and victories more frequent and the days of challenges, disappointment, and stress more infrequent.

CREATE A LIFE OF JOY AND PEACE

"To experience peace does not mean that your life is always blissful. It means that you are capable of tapping into a blissful state of mind amidst the normal chaos of a hectic life."

— Jill Bolte Taylor

I have developed and used the suggestions in this book to create a better life for myself. With a great sense of satisfaction, I share that I've guided many other women who also have been able to change their lives for the better and achieve their dreams.

I often describe myself an ordinary woman who leads an extraordinary life. I am ordinary. *Fortunately,* I've been able to remove many obstacles and have a clear vision of my dream life and how to achieve it.

One thing I do know is that, if I am alive, I will find the answers to solve any problem I encounter. I strive for a positive view of life and a great deal of compassion, personal and social responsibility, and love, which in turn give me joyous days and peaceful nights.

That's the ideal to aim for — to find the joy in living, where most of the things you do are things that you don't mind doing and even take pleasure in, no matter what those things are.

Why do people who have lots of money do their own gardening or paint their own houses? Or clean their own cars? Those things are not chores to them; they are things that bring them joy.

That's what I want you to have — joy in living. Identify those things in your life that bring you joy. Perhaps it is a sunrise or a sunset; the laughter of your niece; the joy of making dinner for friends, working on a home improvement project, following a new recipe to create a baked delight. Maybe it is an accolade for a job well done that brings you joy. Maybe it is your internal feeling of pride for the way you handled something. Or maybe

simply doing nothing, sitting by water, reading, or meditating. Then that is what you must do: indulge in that joy.

I equate real success with undisturbed peace of mind. I would follow that up by equating true peace of mind with internal happiness.

No one on earth is ever peaceful (one hundred percent of the time), yet peacefulness is a state you should find yourself in often. It has been written that truly happy people know how to return themselves to a state of peace, relatively quickly, whenever they become disturbed. This ability transcends all types of possessions and achievements, and it does not depend on anything but the individual for its continuity.

As you go forth and apply what you have learned in this book, aim for a life where you can experience the joy of living, and peaceful days — days filled with the things that make you smile.

> *"The greatest discovery of all time is that a person can change his future by merely changing his attitude."*
>
> **— Oprah Winfrey**

Everybody dies but not everybody lives. I live a full yet satisfying life. I laugh far more than I cry. It is not because I have attained wealth or fame. One problem with money, fame, careers, and possessions is that it's entirely possible to lose them. Another problem is that it's also entirely possible to get money or fame or a possession and then find out that it is disappointing.

I think that my state of mind, being peaceful and happy is my most significant achievement. That is the million-dollar Lotto prize for me. I am quite tired some days, but I put my head on my pillow at night filled with inner peace and happiness. You can have it all too: joy, peace, harmony, love and happiness. These can all be words you use to describe your life. It is all within your reach.

My life changes did not happen overnight, nor will yours. Use this book over and over again. Don't hide it away; keep it out for easy access.

Want to experience something quite interesting? Go back and look at the things you highlighted, the notes you took as you read through this book. The chapter that had a strong impact on you the first time through the book will *not* be the chapter on which you focus, the second (or third) time you open the book.

This is because, even if you did not realize it, you and your life will have changed. If you followed the advice in this book, you will have progressed in your personal development. You will have advanced day by day, making the life changes you feel are important. And you will continue to do so... day after day... year after year. Remember, life changes, you change, what is happening in your life's Circles changes, often impacted by things you cannot control. But you can control and manage your responses, how you handle what life sends your way. I encourage you to continue your journey of personal growth.

It is you who will make exciting new choices as you navigate your journey through this new reality. It is up to you to work on your future and to figure out which pathway is yours and where you want it to lead. I emphasize

that it is your life and you, as Pilot, will determine the paths and destinations. You have the power and the tools to create a remarkable life. It is my fondest hope that this book will help you achieve all of that.

I wish for you inner strength, peace, and happiness, and for your journey to be filled with love and laughter.

Donna Discoveries

✓ Being alone does not mean being lonely.

✓ Whether you think you can, or you can't, you're right.

✓ You cannot change Yesterday, and your Tomorrows will be all the same, unless you use your "Power" to change Today.

✓ Life is the only place where you take the test before you learn the lesson.

✓ Everyday Life-Balance is a Hoax.

✓ Wishing without action is of no value.

✓ The picture you hold of yourself is the image others will see.

✓ To have a good friend, you must be a good friend.

✓ To be loved, you must give love. Tolerance given is tolerance received.

✓ Friendship is a gift — one you must give in order to receive.

✓ To be happy, you must deny hatred a place in your heart.

✓ Being happy is a Choice.

✓ Generally, most men make more money than women. But there's no reason you can't make more money than most men.

✓ You can use a positive attitude as your secret power.

✓ If you see someone without a smile, you should give her one of yours.

✓ Life's sweetest victory is the victory over negative thinking.

✓ The best revenge is living happily ever after.

✓ Your boss might oversee the office, but you're in charge of your attitude. You can't change his behavior and he can't change your attitude.

✓ Nothing is quite as satisfying as silencing the voice of fear.

✓ If a woman wants to accomplish something generally done by a man, it doesn't mean she wants to be a man.

✓ Equal does not mean the same.

✓ Women have the right to financial security and economic success. Yes, that means you!

✓ Set goals, otherwise you will travel aimlessly through life. The secret to juggling it all is... enjoying it all!

✓ To open the door to the future, you must close the door to the past.

CONTINUING THE CONVERSATION

Helping people find happiness and success in their lives has always been a very important and rewarding part of my own journey. This book reflects not an end of those travels but rather an exciting new chapter where I can continue to be a resource to help others transform their lives. I have been blessed by meeting many wonderful people along the way and maintain those connections still.

Please join me: I invite you to join me in further exploring the myriad of options available to conquer the challenges facing people of today on a personal and professional level by visiting my website www.donnacornell.com. There we can continue our conversation, learning and inspiring each other, through a variety of resources, including additional books, podcasts, and seminars. I look forward to hearing from you soon and continuing the journey together!

info@donnacornell.com

About the Author

Donna Cornell, a highly successful entrepreneur, has been a driving force within the professional search, career counseling, and life skills industries as well as an exceedingly accomplished community leader. A prime example of entrepreneurial success, she built a multi-million-dollar business into a significant presence with multiple offices throughout the United States. She repeated her entrepreneurial ventures creating other businesses nationally that she then also successfully sold.

But more than that, her exceptional leadership talents have also been called upon on behalf of many community endeavors. She now serves as volunteer chairman of the board of directors of a multi-location, not-for-profit health-care system caring for over 3,000 people a day, with 1,100 long-term care beds, 6 locations, a $90 million budget and thousands of employees. With her superior leadership skills, she is helping this organization travel the challenging road of change in the healthcare industry today. She has a myriad of impressive accomplishments in leading change within this organization and so many others.

Donna served as start-up chairperson of The Orange County (N.Y.) Partnership, an award-winning regional economic development organization. She helped develop and guide it to earn *national* recognition.

Ms. Cornell serves/served on both not-for-profit and for-profit boards and committees including but not limited to: (partial list)

- Advisory Board of HUBCO Bank
- Advisory Board of Fleet Bank
- CISE-NYS Manufacturing Association
- Dutchess Arts Council
- Elant, Inc., Healthcare
- Hudson Valley Technology Development Center, Chairperson
- New York State Trustees of Healthcare
- Mid-Hudson Pattern for Progress
- Greater Hudson Valley Health Center/Cornerstone
- Glen Arden Residence Center
- Hudson Valley Philharmonic
- Marist College Advisory Committee
- YWCA Tribute to Women Board
- Orange County Partnership -Chairperson
- EOC Chamber of Commerce, Chairperson
- Orange County Workforce Development Board
- SUNY MBA Advisory Board
- Women's Leadership Fund
- Venture Capital Investors Group
- SCORE advisor

- Big Brothers, Big Sisters mentor

These and other distinguished contributions led to recognitions that include:

- A profile in *2000 Notable American Women, World Who's Who of Women.*

- A *Business Leader of the Year* award *from* the Orange/Rockland Arthritis Foundation.

- A commendation by the U.S. Congress.

- A New York State Senate *Recognition for Service Award.*

- A 2008 *Flame of Excellence Recognition Award.*

- A feature in issue 17, 2003 of The *International Executive Search Magazine.*

- *A* 2013 acceptance into the International Women's Leadership Association.

- Registration in *Who's Who of the Year (1993), the World's Who's Who of American Women.*

- A 1996-97 listing in *Strathmore's Business Leaders.*

- A *Business Leader of the Year* award from The Family Health Center

- A *Distinguished Citizen* award from the Hudson Valley Council of Boy Scouts.

- A 2007-2008 listing in the Cambridge *Who's Who of Executives, Professionals and Entrepreneurs.*

- The *Hudson Valley Accelerator Award for Leadership* presented at a Leadership for Women conference.

Ms. Cornell has been cited as among the most influential people in the Hudson Valley, N.Y., region and has adorned

covers of regional publications. With little formal education after high school, she has successfully positioned herself as a powerful force, frequently serving as the first and only woman to break into the smoky male dominion of influential boards and committees.

Donna has appeared on radio and television shows, including being featured on *CNNfn* and *Lifetime Television* and has been a guest columnist in the *San Francisco Times, New York Times,* and *Vault.com.*

An accomplished author, Ms. Cornell is publishing books on life empowerment and personal fulfillment. Ms. Cornell holds the designation of Certified Personnel Consultant and International CPC. Married to Honorable Jeffrey Werner (ret.), she has 4 children and resides in Orange County, N.Y., and Longboat Key, Florida.

Ms. Cornell is also a graduate of an entrepreneurial program conducted by Dr. Jeffry Timmons through the Harvard Entrepreneurial program. In 2004, the US Association named Dr. Timmons the Entrepreneurship Educator of the Year for Small Business and Entrepreneurship.

Ms. Cornell was one of a select group of entrepreneurs who were invited to participate in reviews of the recommendations of the Grace Commission. The Private Sector Survey on Cost Control (PSSCC), commonly referred to as The Grace Commission, was an investigation requested by President Ronald Reagan in 1982 to focus on waste and inefficiency in the federal government. Its head, businessman J. Peter Grace, asked the members of that commission to "be bold" and "work like tireless bloodhounds."

Donna has impacted the lives of women across America who can offer heartwarming testimonials about the powerful results of her guidance and advice. A much sought-after motivational speaker, Donna Cornell has captivated nationwide audiences from all walks of life with her high energy and inspiring messages of a woman's path to happiness, success and fulfillment.

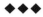

For More Information, please contact Donna at:

info@donnacornell.com
www.donnacornell.com

CPSIA information can be obtained
at www.ICGtesting.com
Printed in the USA
LVHW081147141019
634126LV00026B/5260/P